# Chinese Brushwork in Calligraphy and Painting

## Its History, Aesthetics, and Techniques

## KWO DA-WEI

Dover Publications, Inc., New York

*To*
*Marie and Louis Zocca*

Published in Canada by General Publishing Company, Ltd., 30 Lesmill Road, Don Mills, Toronto, Ontario.

This Dover edition, first published in 1990, is an unabridged republication of the work originally published in 1981 by Allanheld, Osmun & Co., Publishers, Inc. and Abner Schram Ltd. (Allanheld & Schram), Montclair, New Jersey, under the title *Chinese Brushwork: Its History, Aesthetics, and Techniques.*

Manufactured in the United States of America
Dover Publications, Inc., 31 East 2nd Street, Mineola, N.Y. 11501

*Library of Congress Cataloging-in-Publication Data*

Kwo Da-Wei, 1919–
   [Chinese brushwork]
   Chinese brushwork in calligraphy and painting : its history, aesthetics, and techniques / by Kwo Da-Wei.
      p.    cm.
   Reprint. Originally published: Chinese brushwork. Montclair, N.J. : Allanheld & Schram, 1981.
   Includes bibliographical references (p.    ) and index.
   ISBN 0-486-26481-5
   1. Calligraphy, Chinese.  2. Painting, Chinese.  3. Brushwork.
I. Title.
[ND1457.C53K88  1990]
745.6'19951—dc20
                                        90-3751
                                           CIP

# Contents

## Part Two    AESTHETICS OF BRUSHWORK

*Part Three*   THE TECHNIQUES OF
CHINESE BRUSHWORK

# List of Illustrations

# Preface

In China, only two arts are considered fine arts—calligraphy and painting— and the only tool employed by these sister arts is the Chinese brush, whose scope is truly unlimited. The key, therefore, to understanding Chinese art lies in a knowledge of Chinese brushwork.

There are many treatises, books, and manuals on brushwork that have not been translated from the original Chinese. Many of them are either very scholarly or theoretical in approach and leave one with the impression of "viewing flowers through a mist." Others try to teach painting in "three easy lessons." And, too often, in these Chinese works, when a subtle quality is discussed, one meets the comment, "It can only be perceived; it cannot be explained." There are, of course, books in English on Chinese painting or calligraphy, but none that deal in any significant depth with the aesthetics or techniques of brushwork or that make intelligible the intrinsic relationship between Chinese painting and calligraphy.

For these reasons, I thought it would be helpful for students and teachers of Chinese art, as well as lay devotees, if an explicit guide were prepared that analyzed and fully demonstrated both the aesthetic elements and fundamental techniques of Chinese brushwork.

We all recognize that art is a universal language, but where there are great differences in the cultural and philosophical backgrounds of people, a gap often remains to be bridged before successful communication can be achieved. Certainly, exposure without adequate understanding hardly enables one to grasp the core of that art.

To understand Chinese art, it is necessary to appreciate the historical factors which molded Chinese philosophy and Chinese culture. I have summarized this type of material and stressed those events or influences which had a profound effect on Chinese art. I have also included material on the various calligraphic styles, since without at least an overview of the major styles, it would be impossible to discuss intelligently the relationship between painting and calligraphy. The section provides, in addition, an analysis of each style in terms of its chief characteristics as well as a discussion of the criteria for judging what constitutes good calligraphy.

The aesthetic background of the art of brushwork is delineated in terms of form, line, space-consciousness and composition, and a full discussion is to be found of the criteria by which Chinese art is critically judged. The "flavor" or dominant expression of each major period and style of Chinese art is noted.

Among the major techniques discussed and illustrated, one will find how to hold and wield the brush properly, how to coordinate the position and moving angles of the brush, and the role of moisture, pressure, and speed. The major strokes are all dissected: center brush, side brush, dry brush, split brush, slip brush, pulling brush, as well as the turning, folding and rolling of the brush. The particular effects produced by the different ways of handling the brush are made explicit. This was not done in an attempt to show one how to draw (although the material is indeed helpful in this respect), but in order to help Westerners see Chinese art with a deeper understanding, as if through the eyes of an Oriental.

In the United States, the first formal exhibition of Chinese calligraphy was sponsored by the Philadelphia Art Museum in 1971. In 1976, the Metropolitan Museum of Art secured a major permanent collection of Chinese paintings. Today, both here and abroad, there is a surge of interest in Chinese painting and calligraphy, reflected, for example, in the special auctions on Chinese fine arts by such leading houses as Sotheby Parke Bernet and Christie's, and the demand for such works by interior decorators and collectors.

"Viewing flowers on horseback" is, indeed, a very superficial approach and certainly not the way to savor their beauty or aroma. I think a viewer of a Chinese painting or calligraphy would want to be able to classify a piece as to its period or style, be able to judge the quality of a line, examine critically the elements of the composition, while at the same time following the movements of the brush. If this study helps one to know where and how to look at a Chinese painting or calligraphy so as to appreciate the brushwork, then the author will be well rewarded.

Naturally, Chinese sources were used to annotate and illustrate the essence of brushwork. I added illustrations of my own to help in this task, and any illustration without a credit or identification line is an original drawing. For greater comprehension, the titles of Chinese publications are given in English within the text, but their original title, together with the English translation, appears in the Bibliography. All translations of titles and texts are by the author.

Concerning romanization: I have not adhered strictly either to the Pin-Yin or Wade-Giles system. However, the latter was generally followed, with some modification in order to provide a more accurate guide to pronunciation, particularly with the "D" and "T" of the Wade-Giles System. I prefer the use of "B" and "D" for these sounds approximate the Chinese more closely and are easier for Westerners to articulate. For example, "Dao" is closer to the true pronounciation than "Tao." In this instance I did not substitute "D" for "T", since the word is so widely recognized. I did make such substitutions, however, in romanizing proper names and other major terms.

In analyzing brushwork, it was necessary to coin many English phrases; for all major terms in the manuscript, the Chinese appears together with the English equivalent in an Appendix.

I wish to express my gratitude to the following institutions for their permission to reproduce pertinent works of art: The British Museum, London; The Museum of Fine Arts, Boston; National Palace Museum, Republic of China, Taiwan; The Seattle Art Museum;

and The University of Chicago Press for permission to reproduce four illustrations from the published study of Dr. T. H. Tsien on ancient Chinese writing materials. I am deeply indebted to my dearest friends and mentors, the late Dr. Louis R. Zocca and his wife, Marie, for their invaluable advice and probing questions throughout the entire task. My sincere thanks also go to Dr. Tan Tze-Chor, Dr. T. H. Tsien, Prof. Wei Tze-Yun, and Miss H. T. Yang who provided me with fruitful advice and reference material, and to Miss Louisette Couderain who assisted me in the rather large photographic chore involved in this study. I would like, too, to thank my wife, Rita, for her full cooperation, understanding, and patience throughout the undertaking.

K. D.-W.

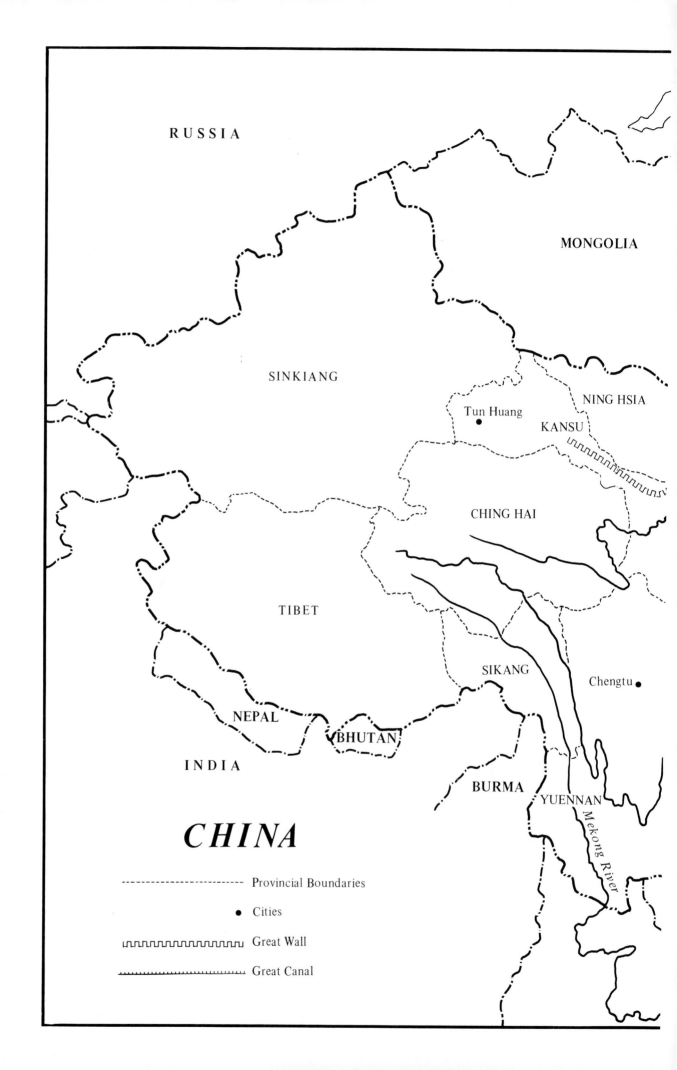

RUSSIA

MONGOLIA

SINKIANG

NING HSIA

Tun Huang  KANSU

CHING HAI

TIBET

SIKANG

Chengtu

NEPAL

BHUTAN

INDIA

BURMA  YUENNAN

Mekong River

# *CHINA*

----------------- Provincial Boundaries

● Cities

⊓⊓⊓⊓⊓⊓⊓⊓⊓⊓⊓ Great Wall

································ Great Canal

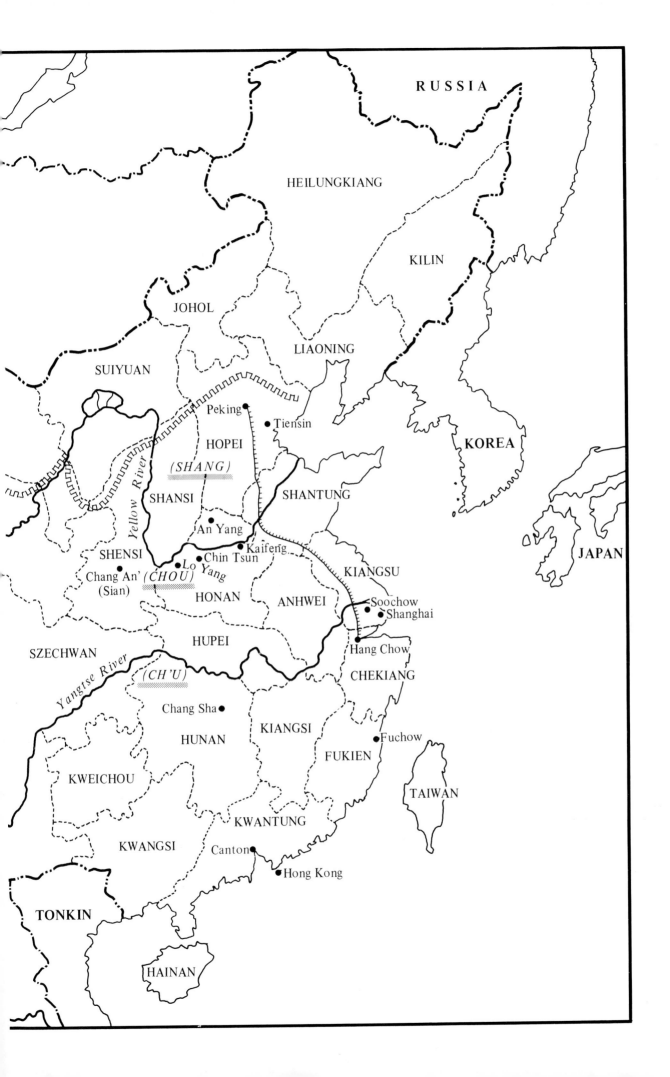

# The Historical Development of the Art of Brushwork

When one reaches back some 5000 years into Chinese history, the data that one can gather point to the fact that the Chinese brush has a longer and more continuous affiliation with calligraphy than with painting. The evidence of brushwork may be traced back to the Shang period (14th cent. B.C.) in calligraphy, whereas the earliest trace of painting can be found only in rubbings of pottery tiles, painted tiles, tomb frescoes, and painted lacquer baskets in the Han Dynasty (3rd cent. B.C.–3rd cent. A.D.). One may conjecture, however, that as new uses of the brush were developed with the passing of time, these techniques would have been applicable equally to painting and calligraphy, but they are more easily perceived in the latter since there is solid evidence concerning the development of calligraphy. For this reason, I decided to offer a short historical overview of Chinese calligraphy in order to provide the background of Chinese brushwork. Before proceeding, it will be necessary to give the reader some capsule facts which will be discussed more fully later.

Chinese artists have relied on a single tool—the brush—which over the centuries has proved its broad capacity and versatility.

The supple Chinese brush with its black ink can produce unlimited variations in the shape of lines and dots, as many as the artist can possibly manage (see Fig. 1). A "dot" in Chinese art is understood to be a dab with the brush, resulting in a point, a hook, or a small touch of color.

In Chinese art, black ink is considered and referred to as "color."

Chinese art is an art of line.

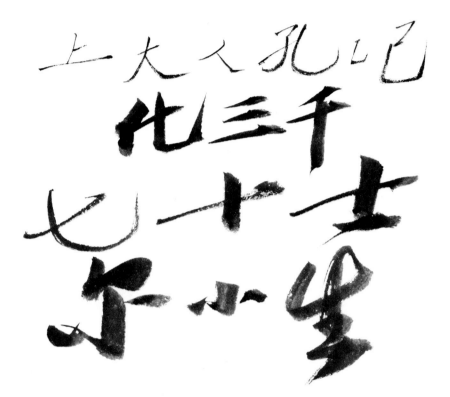

*Figure 1.* Examples of the various brush strokes done with a single brush.

Among the basic categories of Chinese brushwork are:

1. *Center Brush*: With the brush held upright, the tip does the painting.

2. *Side Brush*: When a wide enough stroke cannot be made with the tip of the brush, one must tilt the brush, and this tilting brings the side of the brush into action. One may use a quarter of an inch, a half inch or even the whole side of the brush, depending on how wide a stroke the artist wants to write or paint.

3. *Turning Brush*: When the brush is in motion and the artist wishes to change the direction of a line, he twirls the brush as much as necessary to place the brush in the proper painting position to effect the directional change.

4. *Rolling Brush*: When side brush is being used, the twirling of the brush to achieve a directional change is actually a rolling over of the brush.

5. *Folding Brush*: When changing direction, the brush is often actually folded over.

Each specific technique produces a widely different effect or line appearance. (See Fig. 2)

Painting and calligraphy share a close technical relationship. This affinity was first pointed out by the 7th-century art critic, Chang Yan-Yuan:

> An object must be depicted by its form; and the form should be filled up by its bone structure; both the form and the bone structure are based upon the original idea. All these are carried out by the brushwork. Therefore, the one who is a master of painting will also be good at calligraphy.[1]

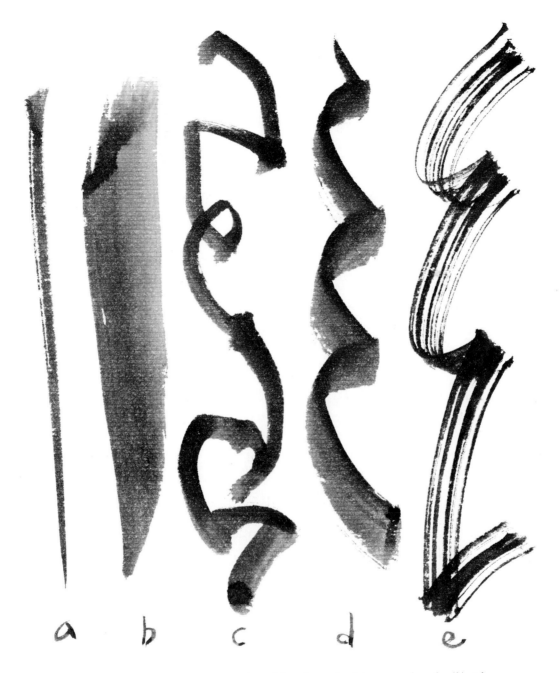

*Figure 2.* Some major categories of brushwork. (*a*) center brush; (*b*) side brush; (*c*) turning brush; (*d*) rolling brush; (*e*) folding brush. Each example is done in one stroke.

What he was saying about the sister arts is that the two arts, which share the same tool and the same materials, also share common principles and techniques of execution.

Chinese artists have all along been ready to exploit the advantages made possible by the close relationship between calligraphy and painting. In fact, they use the theories of painting to write and impart the techniques of calligraphy to their painting. The same strokes are evident in both. Thus, the two arts are blended into one.

In the Five-Dynasty period (906–960), Ching Hao, an outstanding landscape painter, in his treatise *On Brushwork*, discussed the essential qualities of brushwork: "Generally there are four major aspects: *Chin* [tendon], *Jou* [flesh], *Ku* [bone], and *Ch'i* [the vital force of the line]."[2]

According to Ching, the effect of a tendon-like brush stroke is caused by generating a tension between the two ends of a line, as is demonstrated in Figure 113. What he meant by "flesh" is all the fat part of a stroke which looks solid. The strong expression of a line is called "bone," and ch'i refers to the energy pulsing within a line or among the lines. One can conclude that the study of brushwork was quite advanced in those early days, for they had already discovered the various qualities and functions of each part of a line.

Perhaps, the most terse yet comprehensive definition of Chinese brushwork is to be found in Wang Yu's 18th-century critique entitled *East Village on Painting*:

> What is brushwork? Light, heavy, swift, slow; concentrated, diluted; dry, moist; shallow, deep; scattered, clustered; flowing and beautiful, lively; [the artist] knowing all these, wherever the brush goes on paper will be perfect.[3]

As this description indicates, in the intervening 800 years, the art of brushwork had become much more advanced and sophisticated. Almost all of the essential elements of brushwork are mentioned. The words light and heavy refer to the pressure the artist employs in wielding the brush. Concentrated, diluted, dry and wet or moist are terms applied to the use of ink or color. Shallow, deep, dense and loose are the essential aspects of composition; and the terms flowing, beautiful, and lively refer to the over-all harmony and vigorous expression of a painting or calligraphy.

The historical development of Chinese brushwork as an art may be divided broadly into four periods, the Archaic, Germinant, Ripening, and Flourishing periods. It will be necessary, of course, in tracing this development to use critical terminology derived from a formalistic aesthetic, which will be fully elaborated in Part Two.

# 1  Archaic Period

## NEOLITHIC DESIGNS

There is reason to believe that the Chinese had been utilizing a brush for decorative painting and writing long before the dawn of recorded Chinese history. The designs painted on the red pottery of the Neolithic time (c. 3rd millennium B.C.) clearly reveal the fact that slips of red-earth color and dark dye were applied by brushes. It is obvious that these designs (Fig. 3) were not done by fingers or a wooden or bamboo stick but with a brush, otherwise the fine mesh textures and the curved lines could not have been achieved. Judging from the hard-edged quality of the lines, one can assume that the tool employed must have been made of some kind of hard fur, possibly deer or weasel. As to the dye, it could have been a by-product from the burning of some kind of wood, perhaps charcoal or soot. There is a segment of Shang (c. 13th cent. B.C.) pottery with the character *Chi* (year) written on it in black color; after a chemical test, it was proved to be a kind of carbon dye.[4]

The Chinese brush is usually made of animal fur and its handle either of wood or bamboo—perishable materials—that can hardly be expected to last indefinitely. This presumably explains the lack of direct evidence for the use of the brush in Neolithic times. The oldest brush that has been found, unearthed from an ancient Chu* tomb near Ch'ang Sha in 1954, dates from the Warring States period (480–222 B.C.). (Fig. 4)

Scholars have been puzzled by the patterns on the pottery. Peter Swann in *Art of China, Korea, and Japan* writes, "Since buried with the dead, the designs painted on them, eminently suitable for pottery decoration, may also have had a symbolic content of which, alas, we know almost nothing."[5] Despite the lack of evidence, however, there are ways of probing the problem. It has long been acknowledged that the primitive people in the remote Chinese past were fanatical believers in ghosts, as well as worshippers of ancestors. It was their custom that the deceased be provided with everything that he used during his earthly life—hence the burial objects found in these graves.

That the people of the Red Pottery culture had advanced to living in houses instead of caves, were tillers of the soil, fished, had domestic animals and long knew the benefits of fire, are established archaeological facts, which have buttressed Chinese legendary history concerning the Neolithic period.

Examination of the designs painted on this pottery reveals three common picture symbols (see Fig. 3): the crisscrossing lines undoubtedly suggest the weave of a fishing net or basket; the arch-forming curved lines may portray flames; and the undulant horizontal lines on the outside wall of the basin probably describe ripples or waves. These decorative picture symbols are, in my opinion, merely the result of the inspiration and observation gleaned from daily life; I doubt that there is any deeper symbolism involved.

---

*Chu, located in the south, was one of the large states of the Warring States period.

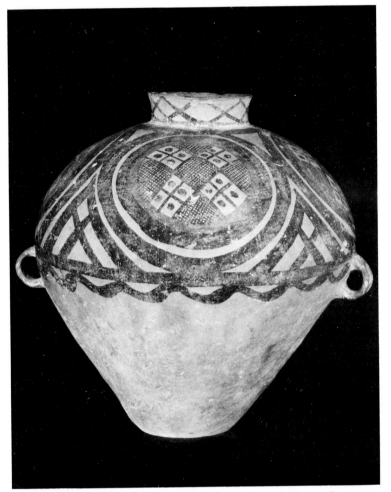

*Figure 3.* Painted pottery: burial urn. Yang-Shao culture, height 16 inches. Courtesy of the Seattle Art Museum.

In terms of Chinese brushwork, the work of this period is too simple and too primitive to be considered more than conceptual.

## HSIANG HSING WEN TZE OR IDEOGRAMS

The next evidence of the brush appears in the ancient ideograms, roughly two millennia later, found inscribed on the unearthed bronze vessels and on shell and bones dating from the 16th–10th century B.C., the Shang and Chou periods. These ideograms had evolved and were in common use at a much earlier date, however. It was long accepted that Tsang Chieh, the official recorder of the court of Huang Ti (2367 B.C.?) was the inventor of Chinese picture writing, but modern scholars consider him a compiler of the ideograms which were in existence at that time.

Since so much has been written on the development of the Chinese language, it will suffice here merely to outline what we are seeing when we view a Chinese ancient character on a bronze or a piece of bone:

1. These *Hsiang Hsing* (hieroglyphic) characters were derived from primitive drawings. Only when primitive man gave his drawing, of an object or an idea, a definite, repeatable, consistent meaning did his painting become a word, a pictogram or an ideogram. (See Fig. 5)

2. Since the words were paintings, but the paintings were the script, one sees in these ancient ideograms the origin of the close association between Chinese painting and calligraphy, an association which has persisted throughout the ages.

3. These ancient characters indicate that the Chinese written language was the product of a slow development, always from the pictorial, gradually modified into abstract signs. The best illustration of this point is the word "to comprehend" as the etymologist Chiang Shan-Kuo traced its evolution. (See Fig. 6)

*Figure 4.* Reproduction of oldest Chinese brush extant. In 1954 a Chinese brush of the Warring States period (480–222 B.C.) was discovered in a Chu Tomb near Ch'ang Sha. Its length, 21 cm.; the brush case, 23 cm. Both the brush handle and the case were made of bamboo; the brush head was made of rabbit hair, a soft fur. Reproduced from Tsien Tsuen-Hsuin, *Written on Bamboo and Silk,* Chicago: The University of Chicago Press, 1962, Plate 26. Courtesy of The University of Chicago Press.

*(1) Pictographs. Examples of single symbols.*

Mountain

Water

Outer city

*(2) Double symbols. When objects or concepts could not be described by a single word, twin symbols were used.*

Tangled

Side by side

Boundary

*(3) Combined symbols. When twin symbols were insufficient, two different symbols were combined.*

Imprisonment

To receive

Opposition

*Figure 5.* Examples of ancient ideograms.

*Ancient picture writing: a hand, a knife, a cow. It represents a man taking a knife to butcher a cow.*

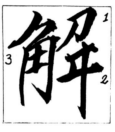

*Picture on a Shang (c. 14th century B.C.) bronze vessel; it appears in a simplified form. The hand and knife have been combined into one unit, and the body of the cow has been reduced to a head.*

*After centuries of change, it becomes an abstract combination of three main parts. Part 1 is the knife, part 2 is the cow, and part 3 is the horn. The framework of the structure remains very much the same as the ancient ideogram. This is still the standardized version of the word.*

*Figure 6.* Evolution of the word "to comprehend." Chiang Shan-Kuo, *The Origin and Structure of Chinese Characters,* 2 vols., Shanghai: Commercial Press, Ltd., 1933, II, 18 [Chinese].

# 2 Germinant Period

Within the Germinant Period, we will examine the style of Shell and Bone as well as the styles classified as Greater Chuan. *Chuan*, meaning "incised," "engraved," but also "curved line," refers to characters comprised mostly of curvilinear lines. Greater Chuan is a general name for the calligraphic styles between Shell and Bone and Lesser Chuan. It encompasses the incised writings on the bells and pots of the Shang and Chou periods, as well as the script on the stone tablets, called Stone Drum, and the Bamboo writings known as *Chu Chien*. These styles appeared prior to 221 B.C.

The special feature of Greater Chuan is its fleshy, soft quality of line, whereas Lesser Chuan, a style of the Ch'in dynasty (221–206 B.C.) is marked by elongated and much thinner lines.

## SHELL AND BONE STYLE

The discovery in the early 1900's of artifacts from the lost Shang culture which had lasted for almost three centuries (14th–11th cent. B.C.) was truly a significant event. Among the treasures brought to light at An Yang, especially valuable were some 100,000 pieces of shell and bones with writing inscribed on them (see Fig. 7), through which scholars have been able to trace the official history and also the daily life of the Shang people. This once-lost written language, since it flourished at a time much closer to the Ancient Ideogram period, sheds light on the ancient style of writing. It serves as a bridge between the early Chou (*c.* 1000 B.C.) and the late Neolithic era. However, of the several thousand ancient characters discovered, to date only about one-third have been translated into modern Chinese.[6]

Most of the characters on the shells and bones were first written by brush and ink and then incised by knife. In most cases vermillion was used; it is a mineral substance the hue of which does not change with age—it remains fresh. The writing, however, was in the main a guide for the carving.

As one examines the structure of the characters of this period (see below), it is evident that the Shang characters were beginning to drift away from the ancient picture words, and had become more stylized and abstract, a natural tendency in the evolution of language. Moreover, in order to produce a large number of words, it was inevitable that the picture be torn apart and rearranged, not according to the representational image, but mainly according to the sound of the words and, above all, specific categories or classes. For example, there were many words utilizing the basic symbol for water—"to wash," "stream," "river," "sea" or "ocean," etc.

On the whole, the handwriting in the Shang period is identified as "documental style" or *Hsiao Kai*, which means "miniature character." It is similar in size to the writings on the oracle bones used by kings; as described by Tung Tsuo-Pin: ". . . [as] the aides recorded the inscriptions on the bones, they always wrote in smallish type, as small as a fly's head, so orderly that not a tiny line was sloppy."[7]

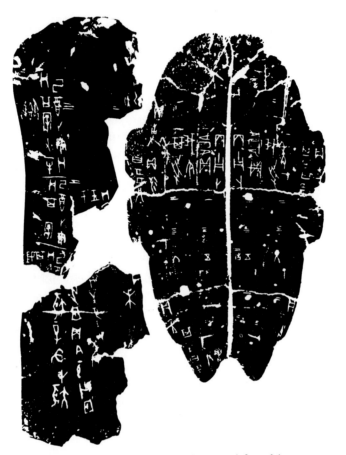

*Figure 7.* Shell and Bone style. *Top left* and *bottom left,* writing on bone; *right,* writing on turtle shell.

As there is no evidence of the kind of brush they used, one is naturally quite curious. However, since the average size of each character was no bigger than a quarter of an inch, it may be assumed that the brush must have been quite small. How small? Probably half an inch long and no more than a quarter of an inch in diameter. Moreover, since each line was so rigid and stiff, before it was carved by knife, the conclusion can be drawn that the brush must have been made of some kind of hard fur, such as wolf, deer, or sable. The brush discovered in the Chu tomb in 1954 (see Fig. 4) looks exactly like the brush conjectured above.

The writing on shell and bone is in vertical columns, from right to left, and reading from top to bottom, as is done today. Since this pattern could not have developed overnight, it is apparent that even before the Shang, a viable script existed and that, undoubtedly, slats of wood and bamboo, materials easily available, were being utilized as writing surfaces. Why vertically? Nature emphasizes the vertical growth, but, more practically, my guess would be that once man tried to tie together the slats, so that his writing, too long to fit onto one slat, could be kept together and read consecutively, he found it more natural and less awkward if the slats were handled vertically. The

earliest such book extant is from the Han period (93 A.D., see Fig. 28), although Chinese writings mention "lacings" of books as early as the 6th century B.C.

Since the script was in vertical columns, there was a natural tendency to emphasize the vertical, and thus, vertically structured characters are prevalent in Shell and Bone, and long remained the traditional structure of Chinese characters.

The Shell and Bone style is quite advanced. Here, there is a sense of design, not only in the structure of each character, but also in their group arrangement, that is, the total composition. The quality of the strokes is good; the lines are very sure and strong, and quite well controlled. Each word seems to be able to stand up by itself; the feeling of strength is obviously there. In composition, a vertical order was achieved by the parallel arrangement of the words. Besides the well balanced over-all harmony, there were enough contrasting elements to keep the whole composition interesting, *i.e.*, square and rectangular shapes juxtaposed with triangular ones, mostly straight lines, strictly parallel or diagonal, mingled with curved ones. These geometric lines and shapes, together with its miniature size, are characteristic features of Shell and Bone.

Although Shell and Bone is no longer used as a medium of language, it is still being utilized in the art of calligraphy. In fact, many contemporary professional calligraphers, such as Yeh Yu-Sun, Tung Tsuo-Pin, and many others, are using it as a model for their creative work (see Fig. 9).

Since this style of writing was almost of miniature size, and the tool undoubtedly small, it is apparent, that calligraphers must have taken a sitting position at work; moreover, for better support they must have rested their wrists on the table as they wrote.

In so far as the brushwork is concerned, the evidence points to the use of "center brush" only. This is apparent from the predominantly vertical lines. Even though that appears to be about all they explored in technique, it is quite well executed. Although this style is far from mature, in Shell and Bone one is beginning to witness the emergence of brushwork as an art.

# GREATER CHUAN

## *Bell and Pot Style*

Bell and Pot (*Chung Ding*) is a designation for the characters cast on bronze vessels during the Shang and Chou periods, from the 14th to the 3rd century B.C. The characters were all incised in a V-groove shape. This style is also called Metal style or *Chin Wen* (*chin* is "metal"; *wen* is "character" or "word"). On the whole, this is a much more advanced form of writing than the previous Shell and Bone. (See Figs. 10–15) Unlike the simple linear shapes of the Shell and Bone style, the brushwork of Bell and Pot is much more varied both in the shape of the lines and the structure of the characters. Note the curves which were used in shaping the characters as well as the combination of dots and lines. Moreover, the composition of the calligraphy, usually an essay of 50 but at times some 400 words, shows a beautiful arrangement. The characters were first written or carved on a clay or wax model, and then the product was cast in bronze.

The Metal style co-existed with the Shell and Bone during the latter part of the Shang period, after the 20th generation ruler Pan Keng moved the government to An Yang in 1384 B.C. While the Shell and Bone civilization was concentrated around the capital area, An Yang in the modern

|  | ANCIENT | SHANG | MODERN |
|---|---|---|---|
| Sun | | | |
| Rain | | | |
| Fish | | | |
| Moon | | | |
| Tiger | | | |

*Figure 8.* Ancient Shang characters.

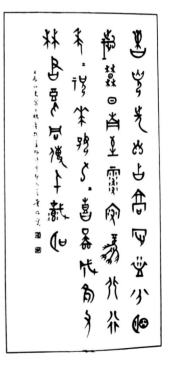

*Figure 9.* Contemporary writing in Shell and Bone style. An example of Tung Tsuo-Pin's calligraphy in Shell and Bone style. It was a poem in connection with a painting of plum blossoms. The study of Shell and Bone was his field and it was also the style for his calligraphy. Courtesy of Mr. Wei Tze-Yun, Taiwan.

Ho Nan province, the bronze vessels were found widely spread over both the Yellow River and Yang-Tze River areas.

In appearance, the Metal style is quite different from Shell and Bone. According to etymologist Tung Tsuo-Pin, the Shell and Bone style was used for daily correspondence and for such purposes as oracle recording, fortune-telling and communication with spirits. It was definitely an applied style. With the Metal style, however, the decorative element dominates since the bronzes were used mainly for religious ceremonies or ancestor worship.[8] The calligraphic characters of Shell and Bone appear very formal, reflecting the solemnity attached to oracle recording, while those of the Metal style are freer in spirit and creative quality, and are very decorative.

This development of the Metal style as a decorative form was, indeed, significant, because, for the first time in the evolution of the Chinese written language, an artistic form emerged. Figure 10c, for example, illustrates the artistic elements which had been introduced into the composition of the ideogram "archery" or "to shoot," composed of an arrow and hand. These picture designs, as seen in Figure 10, reflecting people, animals, objects, and social life in the Shang period, were derived from ideograms which had existed two millennia earlier.

The pictorial symbols on these vessels in most cases were signs representing a tribe or a family; in fact, they served as logograms indicating the profession in which the family was engaged. A picture of a weapon would show that they belonged to the military service; a picture sign of a fishing net would show that fishing was their career. Under the astrologic faith of Shang society, the professions of the families were predestined. If one's ancestor was a fisherman, his descendants for generations likewise would be fishermen.

The Chin Wen writings of the Shang period (see Fig. 11a) were very carefully designed, each character a considered act. Pictorial designs were put side by side with the calligraphic symbols, as shown in Figure 10. As Figure 11a illustrates, the inscriptions show artistic freedom in their composition—that is, the characters are not uniform in size, nor is the framework of the characters stereotyped; instead, one can see projected triangular, rectangular, circular and oval forms. In addition, there is dramatic control in their use of positive and negative space, which makes the composition much more interesting than the Chou Chin Wen, which, as we shall see, with some notable exceptions, is marked by almost absolute regimentation. A Chou composition often results in a series of identical rectangular shapes within almost evenly allotted negative space. Figure 11b illustrates this vividly, I think. It is generally acknowledged that the writings on Shang bronzes reach a high peak in archaic simplicity, and have never been surpassed in their artistic expression.

The Chou people originated in Shan-si province, in western China. After suppressing the Shang dynasty early in the 12th century B.C., they established two capital cities, one in Hao Ching, their original base, and the second, located in Lo Yang in modern Ho Nan. The latter became the political center to which all the feudal lords came to pay tribute. This situation lasted for about three and one-half centuries (1112–700 B.C.), a period known as Western Chou. However, when the invading Jung and Ti from the west occupied Hao Ching, the Chou abandoned the city and moved to Lo Yang permanently, until the Ch'in state unified the whole of China in 221 B.C. This period is known as Eastern Chou (770–222 B.C.). Historians have divided the span into two major periods, Spring and Autumn (770–481 B.C.) and Warring States (480–222 B.C.).

The Chou had maintained a close relationship with the Shang for about three centuries, and in the process they absorbed Shang culture deeply. This was quite clearly reflected in their writing. As one examines Figure 11, one sees immediately the deep influence of the Shang on the Chou. Note the great similarity in the structure of the characters.

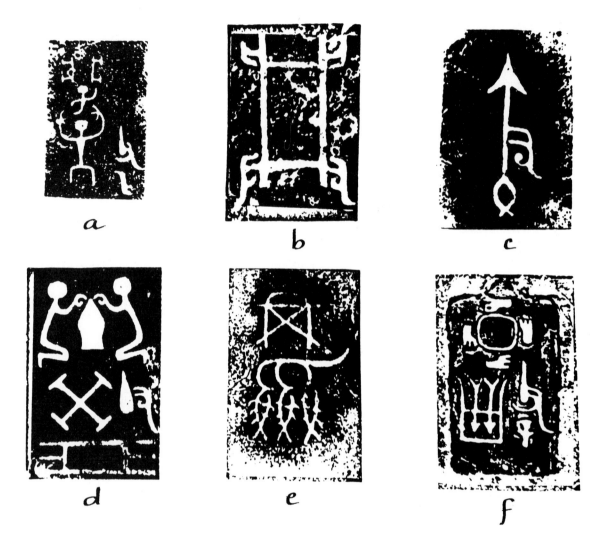

*Figure 10.* Designs from Shang bronze vessels. *(a)* On the left, a man holding a child; on the right, two words, *Fu Yi* (Father Yi), the deceased person being worshiped; *(b)* Four hands are holding a litter or net; it signifies either a cab-like device or fishing; *(c)* A hand holding an arrow, indicating either a hunter or a warrior; *(d)* Performing daily work or housework; *(e)* In the center, three fish are being held by a hand; on top, a piece of fishing gear—all indicating a fisherman; *(f)* The top part signifies walking around a city; the lower left, a container of arrows; juxtaposed, two characters, *Fu Hsin,* a name. The one being worshiped must have been a city protector or must have had some military connection.

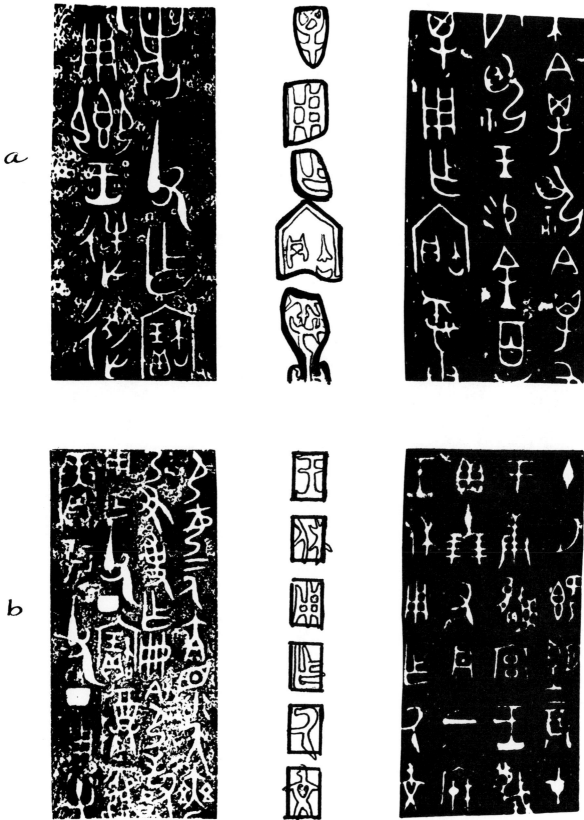

*Figure 11.* Chin Wen (writings on bronze). (*a*) Shang period (c. 16th century B.C.);
(*b*) Early Chou (c. 11th century B.C.).

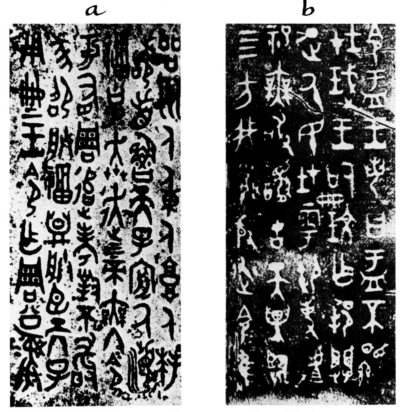

*Figure 12.* Chin Wen, Early Western Chou. *(a)* Chou Kung Chiu, Western Chou (c. 11th century B.C.), taken from a four-legged vessel; *(b)* Ta Yu Ting, Western Chou (c. 11th century B.C.), taken from a long-legged standing pot.

While the Shang were strong ancestor worshippers, the Chou placed importance on social ethics and stressed the proper relationship between people so as to maintain a stable social order. The famous *Book of Ritual*, written by the regent Chou Kung during the Second King Cheng period, became a most influential force in Chinese history. This manual of rules was directly reflected in the extreme regimentation of the Chou writing style.

Unlike the Shang style, each stroke of the Chou writing was so carefully executed that the lines look too polished. Moreover, the size of each character is so uniform that the words fit precisely in the vertical as well as in the horizontal planes. As a result, their writings have less artistic appeal than the work of the Shang artists. The extremely orderly appearance of Chou writing is its chief characteristic.

There are two well known pieces of Chin Wen of the early Chou period which are of artistic significance. One is the *Chou Kung Chiu*\* (see Fig. 12a), a four-legged vessel, full of bold and thick brush strokes, which give it a solid and sturdy feeling. It could be mistaken for a Shang piece. The

---

\*Bronze vessels were used as a medium to record military campaigns, treaties, awards, ceremonial occasions and other important events in government and family life. As inscribed documents, they received specific titles. *Chou Kung Chiu* was named for Chou Kung, a feudal lord of the 11th century B.C., to commemorate his coming to power. These vessels remain as vital historical resources as well as objects of art.

other (on the right), called *Ta Yu Ting*, is a long-legged, standing pot. From its orderly composition, it is apparent, at a glance, that it belongs to the Chou period. However, in spite of its rigidity, the writing possesses a beauty that raises it to the level of art. In fact, scholars and artists include this piece as one of the few representative pieces of the early part of the Western Chou which still reflect the Shang flavor.

The next piece which illustrates a change in Chou style is the vessel *Tsuo Tso Ta Ting* shown in Figure 13a. The characters in this framework are free, but the brush strokes are not as strong as those in *Ta Yu Ting* (Fig. 12b). This period was considered the middle span of the Western Chou (*c.* 10th cent. B.C.), and it drew the line between the previous Shang-influenced pieces and the decadence which followed. This decline is visible in a later example of writing on the standing vessel *Ta Ko Ting* (see Fig. 13b). The characters are so well arranged and so evenly allocated that the composition appears static. The brush strokes are so carefully drawn that the piece seems to lack vitality.

Despite the decline of Chin Wen at the middle of the Western Chou period, there are two outstanding pieces from this period which have enjoyed popularity ever since they were unearthed in the ancient capital Lo Yang about 300 years ago. One was called *Mao Kung Ting*, a large standing pot, (see Fig. 14a), and the other, *San Shih Pan*, a large basin (see Fig. 14b). The inscription on *Mao Kung Ting* was the longest ever discovered for the period, a total of 497 words. Here, the writing was stronger and livelier than that on *Ta Ko Ting* (Fig. 13b); however, in comparison with *Ta Yu*

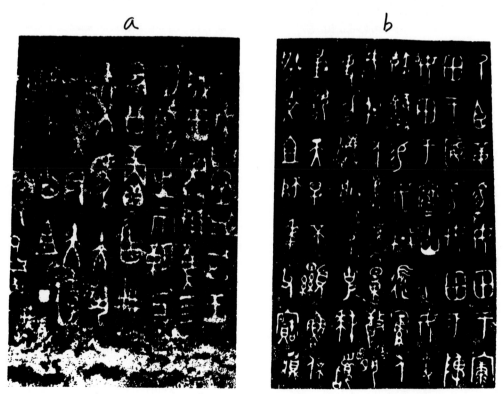

*Figure 13.* Chin Wen, Mid- and Late Western Chou. *(a)* Tsuo Tso Ta Ting, middle part of Western Chou (*c.* 10th century B.C.); *(b)* Ta Ko Ting, latter part of Western Chou (*c.* 9th century B.C.).

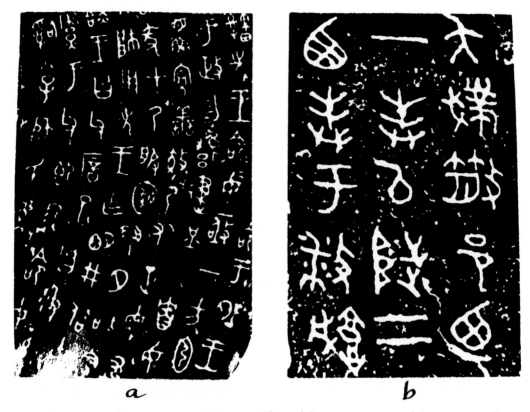

*Figure 14.* Chin Wen, Late Western Chou. *(a)* Mao Kung Ting, latter part of Western Chou (c. 9th century B.C.); *(b)* San Shih Pan, latter part of Western Chou (c. 9th century B.C.).

*Ting* (Fig. 12b), it still appears feeble. Since historical material relating to the Chou period is rather scanty, these lengthy inscriptions certainly provide historians with very valuable first hand information on the period, just as the Shell and Bone did for the earlier Shang. The other piece, *San Shih Pan*, was buried for some two and one half millennia until it was brought to light about 1770. There were 349 words incised in the bottom of the basin, recording the settlement of a border dispute between two tribes. In the past, many legal matters were cast on bronze because of its durability.

The style of writing of the *San Shih Pan* deserves attention for several reasons: there is coherence in the composition; the characters are not rigidly confined to vertical and horizontal lines, and show some freedom in execution. In looking at each word, the greater spontaneity of the artist is visible; the lines have not been labored over. Moreover, there is a certain childlike expression in the characters from the way the brush was used. As is generally accepted, this freedom of spirit is absolutely necessary to achieve straightforwardness in a work of art. One more point worth mentioning is the change in shape of the characters from the traditionally elongated vertical to the opposite direction, horizontally stretched. This change foreshadows the writing style of Chu Chien (Fig. 19), the most popular style of Eastern Chou (8th–2nd cent. B.C.). It might have influenced the development of the Li style (Figs. 23, 24, 25), prevalent in the Han dynasty (2nd cent. B.C.).

Generally, during the Chou period, as seen above, the calligraphic art was declining towards stylization, becoming too artificial; as a result, the style of calligraphy gradually lost its original vigorous expression and degenerated into mere decorative skill.

Of the pieces which have been excavated and studied, Eastern Chou, in its five-hundred year span has yielded only half the number found in the three-hundred years of Western Chou.* Moreover, the inscriptions on Eastern Chou bronzes are very short—seldom more than a few words. Undoubtedly the political turmoil of the Warring States period accounts for this lack of productivity.

By the time the Chou House moved to the eastern capital, Lo Yang, the central government was weakening and lacked the power to control its feudal vassals. As a result, the style of writing was no longer unified and each feudal state developed its own variation. Figure 15 shows four of the major styles which evolved: "a" shows the Ch'in style of the Western state, inherited from the traditional Chou style, with the exception that the shape of each word was somewhat rounder and less orderly in composition. Figure "b" represents the popular style from central China, such as Ho Nan, the mid-land style influenced by both the Eastern and Western states. Each word was suspended in space, with the vertical and horizontal order quite strict; the shape of each word was more elongated, but the structure of each character remained in the Chou tradition. Figure "c," the Eastern style, prevalent in Shan Tung, was obviously different from the Western Ch'in style. Its lines were stretched much thinner, and the vertical order was quite clear; on the whole, it became more decorative. Lastly, Figure "d," the Southern style was even more decorative. The lines were like steel wires, the movement of the brush strokes so exaggerated that the whole composition seems to be an expression of motion. This free style and the Bird style (see Fig. 16) illustrate pointedly the romantic manner of the Southern style. Related to the Metal style, the Bird style, so termed because of the bird features found in each character, served mainly to adorn the weapons of the Warring States period; the writing echoed the symbols and signs on the Shang bronzes and manifested great beauty of design. Ultimately, both styles served as an important source for later artistic developments in Chinese calligraphy.

*Stone Drum Style*

The Stone Drum style has been one of the most influential styles of writing. It was discovered in the early part of the T'ang dynasty (7th cent. A.D.). Scholars have been debating its original date, but it is generally attributed to the Ch'in state about 8th century B.C. There are ten stones in the shape of drums, their height ranging from 45 cm. to 90 cm. (see Fig. 17). They are now displayed at the Confucius Temple in Peking. Originally, there were 700 words, but owing to the wear and tear of the ages, today there are about 450 readable words.

This style is considered classic, for it was derived from the traditional ancient Chou style. In Stone Drum, each word is well balanced; at the same time, its structure is not at all stereotyped. The lines are almost identical in width, a consistent evenness that was traditionally typical. Also traditional is the structure of the character, which still emphasized the vertical order. However, this style marks the beginning stage when the brush first began to dance. Although the strokes were still

---

*Any metal artifacts with inscriptions are classifed as Chin Wen, which means characters cast on bronze vessels.

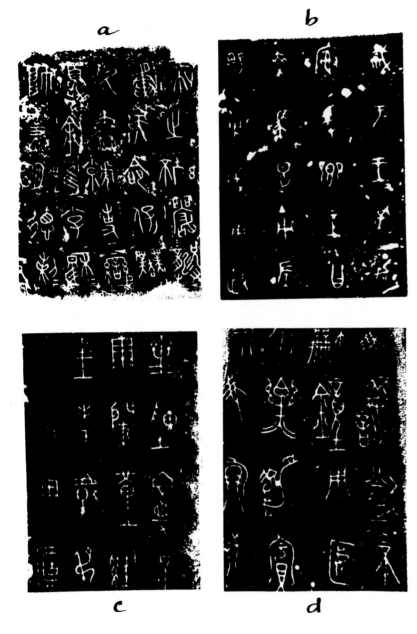

*Figure 15.* Regional styles of writing in Eastern Chou Period.
(*a*) western; (*b*) mid-land; (*c*) eastern; (*d*) southern.

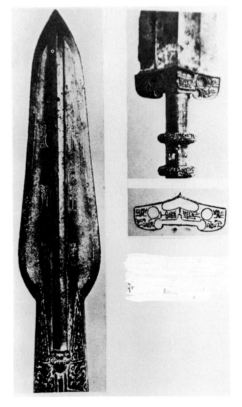

*Figure 16.* Bird style of writing.
The bird style of writing incised on weapons during the Warring States period (480–222 B.C.) in Middle and Southern China.

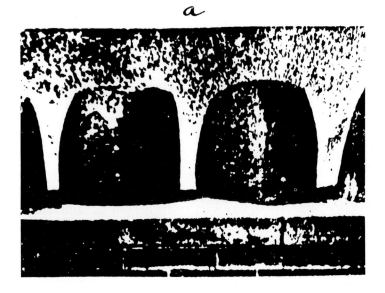

a

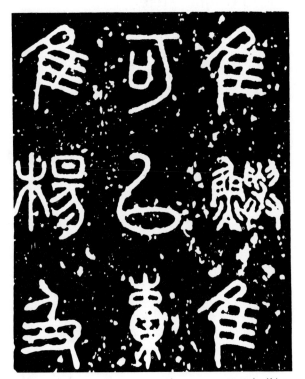

b

*Figure 17.* (*a*) Stone drums (c. 8th century B.C.); (*b*) Part of the inscription on the stone drums.

limited to center brush, the pressure employed was entirely different from previous styles. They had discovered much more about the role of pressure in wielding the brush which gives a Stone Drum line a little more calligraphic interest than Chin Wen. The pressure went beyond the tip of the brush, down to the beginning of the side of the brush; the brush pressed more deeply onto the writing surface, thus making the lines wider and rounder at the ends. That roundness at the end of a line was achieved through folding the center brush, a technique which imparts bone structure to a line. (See Part 3, *The Techniques of Chinese Brushwork.*)

The brushwork in Stone Drum is not labored, and therefore there is a greater freedom in the execution of the strokes; the lines are fluid. Stone Drum is easily identified by its fat, round and soft fluid lines; there is no harsh, angular edge to a line in Stone Drum. It is an imposing style, whose influence is seen even in the work of famous contemporary artists, such as Wu Ch'ang-Shuo (see Fig. 18). In Figure 70a, the Stone Drum flavor is evident in both his calligraphy and painting. The strokes in his bamboo correspond to those in the calligraphy, and both are derived from the Stone Drum style of writing.

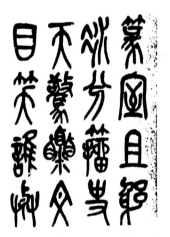

*Above: Wu Ch'ang-Shuo's calligraphy in Greater Chuan style, primarily influenced by the ancient Stone Drum style.*

*Right: An example of calligraphy in Hsing-Tsao style by Wu Ch'ang-Shuo. The round and fat quality of the line and the roundness of his dots are features reminiscent of Stone Drum style.*

*Figure 18.* Works by Wu Ch'ang-Shuo, Greater Chuan and Hsing-Tsao styles.

## Chu Chien (Writing on Bamboo Strips or Tablets)

The ancient Chinese wrote mainly on tablets of bamboo, this practice probably starting in the remote past (before Shang) and lasting until the 4th century A.D., when paper became the more popular medium. A few hundred of these bamboo tablets have been recovered from ancient tombs, most of them being lists or records of the objects which were buried with the dead.

The two tablets illustrated in Figure 19 were among the 43 bamboo strips excavated from a Chu tomb of the Warring States period (*c.* 400 B.C.) at Yang-Tien-Hu, outside the southern gate of Ch'ang Sha City in July 1953. The pieces measure, on average, 22 cm. long, 1.2 cm. wide, and 0.1 cm. thick. On each tablet there range from two to twenty-one words, written in black ink.[9]

This writing may be examined by focusing one's attention on the smaller strip, which has twelve words on it. The upper half reads, "a suit of your red uniform," from which one can deduce that the deceased must have been a general or marshal. The structure of the characters is most representative of the style of writing of the Warring States period. It has the quality of Stone Drum in its round and fat brush strokes.

*Chu Chien* serves as a transition between Greater and Lesser Chuan styles. The brushwork on these bamboo tablets had improved much over its predecessors, notably the Stone Drum. First, the quality of line is much livelier, and the handling of the brush is more skillful. There is a kind of rising and falling movement to the shape of the line, *i.e.*, the beginning of each stroke is usually heavy and rounded, and the end, light and pointed. The brush no longer is a device merely to make an even line, but a more facile tool to be manipulated in several different ways—high or low, fast

*Figure 19.* Chu Chien: writing on bamboo tablets. The most popular style of Eastern Chou. Unearthed from an ancient Chu (c. 4th century B.C.) tomb near Ch'ang Sha in 1953. Tsien Tsuen-Hsuin, *Written on Bamboo and Silk,* Chicago: The University of Chicago Press, 1962, Plate 15. Courtesy of The University of Chicago Press.

or slow, etc. (see Part 3, *Techniques*)—hence the result is more vigorous. The free expression of the brushwork is undoubtedly due to the fact that the style lent itself to a faster pace of writing. There is a feeling of movement also from the sure sway of each curved line. Most important, the structure of the character is more compact and tight than in earlier styles, and since the line of writing had to be confined to the narrow, rectangular shape of the bamboo slat, a unified order was naturally achieved. The general arrangement of the lines tended to tilt from the lower left towards the upper right, which would be natural for a right-handed calligrapher.

The characters of the Bamboo Tablet style appear to be horizontally structured. In this squatty shape with the stretched-out, sidewise brush strokes, one can detect the origin of the Li style which would be developed a few centuries later in the Ch'in dynasty, a popular style which emphasized the horizontal plane.

On the whole, this tablet style of writing was quite sophisticated and decorative and its free spirit of expression may have been inspired by the decorative Shang metal style. Its gay and romantic spirit is undoubtedly the chief characteristic of Chu art.

## Writing on Chu Silk

In 1934, a fragment of writing on silk (*c.* 4th cent. B.C.) was found in an ancient Chu tomb near Ch'ang Sha. It measures 47 cm. x 38.7 cm. There are about 750 characters written on it. The style of writing is Greater Chuan, closer to the Bamboo Tablet style, since the shape of the words is horizontally stretched. The silk is so worn that the words can hardly be discerned. Fortunately, through scientific means, particularly ultraviolet photography, a clear reading was made available; Figure 20 is a copy thus made.

Undoubtedly, since very early times, the arts of painting and calligraphy must have developed side by side, although no ancient paintings survive to prove this contention. However, this panel is the oldest evidence extant showing the union of the two arts. In analyzing the calligraphy, it is evident that this type of writing, Greater Chuan, was an applied style, used for records or documents. The lines of writing are so regular that it is certainly reminiscent of the early Ta Ko Ting (Fig. 13b). It is obvious that the writing in this piece was not meant to be decorative. Each character is so regular that it almost seems like print, a feature that perhaps foreshadows the growth of the Kai style in the 3rd century.

Chinese calligraphy shows significant development from the time of the Shang through the end of the Chou period. The Shang Shell and Bone inscriptions, dating from the 14th to 11th centuries B.C., had already reached a high level of sophistication, although the brushwork was limited to a combination of straight and sharp lines. Surviving pieces are notable both for solemnity and dignity of expression and for subtlety of design. The Bell and Pot style, which developed during the later Shang period, reveals advances in brushwork, expressiveness, and design, as does the classic Chou Stone Drum style. While line work was still limited to center brush, the technique of wielding the brush was much freer than it had been earlier. Artists of the Chou period, working in a variety of styles, learned to increase the effectiveness of the tip of the brush by applying different pressures—this is evident at the beginning and end of the stroke. No longer restricted to the even line, they produced a stroke which varied in thickness and tone—from heavy to light, fat to thin. The content of the line was thus greatly enriched.

*Figure 20.* Oldest piece of brushwork extant. Unearthed from a Chu tomb (c. 350 B.C.). A copy from the worn original made through an ultraviolet process. The two portions of writing, totaling 750 words, are on opposite sides. The tree drawings in the corners indicate the four seasons; the three deities on each side represent the twelve months with indications of their functions, as well as some advice as to which days are most propitious for the performance of specific farm tasks. Tsien Tsuen-Hsuin, *Written on Bamboo and Silk,* Chicago: The Univerity of Chicago Press, 1962, 123. Courtesy of The University of Chicago Press.

# *3 Ripening Period*

The ripening of brushwork manifests itself during the end of the Chou dynasty—the Ch'in era, beginning in 221 B.C.—the period in which the Lesser Chuan and Li styles developed.

## LESSER CHUAN: SEAL STYLE

In 221 B.C., the Ch'in-Shih-Huang-Ti unified the whole of China and became its first Emperor. Although he wrought great havoc by his burning of the classics, in his attempt to obliterate the past and erase the influence of the scholars, he made lasting contributions—a uniform system of measurement and, more importantly, a standardized written language. His prime minister, Li Ssu, regulated and unified the written language known as Lesser Chuan. Even today, when it is difficult and, at times, impossible to understand the spoken dialects of the various provinces, nation-wide communication is possible through the standardized script.

Two years after the dictator established his empire, he travelled around the country and erected seven stone monuments (tablets) in the eastern provinces, such as Shan Tung, to commemorate his great achievements. It has been traditionally held that most of the writings on these stones were written by Li Ssu. Unfortunately, the stones are lost, two fragments of rubbings being the only evidence that has survived (see Fig. 21).

Figure 22 is a print from a Ch'in bronze vessel, an ovalshaped standard measuring utensil. The writing is Lesser Chuan, whose chief characteristic is an oblong, slim, curvilinear structure, highly decorative. Under the Ch'in dictatorship, the law was extremely severe, and this feature is reflected in the writing. The orderliness of the composition creates a very formal impression; in fact, the size of the words is quite uniform, with each word fitted into exactly even-sized spaces. Strict discipline is evident. Although the brushwork technique is outstanding, it lacks any free expression. Since the calligrapher had to be painstaking in the execution of this highly artificial writing, Lesser Chuan did not last very long, and was soon replaced by the Li style. However, Lesser Chuan became popular as a style for seal engraving, and is used even today for this purpose.

The beauty and unique contribution of Lesser Chuan lie in its exquisite rendering of center brush strokes, the most important technique for an artist to master, for it is these strokes which depict the strength and vigor of a linear shape. Since Lesser Chuan lines are slim and long, the spirit and quality of the lines can be clearly seen.

## LI

The reason why Li developed was that Lesser Chuan, so formal and so difficult to write, was not suitable for daily use. Conversely, the big advantage of the Li style is the speed of its execution.

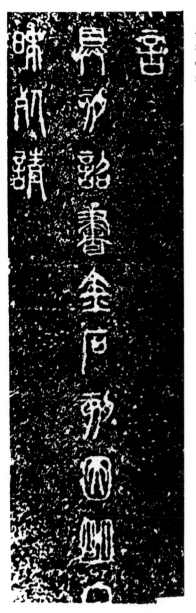

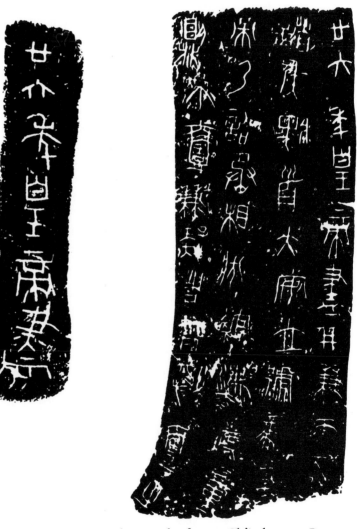

*Figure 21. Tai Mountain Tablet.* This rubbing was from the second stone erected by Emperor Ch'in during his tour to the east coast at Tai Mountain in 219 B.C. The writing, Lesser Chuan style, was believed to be the work of the prime minister, Li Ssu.

*Figure 22.* Lesser Chuan style, from a Ch'in bronze. Portion of a rubbing taken from a container which served as a standard measuring utensil. Its dimensions: mouth diameter, 7.9 inches; with a handle, width and height, respectively, 31 cm. x 16 cm. The writing shows more freedom than is indicated in the stone rubbing in Figure 21.

First used by the common people, it soon became the popular vehicle for everyone. Unlike the rectangular, vertical shape of the Lesser Chuan style, the Li is horizontal (see Figs. 23–25).

Starting with the Li style, full-fledged brushwork comes into evidence. There are round, square, wedged shapes, triangular and hooked strokes, which is the first evidence I see of the use of folding or rolling side brush. The side of the brush is being used from the very tip to the heel; a wide range of pressure is utilized, which causes changes in the rhythm of a stroke; the turning of the brush in completing a stroke gives a continuous flow to that line and contributes to the harmonious movement within the composition. The use of these techniques injects a liveliness into the brushwork.

When the "civil examination system" was established during the Han dynasty, good penmanship became a requisite; this and the fact that it was part of one of the six arts taught at the Confucius School, greatly stimulated the art of calligraphy. For the first time in Chinese history, many fine calligraphers emerged, such as Hsu Shen (58–149), Tsuei Yuen (77–142), Chang Chih (?–193), and others. The most celebrated of these was Tsai Yung who, at the request of Emperor Ling Ti (Hsi Ping reign), undertook a very ambitious commission to write a series of Confucian classics on stone, which were subsequently engraved by a team of stone craftsmen. The job started in the year 175, and when finished in 183, the sixty-four stones, with classical texts engraved on both sides, were displayed in front of the National Institute in the capital, Lo Yang. With the passing of time the original stone tablets were gradually lost, and only a few fragments are extant today (Fig. 23). This series of Li stone inscriptions served as textbooks for students, and that is probably why the writing is so even and regular, instead of being rendered in its more artistic form.

In the first half of the Han period (c. 2nd and lst cent. B.C.), the Li style was commonly used, but it was still evolving, evident from the fact that some of the earlier examples retain some Chuan flavor. However, the popular *Ba Fen** form of the Li style gained wider acceptancy (Fig. 24). This style is marked by the strokes stretching to the sides, both to the left and right, known as "Number 8" strokes. It is obvious that it takes much less time to write than the previous Chuan. It is indeed a very sophisticated and beautiful style.

Among all the fine examples of Li style extant, the *Ritual Vessels Tablet* (Fig. 25) has been considered the best. The brushwork is so superb that it led the famous calligrapher Kuo Tsung-Chang of the Ming dynasty (15th cent.) to question whether it had been done by human hands, praise which has been echoed by scholars and artists throughout the ages.

As one examines this piece, written on stone, one is struck by its excellence. It possesses all the qualities a fine piece of calligraphy should have. The lines are strong but not stiff. Each character, skillfully constructed, is self-contained, yet its structure contributes to the total harmony. There is subtle variation in the components of the characters, particularly in the shapes which are identical in form; thus, the symmetry is not rigid, creating a great feeling of movement. Some strokes are tilted but remain in perfect balance. The expression of the brushwork looks extremely free; however, complete order is maintained. There is no crowding, either in the structure of the characters or in their position within the column. They indeed seem "comfortable" and "loose" in their niches. Despite this airy feeling, the composition is tight, with an excellent horizontal and vertical order, yet an order which is not mechanically rigid.

With the accomplishment of this piece, it is safe to say that the art of brushwork had been firmly established. Also, calligraphy as an art had reached a high plateau. As the Li style spread throughout

---

*Ba* is "8;" *fen* means "apart" or "separate," in the manner of the composition of the character "8."

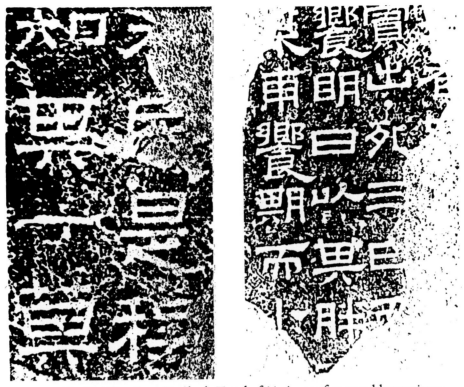

*Figure 23. Hsi Ping Stone Textbook.* Total of 64 pieces of stone tablets written in Li style by Tsai Yung (132–192); inscribed on both sides is a series of Confucian classics. There was an average of 35 lines on each face of the stone, with each line consisting of 70–78 words. The stones were displayed at the National Institute in Lo Yang. The mission took eight years to finish (175–183) and served as a textbook for students. The illustration on the left was a section of the *Book of Odes.*

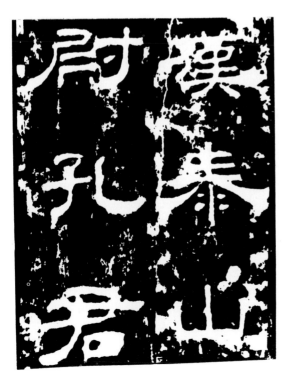

*Figure 24. Kung Chou Stone Tablet.* Kung Chou was the 20th-generation descendant of Confucius. After he died in 164, his students put up this tablet in memory of his achievements as a military commander in the Tai mountain district. Ba Fen style, a form of Li writing.

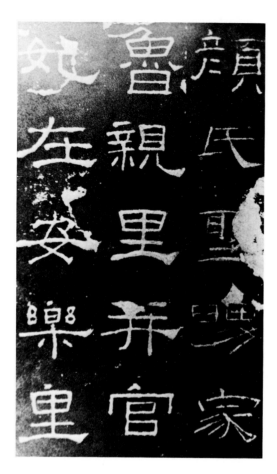

*Figure 25. Li Ch'i,* [ritual vessels tablet]. In 156, when the prime minister Han Lai renovated the Confucius tomb temple in Shan Tung, this stone tablet was erected with inscriptions to commemorate his achievements and to praise the restoration efforts. Considered to be the best example of Li style extant.

the Han empire for a period of 400 years, both the Greater and Lesser Chuan receded. Li is beautiful in form, yet easy to write. It became the most influential style in Chinese calligraphy.

## CHANG TSAO

As a result of archeological excavations in the early 20th century, the *Chang Tsao* style of writing on wooden tablets of the Han period was brought to light. *Chang* means "writing," such as essays, articles, etc. *Tsao* literally means "grass;" the term in brushwork implies speedy, spontaneous action, with short-cuts in execution. Tsao writing thus permits the artist to take advantage of spontaneous or accidental touches of brushwork, which are unplanned, but add to the interest of the composition.

It is believed that this style was first standardized by an official named Shih Yu under the Emperor Yuen Ti (47-33 B.C.) who had assigned him the task of compiling manuals to teach the script. Chang Tsao, also known as *Chi Chiu Chang* (both terms mean "writing hurriedly done" or "speedy script"), was derived from the Li style. It was not a shorthand style, but a simplified, freer

way of writing. It was used in the Han period not only for ordinary writing, but at times for official documents as well.

In examining the example of Chi Chiu Chang (or Chang Tsao) in Figure 26, it is evident that its structure is of the Li style. Notice the beginnings and especially the ends of the horizontal strokes, which bear the same triangular ending as the Li. Notice also the "Number 8" strokes similar to those in Ba Fen, yet more exaggerated because of the greater speed. It is obvious, too, that the lines are much freer, and even more fluent, than Ba Fen (Fig. 24); this indicates that the style was more adaptable to a faster pace of writing. The brush strokes are natural, vigorous and aesthetically pleasing.

In the example of Chi Chiu Chang in Figure 27, the spontaneous expression in the brushwork is even more evident. The rising and falling rhythm of the brushwork seems effortless. The general framework of each character is still within the Ba Fen style, but a greater freedom is imparted in the execution; hence, the whole composition appears to be livelier. Notice that each shoulder, on the upper right side of the character, is mostly rounded; this enables the writer to use less hesitation during the execution of the folding stroke, and also makes it easier to maintain a smooth movement from the upper right to the lower left.

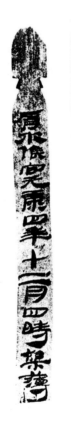

*Figure 26.* Chi Chiu Chang style (Chang Tsao). The characters on the three-sided tablet on the right represent a fragment of the text in Vol. 19 of a manual on style. The picture in the center shows two sides of the writing tablet, and the illustration on the left, the third side. This type of tablet was made by cutting a piece of square wood diagonally. The tablets were used by school children in learning how to read and write in this type of fast script.

*Figure 27.* Han Chien Tablets. These two pieces in Chi Chiu Chang style (Chang Tsao), were among the finds of the international excavation team in 1927 in north-western China. The district was Chu Yan. The tablet on the left was the cover of a report. In those days officials had to submit monthly reports to their superiors. The one on the right read: Yen Shou did borrow a horse and plough at Tun Huang; Yen Shou did come with someone and finish the ploughing. From these words, one can surmise that this must have been part of a court record. The direct expression of the brushwork is very fluent and lively.

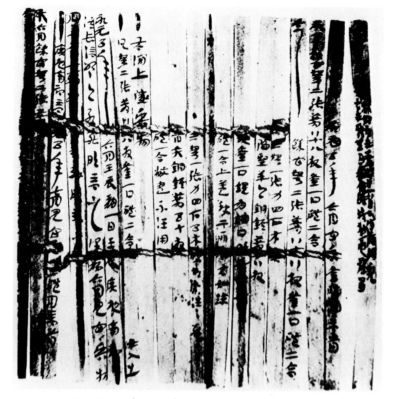

*Figure 28.* Bien Chien. This piece of enlaced slats in Chi Chiu Chang style (Chang Tsao), was discovered at Chu Yan in 1930. The book consists of 77 wooden tablets. The over-all measurement: 33 cm. x 1.3 cm.

In the Han period it was routine that all kinds of reports, such as census reports, taxes, etc. were due in August. All levels of bureaucracy collected data from their subordinate offices. The above illustration is part of such a record. The contents of the column under the arrow: "2 bows, 88 arrows, 1 cooking pot, 2 stone grinders, correct." The whole volume was a combination of two different reports for the years 93 and 95 A.D.

In 1927, during the international expedition in northwestern China, among the finds of wooden tablets was a piece of *bien chien** (Fig. 28), a book, which was made by binding 77 tablet-slats together with two strings of hemp enlaced across them, so that the whole book could be rolled up and put away. Sometimes the tablets were tied together by silk or hide strips. It is interesting to note that according to the *Historical Records* by Ssu-Ma Chien, Confucius studied the *Book of Change* so hard that the strings wore out and broke three times, thus showing that this type of "binding" was used as early as the 5th century B.C.

* A binding that is interlaced.

Originally, Chi Chiu Chang (or Chang Tsao) was considered merely a faster writing of the Li style, but today it is recognized as an independent, original style of writing, and also an art form in itself. Many modern calligraphers are followers of this style.

# 4  *Flourishing Period*

On the solid foundation of the Li and Chang Tsao styles, the art of Chinese calligraphy soon reached its peak when the Kai, Hsing, and Tsao styles were established during the 3rd and 4th centuries. These styles differ in their structural complexity and in the speed with which they can be written: *Kai* can be described as a script "standing still," *Hsing* as "walking," and *Tsao* as "running."

Paper, which had been invented in 49 A.D., was now a common material, liberating the artist from the confinement of the narrow writing surface of the bamboo and wooden slats, which also required much labor and time to prepare. On paper, larger characters could be written and new movements with the brush were possible, thus a higher competency and sophistication of technique could be attained. The brush was being used to its fullest extent. Paper, together with the maneuverability of the Chinese brush, was responsible for the great release and outpouring of artistic expression in this period, which has yet to be surpassed. Great talent, individual giants emerged one after another.

## KAI

*Kai* means "standard" and "formal"; it is also called *chen* which means "precise" and "neat," like print, or *cheng,* which means "straight" or "upright." In its expression, Kai is dignified, highly restrained. It is the formal script one would use to write his superior, head of government, etc. Kai has a beauty of orderly design and an aura of tranquility.

The Han dynasty was followed by the Three Kingdoms—Wei, Shu, and Wu—in the years 221 to 265. This was an innovative period for Chinese calligraphy. In the beginning, Li was still used, as one sees in the stone rubbing of 230 A.D. of the Wei kingdom (Fig. 29a); the brushwork is so skillful that it can match almost any masterpiece of the Han period; however, the difference is that the overall shape of each character tends to be confined within a square instead of stretching out to the sides as in the Ba Fen style. In other words, the character was beginning to change from a squatty form into a square, which becomes the identifying characteristic of the later Kai. In Figure 29b, a trained eye can notice the revolutionary attempt to write in a Chuan design (see Fig. 21) with a Li brushwork (see Figs. 23,24, 25). Why not? It provides the viewer with a new dimension

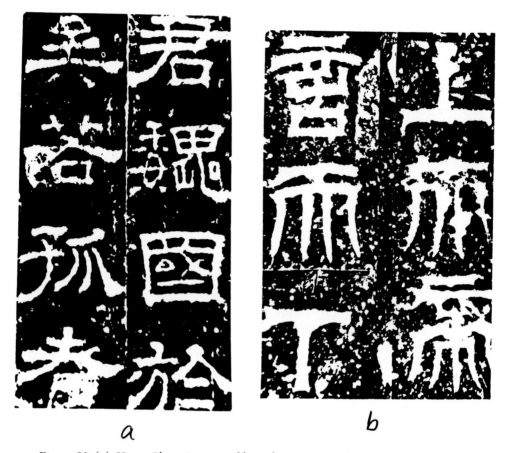

*Figure 29 (a) Kung Ching Report Tablet.* This stone tablet was erected in the domain of Wei, the northern part of China, in 230. The Li tradition was still strong, but the shape of each character was beginning to be confined into a square-like composition. *(b) Tien Fa Shen Tsan Tablet.* This tablet was made in the Wu regime of the Three Kingdoms in 276. It is in the Chuan style of writing, but the brushwork is Li, a square-edged stroke instead of a rounded one. It was definitely an innovative experiment.

in art. The brush strokes are angular, sharp-edged, but not stiff; although the shape of each word is square, the curved lines suggest a great deal of movement. In these years of political chaos, the art of calligraphy broke away radically from the previous traditional styles of Chuan, and especially Li.

Under the Wei regime (*c.* 3rd cent.), Chung Yu was considered to be the leading calligrapher and the first master of Kai; many artists adopted his style of writing and his influence was great. In examining Figure 30, a work of his, one can discern at a glance that here is a style entirely different from Li or Ba Fen. The shape of each word is neither elongated nor horizontally stretched; it is more square in its composition. Upon first glance, one might be deceived by the orderly lines, and find the calligraphy rather flat and not very interesting. However, actually, there is infinite variety in the brush strokes, which is quite exciting from a technical point of view. For instance, the size of

*Figure 30. Cold Snow Note,* by Chung Yu. This work represents the earliest example of Kai style in the Wei regime of the Three Kingdoms (221–280). Some words were in Hsing script, distinguished by the use of continuous strokes where the character, instead, calls for dots, evident especially in the column on the left.

the characters is not at all regulated; some are large and some small. Note the vertical lines in the second column on the right; they are not mechanically parallel, and thus show a lively, free-hand spirit. The expression of his work reveals a somewhat serious attitude, but not too solemn or stiff. Instead, the viewer has before him an abstract work that is solid yet graceful and appealing.

The most outstanding calligrapher of China was Wang Hsi-Chih, who was also known as General Wang (307-365). This Chin artist was a follower of Chung Yu and also a student of the well-known calligrapher Madam Wei. He represents the summit of the art of Chinese calligraphy. He was a master of all the new styles: Kai, Hsing, and Tsao. Wang, in fact, can be considered the master of masters. All outstanding calligraphers, in his time and down through the ensuing years, have studied and followed Wang's technique of writing. His brushwork is superb. In writing any particular character, Wang would vary its composition in myriad ways, demonstrating a genius for design. Yet, each version of that word would be in perfect balance and with sufficient contrasting effect to keep the reader excited.

*The Canons of Longevity* (see Fig. 31) was one of his masterpieces. The characters, as shown, are small—approximately the actual size of the original writing. The style, called Lesser Kai, is used even today for the writing of documents, examinations, official reports, and the like. It is a standard style of writing.

The true merit of a great master in calligraphy lies in the fact that he can handle a difficult skill with ease. Normally, in writing Lesser Kai, people are likely to be nervous and too careful in their

*Figure 31. Hwang Ting Ching (Canons of Longevity).* According to the late Ming scholar-artist Tung Ch'i-Chang, the above example is a precise copy of Wang Hsi-Chih's handwriting made by the T'ang master, Chu Swei-Liang. The original work was buried with the mother of one of Wang's friends, Wang Hsui. Wang did this didactic piece, a perfect example of Kai style, at her request.

*Figure 32.* Yen Ch'en-Ch'ing's (709–785) style of calligraphy. On the left, a part of *Ma-Koo Immortal's Temple.* The characters are arranged evenly in a square space. The fat strokes give a feeling of weight. Every word is in good balance. The example on the right, a cliff writing in Kai, is part of a eulogy for the T'ang Empire, after the royal house rebuilt the ancient capital, Chang An. This illustration was from a cliff rubbing in Hu Nan.

attempt to keep the calligraphy neat and regular, consequently, the result is often wooden. But Wang's writing is effortless. The characters are well spaced and seem comfortable in their arrangement; each word, even each stroke, is very natural and shows no hesitation or laboriousness.

Since the original was lost, many critics, including the famous litterateur Tung Ch'i-Chang (1555-1636), believed this piece to be a copy by the renowned calligrapher, Chu Swei-Liang (596-658). Tung commented: ". . . this clear and sharp style of copy was unmatched by any other of the circulating copies, all inferior."[10]

Besides General Wang, who in China was called the "first prophet" of calligraphy, there was

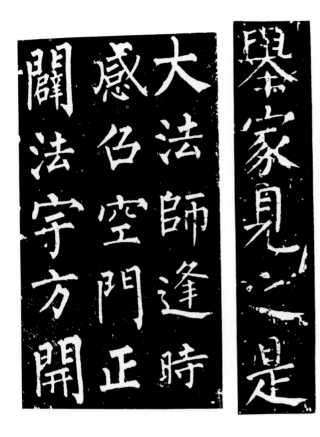

*Figure 33. Hsuan Mi Pagoda Tablet.* Liu Kung-Ch'uan's art of calligraphy, as in the Kai illustration on the left, was known for its bone-like solidity. Scholars often contrast this feature with the fleshy quality of Yen Ch'en-Ch'ing's work, as seen on the right. The two styles are referred to as "Yen's tendon and Liu's bone." The calligraphy of both men still serves as models in the teaching of the art of calligraphy.

Yen Ch'en-Ch'ing (709-785), who was considered the "second prophet" and whose influence on the future development of calligraphy was equally significant as Wang's.

In the Confucian Chinese culture, an artist's popularity and success rested not only on his skill but also on his moral standards and his righteous conduct. Yen Ch'en-Ch'ing held many high offices. In retirement, at the age of seventy-six, he went to deal with a rebellious group, and met death in the performance of his duty. His style of writing reflects perfectly his righteous personality.

Yen's style is indeed most impressive. In the cliff writing shown in Figure 32, one seems to see two giants standing solemnly on the top of a hill with their chests out and their eyes gazing straight ahead. Since the brush strokes reveal a feeling of fleshy roundness, the tool he used must have been a soft kind of fur, most likely goat hair. A special mark which identifies Yen's distinctive style is the *Cheh* stroke (the "axe"), which usually goes to the "four o'clock" position, as seen in the fourth word on the left in Figure 32. The calligrapher must reach the end of the stroke with a momentary hesitation and form a heel; then, lifting the brush, and using the tip only, finish the tapered end of the whole stroke. The timing involved in the execution of this stroke is crucial; only an accomplished calligrapher can handle the technique.

There was another famous calligrapher named Liu Kung-Ch'uan who enjoyed almost equal prestige with Yen and whose style of writing was imitated by many. His lines are so clear cut, the bone structure so obvious, one can very easily study the calligraphic framework of the characters, and, thus, his works are widely used in schools in the teaching of penmanship. When people

mention the Kai style, Liu is often coupled with Yen—as in the West, one often mentions Picasso and Matisse in the same breath.

In comparing Liu's work, in Figure 33, with a column of writing by Yen on the right, one can see reflected the difference in their personalities—the disciplined Yen versus the energetic and freer Liu. Liu's special trait is the harsh bony lines, whereas Yen's style consists of well-fleshed ones. Yen stressed both square and round shapes in his structure of the characters, but Liu imparted some contrasting effects, such as variations in the size of the words within the vertical and horizontal orders. Notice that in column one the first word is almost twice the size of the last character, yet the entire column remains a harmonious composition.

Besides Yen of the middle T'ang (*c.* 8th cent.) and Liu of the late T'ang (*c.* 9th cent.), there were three masters of the early T'ang (*c.* 7th cent.) who should not be neglected: Yu Shih-Nan, O-Yang Hsuen, and Chu Swei-Liang.

Yu Shih-Nan (558-638) followed the traditional school; he was a devotee of the two Wangs, the General and his seventh son, Wang Hsian-Chih. He studied the art of calligraphy under the well known monk, Chih Yung, who was the seventh-generation descendent of General Wang. Yu had a very vast knowledge of calligraphy and fertile talents, *i.e.*, he could produce faithfully many styles of writing. A representative piece, *Confucius Temple Tablet,* shown in Figure 34a, was executed when he was in his 70's. A gentle and serene expression is demonstrated.

O-Yang Hsuen had also gained prominence before the T'ang time. At first he was an adherent of the Wang school, but finally developed his own style, which has been widely copied. The identity of his personal style is a combination of Li and Ba Fen flavor, probably because he spent so much time studying them. His popular work was the *Chiu Cheng Kung Li Ch'uan Ming*\*, shown in Figure 35a, which he wrote at the age of seventy-six. His style is solid and suave—elegant, gentle, and beautiful.

Chu Swei-Liang (596-658) was a disciple of O-Yang Hsuen; consequently, a Li flavor lingered in his work also (Fig. 34b). He had assisted the Emperor Tai Tsung in selecting many of General Wang's works for the palace collection; this provided him an excellent opportunity to study Wang's writing at first hand, and it is undoubtedly why there is so much of the Wang spirit in his work.

O-Yang Tun, the son of O-Yang Hsuen, was also an accomplished master (Fig. 35b). His strokes are sharp and strong, severe as rocks and cliffs. There is much more movement in his work than in his father's.

Although Kai developed as the most used script in formal writing, such as publications, official reports and correspondence, legal contracts, etc., it has maintained a niche in the artistic calligraphic domain.

## HSING

The word *hsing* means "to walk." It refers here to a manner of writing that is freer than the Kai style, from which it evolved; it appears to be sketchy in comparison with Kai, yet it is readable by everyone. Hsing is a less formal style of writing as well as a faster script. Neat in appearance,

---

\*A poem about the sweet waters of the natural spring at the Emperor's summer palace.

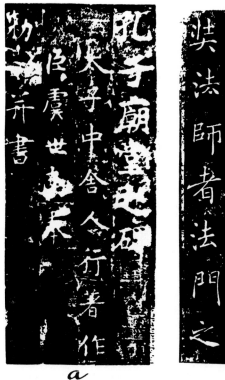

*Figure 34 (a) Confucius Temple Tablet.* Yu Shih-Nan (558–638) was one of the three early T'ang masters, but was already famous during the Suei dynasty (581–618). He wrote this masterpiece in Kai style at the age of 70. *(b)* Copy of the *Sheng Chiao Hsu Inscription.* By Chu Swei-Liang (596–658). He absorbed the style of O-Yang Hsuen and Yu Shih-Nan and finally established his own personal style. This piece, in Kai style, is considered his most representative work.

*Figure 35.* Examples of O-Yang, father and son, T'ang (c. 7th century). *(a)* O-Yang Hsuen, the father, shows in this poem, *Chiu Cheng Kung Li Ch'uan Ming,* a solid yet elegant Kai style. The size of the words are even, but each line is full of variations. Many people use his work as a model to learn how to master the art of calligraphy. *(b)* O-Yang Tun, the son, carried on his father's style but added much more movement to the lines, as shown in the curved touches of the brush. As a result, the calligraphy is more vigorous. This piece in Kai style is part of a tomb tablet for the Master Monk Tao Yin.

capable of being written at high speed, it is a most useful style, widely used for personal letters and other social writings, although not taught in schools.

A viewer looking at the example from the novel, *The Three Kingdoms*, in Figure 36, owing to the regularity of the composition, might ascribe it to the Kai style; however, because of the fast writing manner, it can only be categorized as Hsing. It is fortunate that this excellent example exists in the original, providing scholars the opportunity to examine its brushwork in detail. The story was about the military and diplomatic relations between the Three Kingdoms. From the smooth and rounded brush marks, it is evident that the brush must have been made from a soft kind of fur, probably goat hair, which is inexpensive and easy to acquire. The special feature of this style was the horizontal stroke which started light and ended thick and heavy; even the dots and the vertical strokes are quite sharp in their expression. During the later Han and thereafter, many Buddhist scriptures were written in Hsing. Many fine examples of the flourishing period of the Chin masters' works are extant. The brushwork shows a mature skill.

Among General Wang's masterpieces in the Hsing style, *Lan Ting Hsu*, a recording of a meeting of literati, all friends, at the Orchid Pavilion in Kuai Chi, Che-Kiang province, has been the most popular (Fig. 37a). The brushwork is considered the best he produced. The merit of this calligraphy lies in the extreme freedom in wielding the brush and in the infinite variation of brush strokes, yet the whole composition is in perfect order. Rubbings from this tablet have been used as an orthodox model for learning the Hsing style of writing (Fig. 37b).

In the poem Yen Ch'en-Ch'ing presented to his friend General Pei, who was going off to battle (Fig. 38), he used a combination of different styles: Kai, Hsing, also Tsao. When one looks at this writing, one is impressed by the strong impact of the forceful strokes and the elastic structure of each word. Yen exploits the usefulness of negative space. Owing to the contrast between the dense and the loose portions of the characters, together with the spaciousness of the composition, points of tension were created most effectively. This is truly an outstanding example of those styles which combine all the excellent forms of writing—such as Li, Chang Tsao, and the continuing style of Tsao by the master Hwai Su—many styles integrated into an effective whole.

An example of the work of the calligrapher Hwang T'ing Chian is the section of a poem (Fig. 39) which he wrote and dedicated to the Fu Po Shrine. The poem relates the story of General Ma Yuan, of the Han dynasty, who was reputed to have calmed a stormy sea. Hwang's art was influenced by Yen Ch'en-Ch'ing in both brushwork and spirit. Although his lines are much freer, a serious quality is conveyed by his heavy, fleshy strokes. He was also influenced by his contemporary, Su Tung-P'o, the great artist, poet, and critic. Both Su and Hwang were considered rebels, as they broke away from the orthodox influence of the two Wangs of the Chin period. Notice the composition of the characters in each column; they do not follow a strict vertical order. His use of that effect makes the calligraphy more lively and exciting.

In early Sung (10th cent.), the great scholar O-Yang Hsiou had denounced the conventional manner of writing and encouraged other artists to break away from the traditional stream. Both Su Tung-P'o and Hwang T'ing-Chian followed and augmented his doctrine. The revolutionary spirit reflected in both artists' work has been passed on through the centuries to the present day. On the whole, Hwang's style has more of a note of seriousness, whereas Su's work has a carefree and romantic touch, which reflects his personality.

Mi Fei enjoyed the same homage as his contemporaries, Su and Hwang. He was one of the leading painters of the Northern Sung period (10th cent.), and the originator of Pointillism—the painting of landscape with dots of pure color. His brushwork, like the masters before him, was full

*Figure 36.* From *The Three Kingdoms.* A page from the classic novel. Ink on paper, of the Chin period (317–420). This piece was among the excavation finds in Sin-Kiang early in this century. The brushwork is very close to Chang Tsao, Han Chien, and Bien Chien, shown in Figures 26, 27, 28, respectively.

*a*

*b*

*Figure 37.* (a) *Lan Ting Hsu.* A recording of a gathering of literati in Kuai Chi by Wang Hsi-Chih in Eastern Chin period (c. 4th century). This piece is believed to be a copy by Chu Swei-Liang of early T'ang time (7th century). Hsing script. (b) *Sheng Chiao Hsu.* In early T'ang, a monk named Hwai Jen collected and copied Hsing characters by Wang Hsi-Chih as type for a preface to a translation of Buddhist scriptures, written by the Emperor Tai Tsung. Hwai Jen transferred the characters onto a stone tablet and then engraved them The above is a rubbing from the tablet.

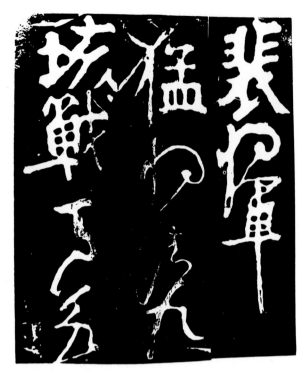

*Figure 38. A Poem to General Pei.* Yen Ch'en-Ch'ing wrote this poem to General Pei in Mid-T'ang time (c. 8th century), using a combination of different styles—Kai, Hsing, and Tsao. It is believed that this poem was presented to his friend when he was leaving to attack the enemy from the north.

*Figure 39. Fu Po Shrine Poem,* by Hwang T'ing-Chian of Sung period (c. 10th century). Although trained in the traditional manner, both he and his contemporary, Su Tung-P'o, were greatly influenced by the scholar O-Yang Hsiou who denounced obeisance to tradition and encouraged calligraphers to break away from the shackles of the past. Hwang did and so did Su.

Notice the column on the left; the three characters contour to the right, left, and right again. The column on the right, on the other hand, is left, right, and left again, thus, a feeling of balance and counter-poise is created. It also imports a sense of movement. Hsing style.

of variations, and he had a degree of competence that permitted him as many varieties as the brush is capable of. The example shown in Figure 40, *Chao Hsi Poem,* shows a clear-cut, fluent, elegant style. Mi Fei followed the school of the two Wangs so deeply that his calligraphy bears a clear mark of the Chin flavor. He is the author of the well-known *Shu Shih,* or *History of Calligraphy.*

Chao Meng-Fu (1254–1322) is another famous name in Chinese art history. He was well known but unfortunately not esteemed because he served under the ruler of the unpopular new Yuan dynasty, the Mongolian government, and therefore was scorned by the intellectuals. When speaking of important names in calligraphy, critics often mention Yen-Liu-O-Chao. Chao's works

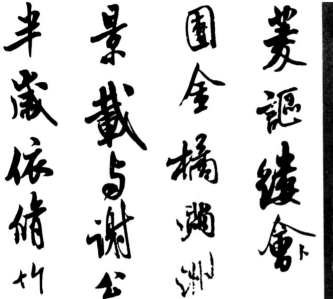

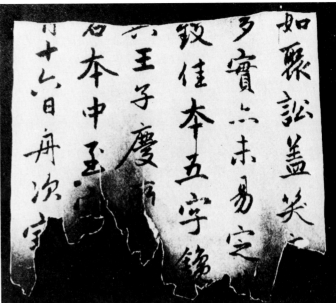

*Figure 40. Chao Hsi Poem,* by Mi Fei. This poem was written when he visited his friends to tour scenic Chao stream. He was then the governor of Hu Chou county in Che Kiang. His calligraphy, usually in Hsing, as above, is rich in the traditional flavor and also has a literary taste.

*Figure 41.* From the Thirteen Essays by Chao Meng-Fu on Wang Hsi-Chih's *Lan Ting Hsu Album.* The above example is a fragment saved from a fire at a collector's home in the Chien Lung period (1736–1796). Chao was once given a copy of General Wang Hsi-Chih's *Lan Ting Hsu Album* by a friend on his way from Wu Hsing to Peking. On this trip he studied it and wrote 13 pieces of commentary. This style can be called Cheng Hsing (Formal Hsing), as it is less sketchy than Hsing.

belong to the traditional school, and therefore he was referred to as a revivalist, in both his painting and calligraphy. He was also well known as a painter of horses. His brushwork is solid but quite free, full of literary taste. Chao was no doubt an influential figure in the field of calligraphy; at least his style of writing was a dominant one throughout the Yuan regime (see Fig. 41).

The Yuan dynasty fell in 1368, and China restored its own government. In Chinese history, despite every change of the ruling class, whether within or from the outside, the new ruler tried to protect and promote the traditional culture, especially Chinese calligraphy. In the Ming dynasty, most of the well known calligraphers were offered high positions in the government where they handled the writing of important documents. In fact, most of the emperors throughout the centuries were great lovers of calligraphy. T'ang Tai Tsung, Sung Hwei Tsung, Sung Kao Tsung, and many other Chinese emperors were trained in this art and became expert. Naturally, they encouraged others to master this art. During the Ming period, most of the scholars and artists gradually moved away from the traditional school, exemplified by Chao's revivalism, and followed more the revolutionary route of the Sung masters, such as Su Tung-P'o and Hwang T'ing-Chian. The "Mad" Tsao (Mad Grass) by the T'ang masters, such as Chang Hsu (see Fig. 46) and Monk Hwai Su (see Fig. 47), were also widely welcomed in the art world.

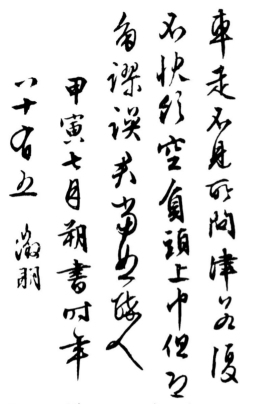

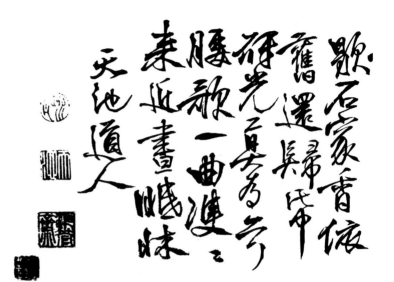

*Figure 43.* Inscription by Hsu Wei in his *Album of Flowers in Black Ink.* Hsing-Tsao style. Courtesy of Dr. Tan Tsze-Chor, Singapore.

*Figure 42. T'ao Yuen-Ming's Drinking Wine Poem.* Written by Wen Cheng-Ming at age 85. This is a typical example of his Hsing-Tsao style of writing.

Wen Cheng-Ming was the most celebrated artist in the Ming dynasty. His poetry, painting, and calligraphy were all famous. His representative style of calligraphy was Hsing-Tsao (less sketchy than Tsao), as shown in Figure 42. He first followed the two Wangs, then the monk Hwai Su of early T'ang, and, finally, Hwang T'ing-Chian, the reformer of the Sung period. The works which he did in his old age were more treasured by collectors, because they showed true mastery of the brush.

Hsu Wei (1521-1593) was the most influential artist — a giant — of the Wen Jen (scholars) school. He was an outstanding painter (see Figures 82 and 151), a poet, as well as a leading calligrapher. Figure 43 is from the inscription on one of his handscroll paintings and is an excellent example of the Hsing-Tsao style of writing.

The emperors of the Ch'ing period (1644-1912), like previous rulers, were great lovers of art, especially Chinese calligraphy. In the Ch'ien Lung period (1736-1796), the nation was prosperous; consequently, art was promoted and flourished greatly. The Emperor built a gallery, known as San Hsi T'ang, for his various collections of art objects. He added his inscription and seal to many of the famous paintings.

*Figure 44.* Couplet by Ho Shao-Chi. Of the later Ch'ing dynasty, 1856, at age 57, in Hsing style.

Among many famous names of the Ch'ing period, Ho Shao-Chi was held in special esteem for his outstanding style (Fig. 44). Like all calligraphers, he passed the national civil examination, and held high offices. He also followed the traditional way of learning how to write, mastering Chuan, Li, and the other classical styles, but, finally, he developed a strong personal style, quite different from the established ones. He obviously was strongly influenced by the Sung reformers, Su and Hwang. No one's work shows nearly as much freedom as Ho's. The structure of the characters is still within the traditional framework, as the Li and Kai influences are clearly evident, but the lines are completely his own creation. Although at times they seem like mere doodling, the expression of strength is carried all the way to the very tip of each line.

## TSAO OR GRASS

The skill of Chinese brushwork is demonstrated best in the Tsao style, which is derived from Hsing, but a script much sketchier and more simplified, almost like shorthand. Lin Yu-Tang once stated, "Chinese calligraphy is nothing but dancing on paper." He was referring especially to the Tsao style. In the Han period, when Li and Chang Tsao were prevalent, the art of wielding the brush reached maturity. However, with the Tsao style, which was first introduced by the two

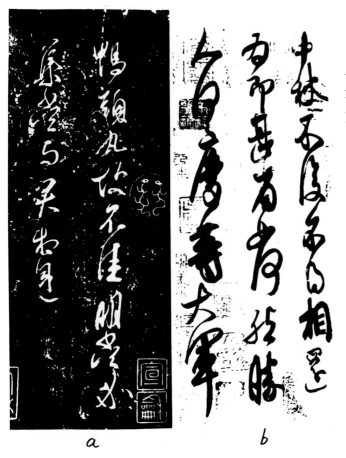

*Figure 45. (a) Duck Head Pill Note; (b) Mid-Autumn Note.* By Wang Hsian–Chin, the seventh son of Wang Hsi–Chih. He was the originator of this kind of continual script.

Wangs of the Chin dynasty (*c.* 4th-5th cent.), the art of brushwork indeed reached its zenith. Although this style of writing has never been taught in schools, as it is too abbreviated for everyone to read, it has always been most popular with professional calligrapher-artists. In fact, to many, Tsao represents the best in the art of Chinese brushwork. The two great stars were Chang Hsu and Hwai Su of the T'ang dynasty (7th cent.).

General Wang Hsi-Chih was the first master of this Grass style. His son, Wang Hsian-Chin, after his father's death was even more popular for a few decades. He created a continuous manner of writing, that is, he wrote a whole column of script without lifting his brush, producing a kind of spiral, word by word, from top to bottom. This technique gives an undisturbed one-breath feeling to the entire composition (see Fig. 45). The *Duck Head Pill Note* and *Mid-Autumn Note* are considered his masterpieces in Tsao style. His influence upon the later development of Chinese art was most significant.

In the 7th century, there were three giants in the art field: the poet saint Li Po, the sword dancer General P'ei Wen, and the "mad" calligrapher Chang Hsu. Chang was a highly emotional person. He once watched the performance of Kung-Sun Ta-Niang, a female sword-dancer, and claimed he experienced a deep inspiration, from which his skill at wielding the brush had much improved. As in Figure 46, the rising and falling rhythm of his calligraphy can, indeed, be compared with the movement of dancing. The brush to him is like the sword in General Pei's hand; both arouse an emotional sensation. In his works, Chang Hsu, like Jackson Pollock, is entirely absorbed in his own

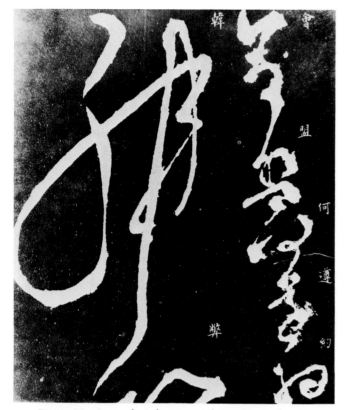

*Figure 46. Stomach Ache Note.* This is part of a note by Chang Hsu who was often called the crazy Chang. The above is a typical example of his famous "Mad Grass" style.

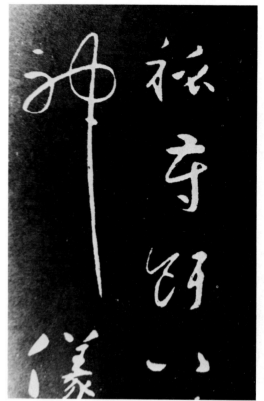

*Figure 47.* From the *Holy Mother Album.* This is part of the album written by the monk artist Hwai Su of the T'ang dynasty (7th century). This represents his formal Tsao style.

emotional drama, forgetting all about established rules. In the *Stomach Ache Note* (Fig. 46) he did not care about the structure of the characters, but instead used distortion and exaggeration to the utmost degree so as to satisfy his own thirst for an emotional outlet. It is a good example to illustrate that Chinese calligraphy is indeed abstract art. Chang Hsu, like Li Po, was well known for his wine drinking. He usually performed after a good drinking bout. When he was sober, he sometimes could not identify some of the words he had written. Notice the two columns in Figure 46; there is one word on the left and five on the right. If a viewer focusses on either one of the columns, it seems to be leaning and falling over; however, the two columns stand comfortably together, for they are complementary to one another. The word *Han* on the left is more than five times larger than any word on the other side. In his time, no other artist dared to break established rules and go so far as Chang did. Undoubtedly, it took courage to do so, but his was a great talent. Chang certainly had mastered all the rules so well that he could improvise his own.

Figure 47 is an example of another famous artist's work, the *Holy Mother Album* by the monk artist Hwai Su, whose Mad Grass, like Chang Hsu's, enjoyed much popularity. However, he held himself under great restraint when he wrote this piece. Jeong Wung, a modern critic and

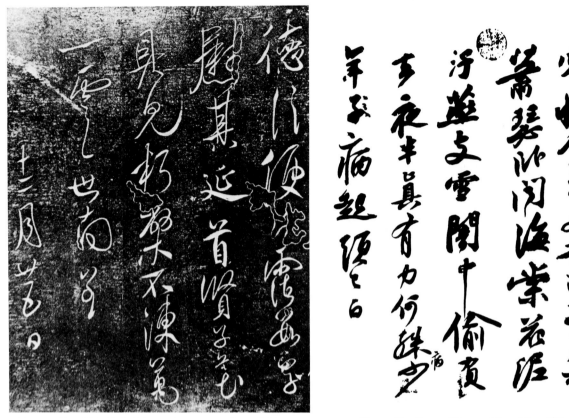

*Figure 48. Chi Shih Note.* An example of Tsao style by Yu Shih-Nan, one of the masters in early T'ang time (7th century). This is a wood-block copy made in the Sung period (10th century).

*Figure 49.* From *Hwang Chou Han Shih Poem Album.* This poem was written to express his sadness when Su Tung-P'o was demoted and transferred to Hwang Chou. Hsing-Tsao style.

calligrapher, commented on this piece: "The Master, Hwai Su, left many examples of his work. However, some of them are too dry and thin and without energy; still others might be too wild and lacking in order. Since this piece is so complete in its technique, it is, therefore, a good model for students to follow."[11]

The chief difference between these two masters' work lies in the fact that Chang Hsu stressed the joints of the strokes more and hesitated longer at each turning point, while Hwai Su, on the other hand, seldom made stops at the turns. Instead, he kept going at an even rhythm, a kind of swirling and rotating movement. Both of them are considered action artists with tremendous power.

The *Ch'i Shih Note* (Fig. 48) was a wood-block copy of Yu Shih-Nan's work. His Tsao style shows the influence of Wang Hsi-Chih. The structure of the characters is excellent. However, the composition seems to be too well polished and lacks spontaneity; consequently, it is feeble in expression. It might be said that it is too pretty.

Su Tung-P'o, like his teacher O-Yang Hsiou, took a reforming attitude towards the traditional arts, and he, too, tried to break away from established rules. Although he went through the academic training of brushwork, he imparted great freedom to his art. The expression in his *Hwang*

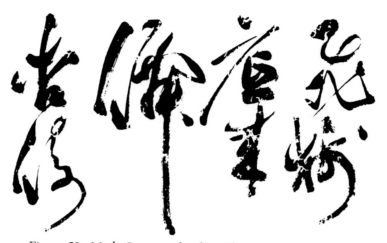

*Figure 50.* Mad Grass style, by Chu Yuen-Ming. Chu Yuen-Ming was good at three different styles: Regular Kai, Fluent Tsao, and Mad Grass. Courtesy of Dr. Tan Tsze-Chor, Singapore.

*Chou Han Shih (Cold Meal) Poem Album* (Fig. 49) is full of spontaneous charm. As to the composition, there are infinite variations created by using different pressures of the brush; also, the size and the shape of each character are obviously greatly varied, some long, some squatty, so as to give the reader a constant change. There is exaggerated contrast between his dense and loose composition of characters and, also, between the negative and positive space. His brushwork bears Yen's seriousness, but it is not so formal.

Among the famous Ming calligraphers, Chu Yuen-Ming was the most popular. The artist was the most influential figure next to Chao Meng-Fu of the Yuan dynasty. His favorite style was Hsing-Tsao, or formal Tsao, which is less sketchy. His Mad Grass style of writing won him great fame (see Fig. 50). Here, we are conscious of his natural, carefree handling of the brush. He was not bound by any traditional rules. Notice the motion of the lines, and the completion of the piece in one breath; there was no hesitation in the execution. One line runs into another, a constant flow. Because of the high speed of the brush, there is much split brush, giving a dry textural effect and these dry, undefined parts of the lines are highly suggestive, creating much artistic interest and offering ample room for the imagination of the onlooker.

By the latter part of the Ming dynasty, the Wan Li period (1573-1620), the most celebrated artist was Tung Ch'i-Chang. He was a well read scholar and a popular art critic. The Second Emperor of the Ch'ing dynasty, Kang Hsi, was an admirer of his work, actually a great promoter of his art. The example shown in Figure 51, a Hsing-Tsao style, shows the typical manner in which he wrote. His style reveals good literary taste, which reflects his scholarly interests. Since he was a favorite of the government, and his art was so highly valued by so many people, particularly in the high social strata, his art, especially calligraphy, became idolized.

The literary taste in his art is an outstanding characteristic. No one can deny his dexterity in handling the brush. However, in comparing his work with any of the T'ang masters, such as Yen Ch'en-Ch'ing, Chang Hsu, etc., Tung Ch'i-Chang is still far behind in competence, both in brushwork and in composition. Although some Western scholars have maintained that Tung was

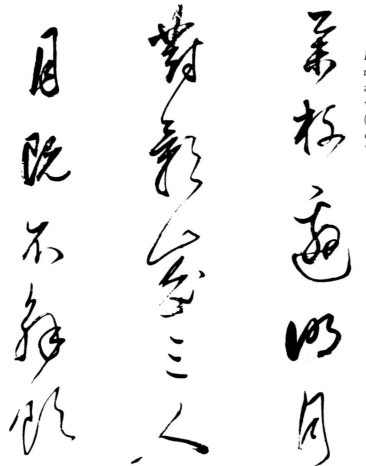

*Figure 51. Li Po's Drinking Wine under Moonlight Poem.* An example of the Tsao style of writing by Tung Ch'i-Chang (1555–1636). A good example of the literati school called Wen Jen Pai.

the greatest artist in Chinese art, this is highly untenable. His influence can be ascribed only to the period of late Ming and early Ch'ing (*c.* 16th–17th cent.)

Chinese painting and calligraphy grew and developed through the brush. Therefore, brushwork, both its principles and techniques, has been the core of this art. Before the Li style in the Han period (*c.* 200 B.C.), the brush was used mainly as a tool for writing. However, from that period on, brushwork gradually became an art form in its own right. Once the Kai, Hsing, and Tsao styles were established, after the Han dynasty, famous names in this art emerged, one great talent after the other, and the art of calligraphy has continued to flourish up to the present day.

## REFERENCES

1. Chang Yan-Yuan, *Famous Paintings Through the Dynasties*, Taiwan: Commercial Press, 1971, 52. [Chinese]
2. Fu Pao-Shih, *Theories on Chinese Painting*, Shanghai: Commercial Press, Ltd., 1936, 116. [Chinese]
3. Ibid., 131.

4. Tsien Tsuen-Hsuin, *A History of Writing and Writing Materials in Ancient China* [translation by Chou Ning-Sun of *Written on Bamboo and Silk*, The University of Chicago Press, 1962], Hong Kong: The Chinese University of Hong Kong, 1975, 158. [Chinese]

5. Peter Swann, *Art of China, Korea, and Japan*, London: Thames & Hudson, 1963, 10.

6. Tung Tsuo-Pin, *A Study of Shell and Bone for the Past Sixty Years*, Taiwan: Art and Culture Press, Ltd., 1974, 10. [Chinese]

7. Ibid., 16.

8. Ibid., 43.

9. Tsien, op. cit., 88.

10. Feng Chen-Kai, *Appreciation of the Famous Examples of Chinese Calligraphy Through the Dynasties*, Taiwan: Art Books Co., 1973, 22. [Chinese]

11. [Monk Hwai Su], *Holy Mother Album*, edited by Tuan Wei-Yi, Taiwan: Hsing Hsuo Publishing Co., 1973, Preface, unpaginated. [Chinese]

# The Aesthetics of Chinese Brushwork

## 5 Aesthetic Roots

Although, in the Far East, aesthetics has not been an independent discipline, its study in China can be traced back to 600 B.C., as Confucius was deeply involved in searching for as well as elucidating a philosophy of aesthetics. Materials in this field are abundant, albeit scattered, in classics, poems, and inscriptions on the paintings of various periods in history.

Aesthetic standards, of course, are rooted in the cultural and philosophical tenets of a people. In China, the major influences have been Taoism, Confucianism, and Buddhism, particularly the Ch'an sect of Chinese Buddhism, which was established in the T'ang dynasty (7th cent.).

### TAOISM

Lao Tze (birth *c.* 571 B.C.), the founder of the Taoist philosophy,* was a contemporary of Confucius. He believed that the desires and ambitions of man were the cause for the social unrest

---

* Not to be confused with the later theological form of Taoism founded in the Han period (200 B.C.).

and turmoil so prevalent in his age. He preached the virtue of withdrawal and non-action, that is non-interference in the affairs of others, both on the part of individuals and states. He urged conduct which is not motivated by self-interest or the pursuit of fame, wealth, position, and tasks of grandiose scale, concepts which were embraced by many of the scholar-painters.

Deities and spirits had no place in his scheme of things, for from experience he was convinced that "Heaven and earth are not kind. They treat everything as straw dogs."[1] His view of the cosmos, instead, was that Tao* and Ch'i, the existent form of Tao, are the vital life forces in all things natural. From Yin and Yang, the complementary positive and negative forces, whose union is essential for creation, sprang the heavens, earth, man and all things natural in the universe. Ch'i is the force which harmonizes Yin and Yang†. All things have their own particular qualities, and their own particular characteristics, all from Tao. Everything natural acts spontaneously, effortlessly. The way of the pine is not the way of a willow; the way of a falcon is not the way of a blue jay.

These concepts were later translated into fundamental principles of brushwork, where their embodiment in painting and calligraphy make the works an affirmation, as it were, of these philosophic precepts. For the viewer, a mystical experience is the desired result.

Since the term Tao is so abstract and difficult to define, Lao Tze used another word, *wu* meaning void, to elucidate his philosophy of nature. Tao is Wu. He gave three examples to explain the function of space, or voids:

> Thirty spokes support the hub of a wheel; because of the space within the hub, the cart is able to move. Vessels may be made of clay; it is the space inside that makes them useful. Build a room with a door and windows; it is the space through the door and windows which is useful.[4]

This concept of the reality of empty space is to be seen reflected in both calligraphy and painting.

Lao Tze stressed simplicity, a tenet which greatly influenced Chinese life. Consequently, simplification becomes a standard of art. An artist is content with simple themes; he strives for the simple approach, economy of line and color. Subdued color becomes an aesthetic standard. In subject matter, landscape and other nature themes become more important than figure form, for in the Taoist thinking man's place in the great scheme of the universe is rather insignificant. In a nature painting, man will occupy a modest space.

## CONFUCIANISM

Confucius (551-479 B.C.) took an entirely different attitude towards the chaotic world of that time. Unlike the withdrawing scholars, he advocated and himself took an active part in the service of his country, constantly seeking ways for the salvation of China.

---

*"Something existed before the birth of heaven and earth; it is always there in silence and void, keeps moving, unchanged; it may be the mother of the world. I do not know its name. I would call it Tao."[2]

†Tao begot one, one begot two, two begot three, three begot ten thousand things; all the things are carrying Yin and holding Yang; harmony is achieved by Ch'i through the blending of Yin and Yang."[3] The concept of Yin and Yang can be traced back a thousand years before Lao Tze's time, the belief being that these forces, though opposites, complemented each other as a primal creative force. This dualism of opposites fused into an effective oneness permeates Chinese thought.

No teachings have influenced China's culture more than those of Confucius. They became texts for study. They are reflected on tomb sculptures and monuments, and in paintings of all periods. They governed China's mores down to the twentieth century.

He placed his emphasis on high ethical standards, with duty the path to a harmonious life. A strict, well-defined code governed man's own conduct, his relationship to his family and ancestors, to other individuals*, and to his sovereign. Sincerity in thought and in action was stressed; this could be achieved only through education and knowledge.

Confucius, of course, worshipped the sages of old, and he edited the classics and poetry of ancient times. He made a compilation of the rites and music. In his school, art had a dual purpose, to develop men of culture and high moral standards, whose tastes in aesthetic appreciation would be refined, but equally important the arts were utilized to illustrate the need for order and harmony in life. His devotion to the ways of the past produced a formalism which permeated all facets of life, and which governed, too, the arts of painting and calligraphy. In accordance with the spirit within the Confucian school, beginners are to follow established rules. A tyro, of course, will not lose his way, for he has definite rules to guide him, but it is not a climate which fosters a search for originality.

# BUDDHISM

When, in the reign of the Eastern Han Ming Ti (58-75 A.D.), the Buddhist religion was introduced into China, with it came Buddhist art, painting and sculpture. During the Southern and Northern dynasties (3rd-6th cent.), since the new religion offered comfort in the belief of reincarnation of the soul, it was readily welcomed by the mass of people who were suffering greatly as a result of the constant wars between the states. The religious images at the temples and the rock caves, as at Tun Huang, Yun Kung, and Lung Men, greatly influenced Chinese art, which during the succeeding 600 years stressed Buddhist principles.

However, the most significant influence on the future development of Chinese art, perhaps, was the establishment in the 7th century of *Ch'an Tsung* (called Zen by the Japanese), which, in fact, is a form of Chinese Buddhism. The special characteristic of this Buddhist sect is the emphasis laid on sudden enlightenment, which is to be obtained through meditation. This kind of enlightenment, or inspiration, is quite beyond explanation; it cannot be put into words as the comprehension rests in one's heart. Many artists and scholars became followers of this Chinese Buddhist faith.

In *On Ch'an*, Chu Lin Pa Hsian, an expert in Ch'an study, discussed the basic philosophy of Ch'an; he said: "The slogan of Ch'an is: A discipline outside the Buddhist faith; without scriptures of any kind; concentration on one's heart; discovering one's character and reaching the goal of Ch'an."[6] Thus, through the mind's eye one can clearly perceive one's heart and soul; this is the path to enlightenment.

The Ch'an practice, through intuition and search for man's nature and soul, greatly influenced the development of Chinese philosophy and art. The famous philosophers of the Sung period

---

*Confucius preached *Shu* or humane action in regard to others: ". . . do not do anything that you would not like done to yourself." Mencius (372-289 B.C.), another outstanding Confucian scholar, who was the first to promote democracy, further explained the meaning of Shu as ". . . taking care of my old generation, and extending the same service to all people; nursing my child, and doing the same to all other children."[5]

(10th-13th cent.) were mostly influenced by the Ch'an approach, such as Chu Hsi and many others. With respect to art, the monk-artists, such as Liang Kai (early 13th cent.), were masters of the Ch'an school (see Fig. 86). Both Ba Da Shan Jen and Shih T'ao were believers in Ch'an Tsung. (See Figs. 100, 101)

The Ch'an school of art is marked by the following features: (a) Black is the predominant color used. (b) Extremely simple strokes are employed. (c) The expression of the work, whether it be a landscape or a still-life, lies beyond the mere rendering of the form; in other words, it should be contemplative rather than decorative in order to reflect the intuitive faculty. The widely reproduced *Six Persimmons* by the monk Mu Hsi of the early 13th century, is a good example of Ch'an art.

# 6   Aesthetic Components

## FORM

In visual art, form comes first, for it is shape that gives the onlooker the basic sense of an object, such as tall, short, fat or slender, etc. Distinct impressions of certain forms are generated between the object and the viewer.

What is form? In its everyday sense, form is the shape and the structure of anything. On the whole, this is a sufficient explanation; however, in art, since form is one of the major means of expressing and conveying sentiments and ideas, an additional essential element should be included in its definition, that is, aesthetic quality. Thus the form that the artist creates will be an artistic form, which, in itself, will possess the power to convey a certain mood, be it comic, tragic, etc.

In China, before the advent of modern science, it was believed that the universe moved in a circular orbit, and that the shape of the earth was an immense square with the sides running east, south, west and north. In the humanities, the Confucian school stressed the rules of proper conduct, from sitting up straight to acting in strict accordance with the code of ethics. From childhood, Chinese are urged to develop in their conduct and in their character a combination of "the round and square," namely, to be round and smooth in dealing with people, yet, at the same time, to be strict in self-discipline. Thus, the shapes of the circle* and square are deeply rooted in Chinese consciousness.

*The word "circle" in Chinese, in addition to the geometric form, signifies completeness, fulfillment, or successful conclusion.

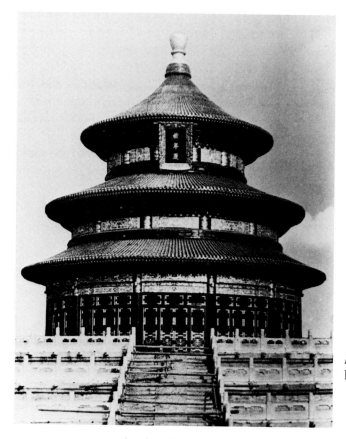

*Figure 52.* The Temple of Heaven in Peking.

The manifestations of the concept of combining the circle and square are reflected in many art forms. One such illustration is The Temple of Heaven in Peking (Fig. 52), which conveys a feeling of dignity, sacredness, and the fullness of life. The general arrow shape pointing towards heaven arouses the sense of religious worship.

Since one cannot help being influenced by what one sees and hears, the forms one creates in art will inevitably be based upon one's experience. The forms conceived and established in Chinese art—calligraphy and painting—are both directly or indirectly influenced by nature. Many Chinese brush strokes parallel forms observed in nature—the dot that looks like a "falling stone," a "tiger's claw," an "eagle's beak," etc.; the stroke which resembles a "nail-head," a "rat's tail," an "axe-cut," etc. Chinese painting, as is well known, became recognized for its landscapes, which encompassed the poetically serene as well as the gaunt and grotesque, and also for its near-worship of even the smallest of living creatures, the insects of the grasses and ponds. The aesthetic criterion in such works is not a facsimile of form, but rather an abstraction of its vital essense endowed by nature, its Tao or Ch'i.*

In Chinese calligraphy, each word has a standard, accepted form. However, each character can take on a different appearance and expression, depending on the unique personality and disposition

*Ch'i literally is air or atmosphere; in philosophy and art, it conveys the meaning of energetic force or the vitality of life.

of the individual artist. In Figure 53, the four examples are all of the Kai style of writing, yet, due to the different personalities of the artists, each piece projects a different expression. For instance, the *Tung Mei Jen Tomb Tablet* in Figure 53a, an unsigned work of the Suei period (581-618), shows a gracefully elegant style, yet slightly reserved in temperament. Figure 53b is the tomb tablet of a T'ang official, Huang-Pu Tan, written by the famous calligrapher O-Yang Hsuen of the 7th century; his style shows a less rigid quality in structure as well as in composition, reflecting his free character. The calligraphy looks more loose and relaxed. Figure 53c, the *Ban Juo Scripture* by the great calligrapher Liu Kung-Ch'uan, reveals more bone-like lines, which naturally reflect his strong character. Figure 53d, *Tuo Pao Pagoda*, is an inscription written on a stone tablet by the most popular calligrapher in the T'ang period, Yen Ch'en-Ch'ing; his righteous character is exposed in his heavy and fleshy writing.

Art forms catch the viewer's attention by their shape and structure, and they convey their message by their posture as well as the movement they indicate. In Figure 54, there are two different styles of Chuan, Greater and Lesser Chuan. The Stone Drum form gives an impression of being heavy, calm, and exuding a warm feeling, whereas the Lesser Chuan impresses the onlooker in quite a different way—harsh, severe, and aloof, a reflection of the political climate of the age. Figure 55 shows the character "to teach" as written by the famous calligraphers Chang Hsu and Hwai Su of the 7th century. Although both wrote with lightning speed and individualized the form by means of distortion and exaggeration, Chang impresses the viewer by his heavy, carefree,

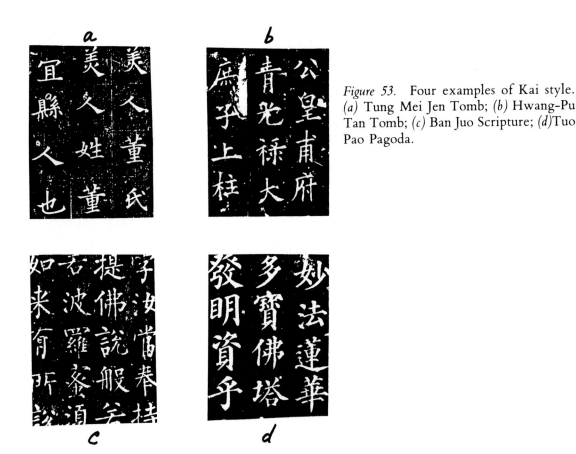

*Figure 53.* Four examples of Kai style. (*a*) Tung Mei Jen Tomb; (*b*) Hwang-Pu Tan Tomb; (*c*) Ban Juo Scripture; (*d*)Tuo Pao Pagoda.

Figure 54. Examples of Greater and Lesser Chuan styles. (a) Stone Drum; (b) Lesser Chuan.

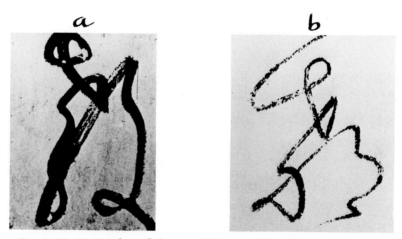

Figure 55. Examples of the word "to teach" in Tsao style. (a) by Chang Hsu; (b) by Hwai Su.

and galloping manner while Monk Hwai Su achieves an entirely different expression, lighter and more controlled. Both samples, of course, are extremely dramatic abstractions.

Figure 56 is Kuo Hsi's (1020-1090) masterpiece *High Inspiration of Woods and Springs.* The forms of rocks and trees are all vivid with Ch'i, and the interest it stimulates is lasting. Figure 57 is a landscape by the inexhaustibly creative artist Shih T'ao (1641-1717?). Notice that each tree form in this composition is endowed with its own unique characteristics. They are not at all photographic. Mountains and rocks are made distinctive from one unit to the other through using a clear contrast of light and dark. In *Narcissus* by Hwang Shen, one of the Eight Eccentrics of the 18th century (see Fig. 58), one sees that the artist imparted his whole being in these two plants. The leaves seem to

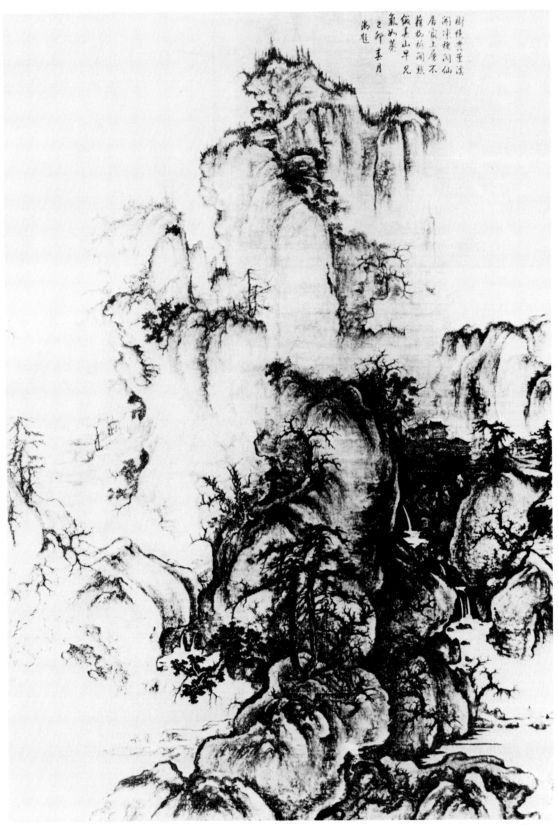

*Figure 56. High Inspiration of Woods and Springs,* by Kuo Hsi. Courtesy of the National Palance Museum, Taiwan, Republic of China.

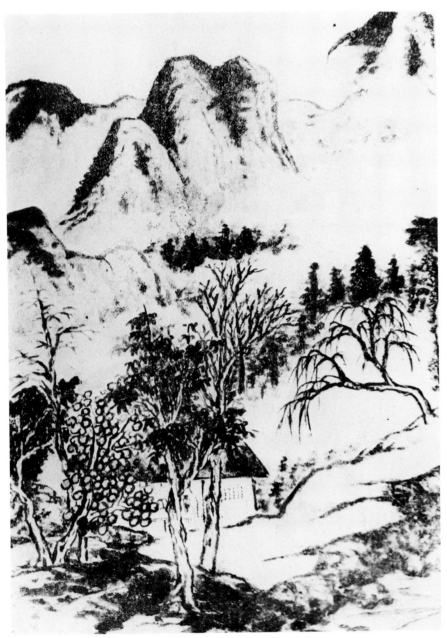

*Figure 57. Landscape,* by Shih T'ao.

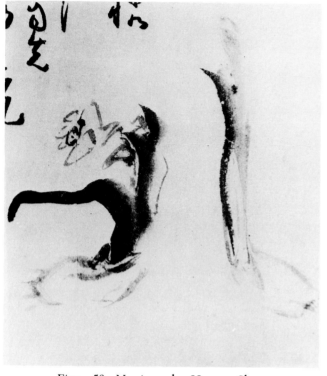

*Figure 58. Narcissus, by Hwang Shen.*

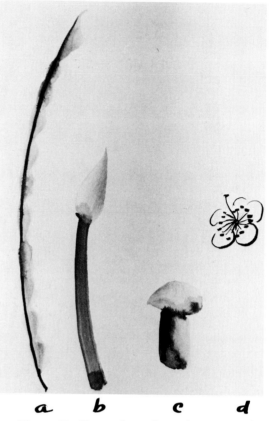

*a*    *b*    *c*    *d*

*Figure 59.* Examples of combination of lines and dots in painting.

gesture as if they were dancing arms. Like Chang Hsu, he was an artist whose emotion and sentiments permeated his art. He considered emotion an indispensable ingredient in a lively work of art.

## LINE

Line is an outstanding, obvious, definite form. It attracts the viewer's attention and will guide him on a tour of its wanderings.

Line is the major component of Chinese painting and calligraphy. Lines define form, suggest space, connote surface, indicate movement. Even a dot may serve the same function as line.

In painting and calligraphy, most forms are composed of a combination of dots and lines. The examples in Figure 59 illustrate four of the various ways whereby dots and lines are utilized in Chinese painting: (a) a row of dots executed in one continuous stroke, connected by a black line; in the illustration, a string bean. (b) a dot supported by a line; here, representing a lotus bud. (c) another combination of a dot and a line, showing a mushroom. (d) a combination of dots and lines; here, a plum flower.

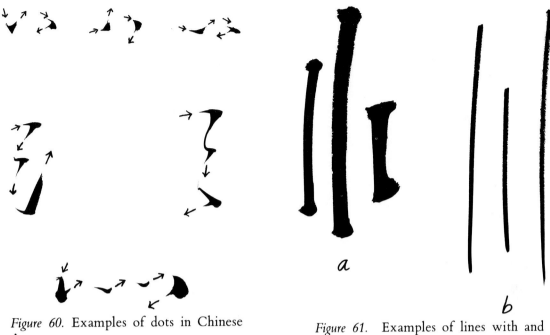

*Figure 60.* Examples of dots in Chinese Art.

*Figure 61.* Examples of lines with and without bone structure. *(a)* lines with bone structure; *(b)* lines without bone structure.

In calligraphy, it is obvious that the characters are all composed of dots and lines. Dots are not circular in shape as in the West but vary in thickness, and their "tails" indicate direction of movement in the structure of the character (see Fig. 60). This gesturing creates the "one-breath" effect. (See Figs. 45, 46, and 50.)

The famous critic Hsieh Ho of the Southern Ch'i period (479-501), in his celebrated work *Six Methods*, touched upon the art of line in his second canon—the "bone" treatment of line— and revealed the essence of Chinese art, the quality of line. Through many years of experimenting, I have come to accept the tenet that if a line is properly drawn, it will be a complete entity in itself, with a bone and nerve structure, with flesh and blood, hence endowed with a body and soul. This will be fully discussed in Part Three, *Techniques*. By the same token, if all the lines and dots are perfectly done, then, each character or each painting will become a solid composition with spirit and vitality.

The first requirement for a good line or dot is to possess Li, vigorous strength.

First, the so-called bone structure must be embedded in a line, so that it will appear solid and strong, as in the lines shown in the Greater and Lesser Chuan style of writing. (See Fig. 54.) When the artist draws this kind of line, he must do it in one stroke, without hesitation, maintaining an even pressure and speed; he thereby injects tension between the two ends, as if the lines were being pulled taut (see Fig. 61a). The lines shown in Figure 61b, in comparison with those in 61a, though they are equally strong, have considerably less impact of tension, which shows how important full "bone structure" is to a line.

According to its natural structure, a bamboo tree looks quite stiff and smooth on the surface, as illustrated in Figure 62b. However, in an artistic approach, this form must be dramatized so as to

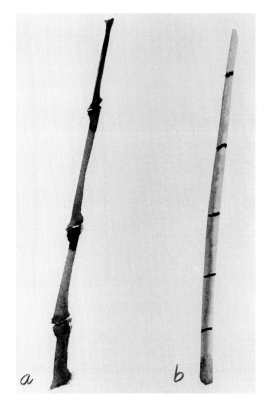

*Figure 62.* Examples of bamboo with and without bone treatment; (*a*) with bone treatment; (*b*) without bone treatment.

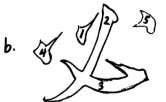

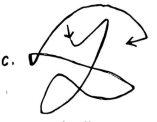

*Figure 63.* The illustration of "Ch'i" and "Li" qualities of the character "Pi". (*a*) the character "Pi"; (*b*) the sequence of its strokes; (*c*) the flow of the strokes: "Ch'i".

make it more interesting. To make the bamboo seem stronger and more forceful, it is necessary to give the straight lines a "bone structure." Figure 62a suffices to show the difference in impact between the two presentations. (See also Fig. 102)

Li is not the only means of injecting life into an art work. Another even more important element is Ch'i—the atmospheric, one-breath performance. Actually, Li and Ch'i are like "body and soul"—inseparable. Let us take a dancer, for example. Li represents his strong body; Ch'i stands for his movements, the action which goes on and on, never chopped off, never halted. Thus, the whole dance is a result of a strong body and energetic movement, a product of Li and Ch'i.

The character *pi*, which means "must," in Figure 63 is completed with both Li and Ch'i. From stroke 1 to the final stroke 5, the whole action of writing is executed in one breath. Though each stroke stands by itself, the Ch'i between the strokes is uninterrupted. The Ch'i actually serves as an invisible string to hold the five pieces together. Therefore, this character *pi* is alive.

*Figure 64.* Calligraphies written at different times of the same day. Illustrative of "One-Breath" writing and a broken Ch'i, *(a)* morning; *(b)* noon; *(c)* evening.

Calligraphy does reflect the artist's mood and frame of mind at the moment of writing, as does a rendition by a pianist. Unless the writing is done in one sitting, there is great possibility of losing the Ch'i, or the coherence of the work. For, upon resumption, the mood is likely to have changed markedly. In Figure 64, the three words, *wan li ching,* or "the feeling of ten thousand miles," show the one-breath feeling, for each column was written in one sitting, without interruption. However, each column was written at different times of the day. Figure 64a was written in the morning, when I was fresh; 64b was written at noon, and appears to be more energetic; 64c was written in the late evening, and looks a bit hesitating and weary. In order to avoid a broken Ch'i, a painting or calligraphy must be finished in one breath, or, at least, in one concentration.

## SPACE-CONSCIOUSNESS

Man's feeling of space, it is believed, is an intuitive activity, and the psychological consciousness of space is constructed by the universal faculties of perception, such as seeing and feeling. In viewing a Shang bronze, one can discern its monumental and solid quality. One can feel, also, the external

and internal space of an architectural structure. A German scholar studying Chinese music found within it the presence of perspective, *i.e.*, the realm of depth.[7] Dance, too, with its turnings, risings, fallings, and other movements likewise creates the sensation of space.

Every art form produces a type of space-consciousness. What triggers the spirit of space-consciousness (*k'ung chian kan*) in Chinese art? The answer lies within the unique expression of Chinese calligraphy.

The spatial structure in Chinese painting is formed by the modeling of light and shadow, not by conforming to the sculptural spirit. Chinese ink painting has always been a product of abstract rendering. There is a spatial effect which is stimulated by the gestures and rhythmic indications of line. To put it in a more appropriate way, it is a calligraphically created space.

Chinese calligraphy is a rhythmic art. Unlike the Western word, which is a combination of many letters, a Chinese character is composed of different shapes of lines and dots, with each combination occupying a unit of space on paper. This unit of form is an arrangement where all parts, left, right, top, bottom, and the four corners, are perfectly balanced and echo each other—an architectural structure.

If a piece of calligraphy is well done, it should be a work of fine art creating the impression of space and depth. If each column is properly composed, one may see the harmonious unity, just as one sees the continuous movement of the wave on a lake or the swaying of branches and leaves in a tree before a wind. So, such a piece of calligraphy becomes a stream of life, a fugue, or a dance. As has been noted above, in the T'ang dynasty (7th cent.) the great calligrapher Chang Hsu derived his Mad Grass style of writing, which is a vigorous script, from watching the sword dance performed by Lady Kung Sun. And, in this same period, the famous painter Wu Tao-Tze improved his art of painting after he viewed a military dance by General P'ei Wen. There is, indeed, a feeling of space aroused by parallel movements in the arts of music, dance, and calligraphy. The Ch'i expressed in calligraphy is an essential means of creating the atmosphere of space, for space is the stage upon which all action and movement takes place.

In a relatively simple painting, such as that of a single branch of bamboo, or some leaves of the orchid plant, a few effective lines may suggest an atmosphere of light and air, the two aspects which are not actually painted into the picture yet occupy a definite space. I once saw a fish painting by Chu Ta, the well known artist of late Ming and early Ch'ing dynasties (1626-1705). There is nothing on the paper except the fish, depicted by only a few strokes. The lines portraying the fish are so well executed that they effectively indicate the space surrounding the fish, suggesting the existence of water.

This use of suggestion is exemplified also in the art of Chinese opera. In the traditional Chinese theatre, very little stage setting is used; usually only a table flanked by two chairs. The actor might swing his whip to show that he is mounting a horse or gesture with his hands to show that he is opening or closing a door. Such hints, through gestures, are similar to the suggestive lines used in brushwork to indicate movement, and, consequently, space.

Thus, since the effect of depth is created by the symbolic lines, the element of perspective is not really needed. The realm of a piece of painting or calligraphy actually transcends reality. It exists in the mind's eye as an imaginative space.

The early stage of landscape painting dates back to the Southern and Northern dynasties period (*c.* 5th-6th cent.). Tsung Ping and Wang Wei* were among the early art critics and were especially

---

* Not to be confused with the artist Wang Wei of the T'ang dynasty.

important for their studies on perspective as well as space-consciousness in Chinese art. Moreover, their discoveries and discussions greatly influenced the future development of Chinese art, and formed decisive guidelines for the artists who followed.

One thousand years earlier than in the West, Tsung Ping had already discovered the realistic approach of including perspective in painting. He used a piece of silk through which he looked out to a distant mountain and then painted the scenery on the silk as it loomed before his eyes. In his treatise on the theory of painting, he notes: "The farther an object recedes, the smaller it appears to your eyes." He goes on to suggest that the painter "detail the near, and suggest the distant."[8]

His contemporary, Wang Wei, on the other hand, was strongly opposed to the idea of emphasizing perspective in painting. He considered that the realistic approach was rather limited in scope. Wang thought that if one paints from a fixed spot and paints the immediate scene before him, he can only see the mountain in front of him, not the many, many mountains beyond his naked eye. He, thus, held that a suprarealistic view should be taken in order to depict a much richer panorama. To him, painting was meant to convey the poetic quality of a scene. Above all, the spiritual quality seen by the mind's eye and the space filled by the eternal Ch'i, or Tao, should likewise be rendered and to depict these realities should be the goal which all artists should pursue. Therefore, he advocated that a "bird's eye" view should be adopted in order to liberate the artist from the bondage of the perspective view which is too limited in scope. This was an advanced and intellectual point of view. Chinese artists have followed his counsel ever since.

The Chinese attitude towards the cosmos is not a state of opposition. They have never tried to conquer nature. They love nature. People who blend themselves with nature will live with it harmoniously. In Chinese literature and poetry a word such as "linger" and in philosophy the concept of *wang fu,* "no departure without return," are frequently found. Such words describe well the Chinese attitude toward space.

Thus, looking at a Chinese landscape in a hanging scroll form, the onlooker may first notice the distant peak in the higher part of the composition; then, his eyes may wander downwards, to the middle range, viewing leisurely the rockeries, trees, or water fall to be found there; then, gradually following the movement of such interest points, he reaches and lingers to view the trees, hut and stream at this close range, where the artist himself lingered. He then may go back upwards, or once again repeat his wanderings downward. This kind of back and forth movement describes the feeling and sentiment of "linger" and Wang Fu. This is the intrinsic spirit of the Chinese concept of space-consciousness in art.

Sometimes, the sound of a bell from a temple may linger in the woods. Tsung Ping once faced his paintings on the wall, and playing his lute sang: "I want all the mountains to echo my song."[9]

Figure 65 is *Tadpoles,* a reproduction from my ink drawing.[10] The space is filled and animated by the vividly moving tails. The black and white contrast in this composition is quite clear. The S curve in the over-all view constitutes the action line or the backbone of this composition. My signature and seal tie the lower group of tadpoles to those in the upper right corner, forming two counterparts to balance the heavy group of tadpoles on the opposite side.

The feeling of unity is also achieved by the almost uniform size of the small animals. However, a contrasting effect is gained not only by the positive and negative spaces in black and white, but also by the various postures of the swimming creatures. Notice the fact that none of them has been drawn exactly the same in shape and direction, so as to avoid repetition.

The function of form in a Chinese painting is not to reproduce the natural shape, but rather to create a denotation or suggestion of its very essence.

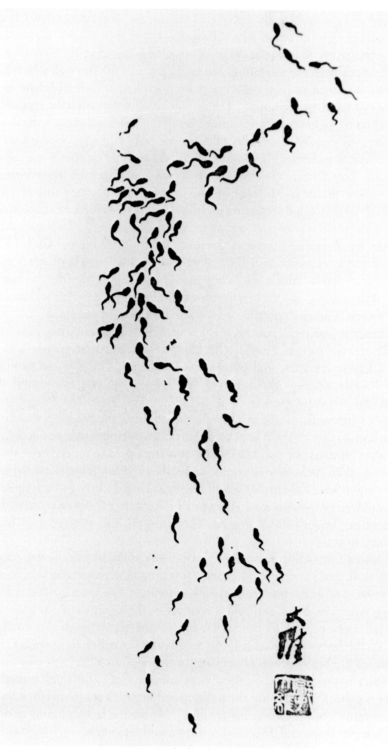

*Figure 65.* Tadpoles, by Kwo Da-Wei.

As one views this drawing, he is conscious that the tadpoles are swimming in water. It is not necessary for the artist to create that space by adding pigments to the background. It is more subtle to let the onlooker fill in the space through his imagination. If I had created the water by adding colors, or lines, the result would have been like painting "a snake with feet."

# COMPOSITION

Among all the components of visual arts, such as painting and calligraphy, composition, which is the organization of all the elements of painting into a cohesive design, is the most fundamental. To achieve line and color comparable to that of the great masters is not an impossible task, for excellent line quality and comparable skill in other elements of painting can be mastered in time. However, the grasp of composition may take a lifetime to attain. Usually, an outstanding art work, whether painting or calligraphy, surpasses another mainly in the way the artist organized the design and not because his painting technique was vastly superior.

The art of composition encompasses six essential principles:

## Host-and-Guests Concept

In Chinese art, the major form in a composition is referred to as the "host," and the "guests" play a secondary role, mainly to balance that major point of interest. However, the guests are not insignificant; on the contrary, they are necessary, as essential as the leaves are to a flower.

In a landscape, the mountain form would be the host, whereas a cascade, trees, a hut, travelers, would all be considered as the guests, the subordinate objects. In a composition, the first step is to decide where, in the picture plane, to plant the host, which often will be the action line; then, where the rest of the forms, which carry lesser weight, should be arranged to balance or render contrast to the main form. This holds true in calligraphy, also. (For example, see Figs. 46, 47.) Needless to say, the host should occupy a commanding post; otherwise, the result would be like "noisy guests overpowering the host."

The famous poet painter Wang Wei of the T'ang period (7th cent.) once stated in his *Treatise On Landscape*: "Arrange the proper position of host and guests; set in order the posture of the peaks."[11]

A well known artist of the 10th century, Li Cheng, echoed this same view in an article, *The Secret of Painting Landscape*: "In painting landscape, the first thing is to decide the locations between the host and the guests; next, to arrange the relations between the near and the far; afterwards, to set forth the objects in the scenery, and adjust the forms in higher and lower parts."[12] This was reiterated in the eleventh century by the great landscape master Kuo Hsi of the Sung period (1020-c. 1090) in his painting *High Inspiration in Woods and Springs*: "In painting landscape, first mind the large mountain, called the leading peak; once established, then, the near, the far, the little ones and the big ones."[13]

## Depth or Perspective

As has been described in the section on space-consciousness, the Chinese concept of perspective, unlike the scientific view of the West, is an idealistic or suprarealistic approach, so that one can depict more than can be seen with the naked eye. The composition is in a ladder of planes, or two-dimensional or flat perspective. Figure 88 illustrates well the bird's eye view or imaginary perspective (see also Figures 88–91, 94, 96).

## Mi and Shu, Density and Looseness

An effective composition cannot be too loosely organized or too scattered. Without a contrast of density (Mi) and looseness (Shu), a picture will appear too flat and lack any sense of depth (see Fig. 66). On the other hand, with adequate arrangement of the dense and the loose, the composition becomes well organized and will naturally give a feeling of depth (see Fig. 67).

How to achieve the effect of Mi? Mi is actually a cluster of anything, such as grapes, foliage, etc. The only way to accomplish this effect is to employ the overlapping technique. For example, when one sees a bamboo grove, one can only see the leaves in front of him, yet he knows that there are many, many leaves behind those. Some of them are partially covered but there are still more, entirely hidden. Only with this type of vision can one see the whole bamboo bush in-the-round or in a three-dimensional shape, rather than as a flat plane. Therefore, in order to paint something so as to avoid flatness, overlapping must be used to solve the problem, that is, one must superimpose one group of leaves upon another grouping. This process may be repeated so as to achieve a deeper or tighter area, which is called Mi, or density.

The terms Shu and Mi may also be interpreted as hollow (*Hsu*) and solid (*Shih*). This explanation suggests the solution to the problem of how to attain the contrasting effect of Shu and Mi.

There is a rule which has often been repeated by masters in teaching the art of composition: "Let your painting be dense without muddiness; loose but not scattered." It takes an experienced artist to handle a clear-cut Mi. If one keeps adding strokes without any control over the amount of water in the brush, the ink will bleed or run and become muddy. In the loose area, one has to achieve the contrasting effect of Shu-Mi; if the loose parts are too evenly distributed, then, the effect will be too even and appear to be flat and lack any depth, or more likely, be too busy. In other words, the composition must be neither too tight, nor too loose.

## Yin and Yang, Dark and Light Contrast

In Chinese philosophy, Yin and Yang are used as symbols to describe the negative and positive principles of the universe. In archaic times, the term Yin meant dark, but also earth, mother, moon, water, etc.; Yang stood for light, but also father, sun, emperor, fire, gold, etc.

The concept of dark and light contrast certainly is another requisite of a good composition. This contrast not only helps to bring out the shape of an object, but also effects a three-dimensional quality, such as that of a rock, a peach, etc.

*Figure 66.* Example of composition lacking the Shu and Mi contrasting effect.

*Figure 67.* Example of a composition with the Shu and Mi arrangement showing the effect of depth.

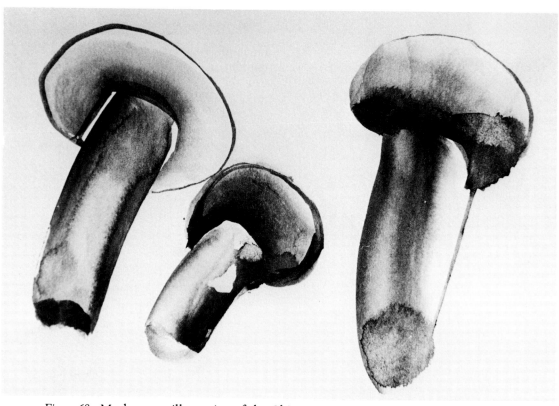

*Figure 68.* Mushrooms, illustrative of the Chinese concept of light and dark contrast.

In Chinese art, the principle of Yin and Yang is not confined to natural phenomena, *i.e.*, if the light comes from the east, then the shadow must be put on the western side. Like the theory of imaginary perspective, the Chinese conception of the source of light is also an imaginary one: the light may come from any direction or all directions, so long as it serves the purpose of bringing about a light-dark contrast in the composition, whether it be calligraphy or painting. Figure 68 shows three mushrooms. Every part of each vegetable is quite clear in showing the Yin and Yang; however, the source of the light is not at all based upon any natural law. In fact, the light source is purely an imaginary one. It has nothing to do with the time element, not of the morning nor of the twilight; instead, it conveys an eternal sense of time. The light, in fact, comes from all directions. Yin and Yang is not bounded by anything; it is the final result that counts—in this illustration, the roundness.

### Space

Areas of the white paper—voids—are always to be found in Chinese painting and calligraphy. They are not unfinished, empty, or yet-to-be-filled-up spaces. For, these voids are not actually empty. In fact, they are an integral part of a painting or calligraphy.

Take Figure 67 for example. The composition is held together not only by the placing of the three clusters of leaves, but also by the continuous clockwise flow of the lines, right through the negative spaces, in a circular pattern of perpetual motion. The negative space is as essential to this flow of movement as the lines themselves.

The dense group of leaves, on the left, are pointing upwards: this leads the onlooker's eye to the small bamboo tree; then, at the fork, the bending branch catches the viewing eye and forces it to move to the right, and at the end, downward. The strong tip of the leaf brings the onlooker's eye to the smaller group of leaves at the lower right section of the composition. Here, the eye halts for a moment, and then, following the branch, the eye travels back to the bottom part of the big bamboo. Again, it halts for a second; the viewer sees the heavy group, on the left of this composition. The whole cycle of movement can be repeated over and over.

The negative spaces represent the air or wind in which the leaves live and move. The same principle applies to the medium of water for a fish, or the sky for a flying bird, etc. If lines or color were used to paint these elements of nature into a painting, they would detract from the lines portraying the major form—the bird, the flower, etc. As has been already observed, the space concept in Chinese art is suggestive and imaginary. Both the positive and negative spaces are complementary to each other, and they are equally important to convey form, texture, movement, etc.

## Balance

It is widely recognized that a good composition contains good balance, *Chun Heng*. However, without contrast, the effect would be too well balanced and would result in dullness.

The kind of balance used in Chinese art is an asymmetrical one. It is not $8 = 8$, but rather, $8 = 5 + 2 + 1$ or $8 = 4 + 3 + 1$.

Kuo Hsi of the 11th century, in discussing the arrangement of composition, said: ". . . leave enough space for the sky; enough ground space below; the middle portion is for planning the scenery."[14]

Ch'in Tsu-Yung of the 18th century, in discussing the arrangement of composition, advised: ". . . the right side should be heavier if the left side is too light, and vice versa."[15] Since there is no balance in a counterpoised manner in Chinese art, in either calligraphy or painting, one side is bound to be heavier than the other side; therefore, the parts on the two sides, the left and right, and even the heavens (the sky) and the earth (ground), or the background and foreground, must be well adjusted, so as to keep the total composition in good balance. In Figure 68, for example, the two mushrooms balance the taller one on the other side.

# 7 *Aesthetic Standards*

## CH'I YUEN

*Ch'i Yuen*—which has been translated by Western scholars as "rhythmic vitality," "spirit resonance", "vibration of vitality," "harmony with the spirit" (*Ch'i*)—is the paramount element in Chinese art. Stated simply, Ch'i Yuen refers to the spiritual expression which emanates from a painting or calligraphy, where there is harmony of its vital components. With Ch'i Yuen, an art work is vibrant; without it, the work is lifeless, stiff.

The Chinese believe that all creations of nature, though they be inanimate to the Western mind, reveal an inner vitality. Within everything natural, a blade of grass or a bamboo shoot, a mountain or a cloud, there is Ch'i. Since every creation has Ch'i, it consequently possesses Yuen, an innate flowing vitality. There must be an atmospheric blending or harmonious flavor of all the elements involved—as in a massive fog, a symphonic movement, a turbulent ocean, the flow of summer clouds. That rhythmic, concordant effect or flavor is Yuen. Once the coherence of the growing power of anything is broken, it withers and becomes lifeless, like an artificial flower or paper grass.

The term Ch'i Yuen was first used by the artist and critic Hsieh Ho* in his book *Critiques on Old Paintings*. In one section he enumerates six essential approaches toward achieving a strong art work. He used the word *fa*, which Western critics have translated as "principles" or "canons," but which literally means "methods." His famous six methods are: (1) *Ch'i Yuen Sheng Tung; sheng-tung* means "lively movement" and is a result of Ch'i Yuen. (2) Using the brush in the bone manner (see Part 3). (3) Sketching form from nature. (4) Coloring according to various categories, such as warm (red, yellow, orange) or cold (green, blue, purple). (5) Composition. (6) Tracing or copying.† The Six Methods became sacred rules and no one dared to challenge them until close to the end of the Ming dynasty.

These rules went unquestioned partly due to the powerful influence of Sung artist-scholar Kuo Juo-Hsu (*c.* 11th cent.). In his book, *Record of Viewed Paintings,* some 600 years after Hsieh Ho first stated his views, Kuo wrote:

> The authoritative statement of the Six Methods stands and lasts forever. However, the five methods are like the bone method, which can be learned; but, the first, however, is innate, and it cannot be attained by effort, nor can it be acquired by time—months or years.[16]

---

*Hsieh Ho was a well known painter of the Southern Ch'i period (5th cent.).

†Often, particularly in 20th century books, such as in the *Series of Art Books* by Hwang Pin-Hung, published in Shanghai in the 1930's, one comes across the incorrect term for Hsieh Ho's sixth method. It is written as Chuan-Yi-Mo-Hsieh, which means to transfer a master design to one's paper and imitate or copy it exactly. Instead, Hsieh Ho's sixth method is Chuan-Mo-Yi-Hsieh as printed in *Famous Paintings Through the Dynasties* by Chang Yan-Yuan (7th cent.). See page 51 in the reprint of this book published by the Taiwan Commercial Press in 1971. Chuan-Mo-Yi-Hsieh means to use a draft merely as a guide. One does not blindly follow the draft but alters the composition to suit one's own perception of the subject; here there is room for creativity.

Ironically, people blindly followed every word Kuo said for another 600 years, until the 17th century, when a famous artist, Tung Ch'i-Chang voiced the first note of doubt in his book *Principles of Painting*:

> With respect to the Six Methods, Ch'i Yuen Sheng Tung, the first, is an instinctive talent, which cannot be achieved by learning. But, to a certain extent, it may be learned. To read ten thousand books, and travel ten thousand miles . . . then, whatever you paint, the landscape will be a lively and inspiring one.[17]

Although in the first half of the statement Tung passively echoed Kuo's doctrine, he did offer some hope for students to reach Ch'i Yuen by reading and travelling. Of course, the purpose of reading is to enrich one's knowledge, and travelling to enhance the power of observation.

In my opinion, the trouble with most Chinese artists in the past is that they admired the old masters so much that they religiously obeyed their rules without any question. I hold a quite different attitude towards the so-called established Six Methods. I believe:

(1) Ch'i Yuen is the lively spirit of a piece of art work. It is a result, NOT a method, and thus should not be included among the methods. It would have been more logical if Hsieh Ho had listed Ch'i Yuen as the first criterion for judging or appreciating art, and had listed the other five as instrumental in achieving Ch'i Yuen.

(2) The Sixth method, Chuan Mo Yi Hsieh, deals with the technique of tracing, and it seems to me that this activity should not be included among methods of painting, but rather belongs to a general discussion of procedures preliminary to painting, such as washing the brushes, mixing pigments, mounting the paper, etc. However, before the Southern-Northern Dynasties period (280-581), the time in which Hsieh Ho lived, figure form, such as the Buddhist images or general portraits, was the prevalent subject matter for artists and that is undoubtedly why Hsieh Ho included this method. In portraiture and figure painting, it is helpful to use a draft under the paper, to serve as a guide for the artist to follow but, for other subject matters, such as landscape, plants and birds, a draft is not necessary. Particularly after the Sung period (*c.* 10th cent.) when the Hsieh Yi school of painting (see Chapter 8) became popular, fewer and fewer artists relied on drafts in the execution of their paintings. Surely this sixth method should have been revised a long time ago, rather than being quoted by rote. But, even today people mechanically quote the Six Methods!

Furthermore, because artists fanatically followed Hsieh's methods, they spent too much of their time in copying the old masters' works. This decidedly curtailed the creative power of Chinese art. Perhaps, this passionate devotion to copying the masters* may well be the reason why so many Chinese artists chose to identify themselves with certain schools of art instead of searching for their own individual identity in the art world. In principle, copying and tracing are useful for beginners; the danger is that like addiction to drugs, once the habit is formed, it is difficult to shed. Rather, students should be encouraged to keep away from Hsieh Ho's sixth method.

(3) With respect to the remaining four methods, their sequence ought to be changed with composition coming first, since the act of painting must begin with composition. Moreover, effective composition is of prime importance and is more difficult to obtain than bone treatment of line or proper color, which can be taught and mastered.

Ch'i Yuen is indeed of paramount importance as far as artistic quality is concerned. With it, a

---

* This accounts for the fact that there are so many forgeries of leading artists' works in the Oriental art market.

work of art is alive; otherwise, dead. Every painter can do a portrait, but to bring alive the personality of the subject is not easy. Every painter can paint flowers, but not everyone can show their liveliness. All artists can paint landscape but very few can depict its spiritual quality vividly. It is the very qualities of life, spirit, and vivid movement that create Ch'i Yuen.

T'ang Chih-Ch'i, an artist and critic of the late Ming period (*c.* 17th cent.), in his treatise *A Humble Statement on the Art of Painting*, stated:

> There is the atmospheric effect created by brushwork, ink, and color; there is also the effect of forcefulness created by movement, style and inspiration. The quality of Yuen exists in the above factors.[18]

Of course, the effect of Ch'i Yuen rests on the correct use of brushwork as well as ink and color. This can be methodically explained to, and learned by, a student. It is regrettable that more than 600 years elapsed before anyone dared to challenge Kuo Juo-Hsu's dictum that the Ch'i Yuen quality comes only through instinct and cannot be acquired by learning.

Competent control of brushwork and proper use of ink will result in a lively atmospheric effect in a painting, and this vigorous Ch'i will hold the entire composition together in a harmonious unity.

The reproduction of the painting *Bottle Gourd Vine* (Fig. 69) by Wu Ch'ang-Shuo (1842-1927), illustrates well the quality of Ch'i Yuen in painting and calligraphy.\* Here, the effect of rhythmic vitality is achieved by a combination of animated lines and harmonious ink tone. It is evident that the whole piece was finished in one breath. With the Ch'i, or moving force, and the Yuen, or harmonious tone, the painting is thus endowed with life. In the Chinese art world, it is generally accepted that Wu Ch'ang-Shuo's paintings are most successful in capturing Ch'i Yuen.

His work is so highly individual that one can recognize his identity almost at a glance. His style is marked by bold, strong and harmonious brushwork, especially by the Stone Drum characteristics of his strokes (see Fig. 17).

The composition of *Gourd* starts from the upper right, with the brush turning and folding all the way towards the lower left and forming an S-shaped action line, which is the backbone of the entire picture.

Notice the spiral calligraphic lines that depict the vines and tendrils—exaggerated, but quite effective. Furthermore, the dancing lines also mold the space surrounding the positive forms, *i.e.*, the gourds and the leaves, so that the negative space, the white paper, is no longer an empty background. In other words, the whole paper is filled up by the atmospheric Ch'i, and the positive and the negative spaces are complementary to each other.

The ink also plays a crucial role. Notice that the dark lines on the gray leaves are spreading and running, which produces a watery effect, a sign of freshness and vitality. All the lines and the ink wash are fused into an harmonious unit, hence the wonderful Ch'i Yuen expression.

---

\*The long line of writing on the right consists of a poem. The meaning: "Gourd, Gourd, you serve the purpose; cut into half as a big cup, I got drunk in my humble studio." Followed by "Lao Foou," his pen name, and the words, "after Tien Ch'eh's Splashing Ink technique." (Hsu Tien-Ch'eh, 1521-93, was a famous Ming master.) The writing on the upper left is also a remark by the artist. It says: "I bought Miao master's Ching Hung Hsuan quality ink, and painted this for covering my wall, Foou, 81 years of age, in Kia-Tze (the year), new autumn."

# YA AND SU

*Ya* and *Su* are two of the principal criteria to be used in measuring and judging the quality of an art work—whether it is a good piece or a failure.

*Ya* literally means "elegant," "noble," and "refined," whereas *su* is "vulgar," "ostentatious," "artificial." These two terms refer mainly to the style and taste of a work of art. If a work is shallow in thought, if it is stereotyped, if it is brash, if it lacks harmony, it is Su. No matter how skillfully executed the writing or painting may be, if the work shows a Su flavor, it is deemed to lack artistic value, and certainly would not be collected by a museum. On the other hand, an inspired artist presenting his idea with honesty and sincerity will probably produce a Ya work, whether it be a large ambitious undertaking or a small piece composed merely of a few bold strokes. The Ya or Su quality of an art work certainly reflects the artist's propensities and his inner character.

China until recent times was mainly a rural society in which education was the privilege of a relatively few people out of its vast population, usually the sons and, at times, the daughters, of the upper class families. The Civil Service examinations, open to males, from which the political elite emerged, stressed as did the private tutors, a classical education, which included Confucian teachings, the *Book of Rites*, poetry, calligraphy, etc. This system standardized the curriculum throughout China and was the only path for people with talent and ability to move up in society. Thus, with a standardized education, covering ethics and philosophy, based on standardized textbooks, it is not surprising that there would be a consensus on the part of those educated as to what constituted good taste. Thus, the scholars came to dominate Chinese art.

It has been generally recognized that the major pitfall an artist should guard against is Su. In order to attain the quality of Ya, it is first necessary to get rid of Su. The old masters spoke forthrightly on this.

In his treatise, *A Complete Study on Landscape*, Han Chuo of the Sung period (*c.* 11th cent.) advised:

> The shortcomings to guard against in the art of painting are many. Among them, Su is the most serious one. . . . According to the old masters, there are three defects in using the brush: (1) *Ban*; (2) *K'o*; (3) *Chieh*. Ban means that the wrist is too weak to control the brush; therefore, the object painted shows a flatness and stiffness, not a three-dimensional roundness. K'o refers to the harsh appearance of the brushwork; the rhythm is choppy, and the lines and marks are chaotic, irregular, and angular. Chieh describes the result of an awkward movement of the brushwork, sluggish, tight, so cramped that it can hardly flow.[19]

An artist who wishes his work to be refined, or Ya, must keep himself from falling into these mistakes so as to avoid sloppiness or Su. Flatness will result in dullness; harshness is not harmonious; and, sluggishness looks clumsy; therefore, Ban, K'o, and Chieh are elements of Su to be shunned in brushwork, and should be corrected.

Hwang Kung-Wang, one of the outstanding masters of the Yuan dynasty (1269-1354), in his book *Secrets in Painting Landscapes*, in discussing the defects in painting stated: "The four errors: *Hsieh* [unorthodox], *Tien* [too sweet], *Su* [vulgar] and *Lai* [without creative ability, thus dependent on slavish imitation] should be avoided in painting."[20]

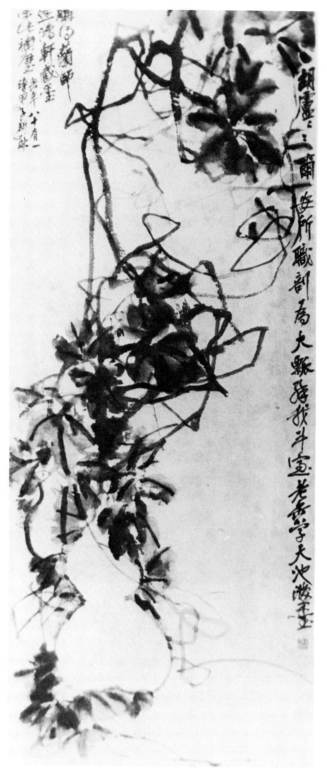

*Figure 69. Bottle Gourd Vine,* by
Wu Ch'ang-Shuo.

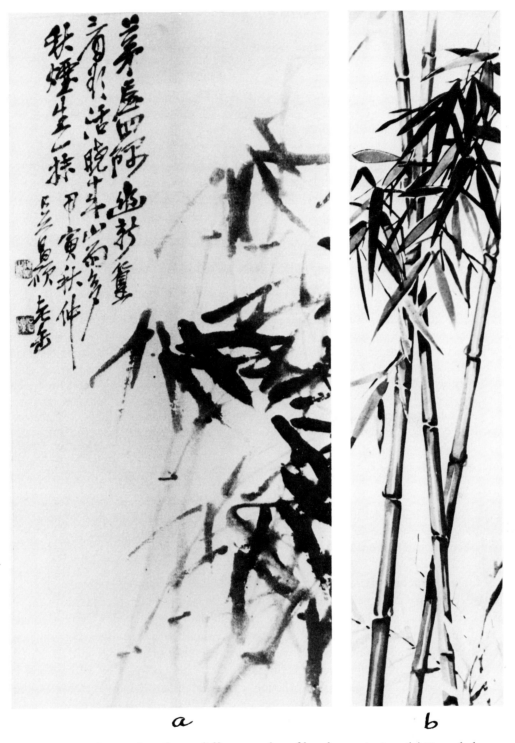

<div align="center">*a*            *b*</div>

*Figure 70.* Examples of two different styles of bamboo painting. *(a)* Ya style by Wu Ch'ang-Shuo; *(b)* Su style by an anonymous artist.

Another artist, Wang Fu of the Ming period (*c.* 16th cent.), explained these four words as follows:

> Hsieh: sloppy brushwork, unnecessary details, ignoring the light and dark, ambiguity. Tien: there is structure, but a lack of inspiration; the more labored the work, the lower the taste. Su: loud color with no harmony. Lai: dependence upon others, *i.e.*, to copy or imitate others.[21]

Lack of sufficient training in the necessary principles and techniques in brushwork will result in chaos. However, to pay attention only to technique, neglecting thoughts and ideas of artistic expression, can only make an artist a technician; therefore, his art will be limited merely to skill, and the product is bound to be vulgar and too sugary. To dazzle with bright red and strong green in composition may be striking, but it will lack harmony, and likely to be Su. If one forms a habit of imitating others, he soon loses his own identity.

A well known artist of the Ch'ing period (18th cent.), Shen Tsung-Chian, in his book, *A Compilation of Learning How to Paint,* commented:

> There are about five things that make someone's work Su: (1) In style: the composition is planar, and repeated over and over again. (2) In harmony: if in a black ink painting, there are only patches of white and black scattered shapes, there is lack of interesting brushwork. (3) In atmosphere: the brushwork is too congested, and the color tone is muddy. (4) In brushwork: to learn from a Su or bad teacher, ignorant about the old masters' methods, and to punish the brush making it dry and stiff, and deliberately trying to shock people with a weird style. (5) In composition: instead of using some good subject matter such as famous or popular stories, to use only those subjects calculated to flatter or please people, or those without poetic taste.[22]

He added:

> Ya can only be captured when Su is abandoned. Therefore, under certain conditions one is not fit to paint, such as: those who have lost their child-like heart; those who are chasing money and profit; those who want to flatter others, and those who are lazy and not hard workers; the above are steeped in Su, and far from Ya.[23]

Some of these aesthetic criteria, such as the selection of proper themes, do not always hold true, for these are, of course, influenced and affected by the social and ethical standards of succeeding generations. However, one point is clear: Ya and Su are a product of a certain educational background, higher and lower education respectively. Without a sound education which teaches politeness, modesty, thoughtfulness, harmony, elegance, etc., the Ya quality is hard to achieve.

The painting shown in Figure 70a is a reproduction of bamboo by Wu Ch'ang-Shuo (1842-1927); Figure 70b is the cover piece of a greeting card from Hong Kong. They are on the same subject matter, yet, the difference between them is so obvious that anyone can tell immediately that they belong to two entirely different artistic worlds—Ya and Su.

The commercial picture was reproduced in natural color, green bamboo against blue sky. The structure of this plant is almost anatomically correct, yet it is less alive than the other. Figure 70a, however, was done only in black and white, and the structure of this plant is by no means accurate; in fact, the brush strokes are indeed very sketchy, apparently done in a great hurry. True, they were, just as the Hsieh Yi school of painting advocates—the entire work should be finished while

*Figure 71. Broom and Dustpan,* by Kwo Da-Wei. Collection, Princeton Art Museum, Princeton, N.J.

all the strokes are still moist, otherwise, the blending oneness will be broken, and, more important, so will be the Ch'i.

The few columns at the left apex are a poem by the artist about bamboo in the spring rain. The calligraphy and his seal are so placed as to balance the heavy black color of his painting.

Notice that the lines of the writing are in harmony with those of the bamboo stems and leaves, and so achieve a feeling of unity. One can spend a long time examining this piece of art, and enjoy coming back to see it again and again. But the interest of the other piece is certainly not a lasting one.

Traditionally, artists are likely to choose propitious themes for their painting, such as a peony to signify prosperity, and other such good luck symbols. Things like a dirty dust-pan are generally referred to as ugly objects, and usually never inspire an artist's attention.

During World War II, while I was teaching at the Kiang-Si Art Institute, I got an inspiration from seeing a broom and dust-pan. I immediately made a composition (see Fig. 71).

The handle of the broom was painted with center brush; its brush portion was painted with a split brush; the texture of the bamboo slats in the dustpan was also done by dry brush. After the War, I sent this painting to my teacher Ch'i Pai-Shih for his criticism. Ch'i liked it very much and added his comment on this work. It runs: "Pai-Shih did a similar theme for the College of Fine Arts of Peking last year; in comparison with this piece, mine is inferior from this Ya quality which is achieved by only a few strokes. My pupil Dai-Seng [my pen name] must believe in these words. 90 years of age Pai-Shih."

Natural ugliness can be artistically beautiful. The scope of selection of subject matter is really unlimited. The Ya flavor lies in the quality of the brushwork, not in subject matter.

# SHENG AND SHU

*Sheng* and *Shu* literally refer to food; *Sheng* is the quality of food in its natural, raw, or uncooked state, while *Shu* is applied to food upon ripening, maturing, or after having been cooked. In Chinese art these words are often utilized to describe the manner of brushwork, whether spontaneous and natural, as opposed to studied, formal, and well polished. These are descriptive criteria, rather than values applied in order to judge artistic merit.

A Shu painting can be compared, as it were, to a person who is well dressed, well polished, very polite, always with a smile on his face, in other words urbane; as a rule, this kind of painting, highly decorative, is quite salable. On the other hand, in a Sheng calligraphy, the expression is straightforwardly serious and strong, usually with a distinct, individualized identity, with raw edges; the artist will continue in this style whether people like it or not.

Ku Ning-Yuan of the Ming period (*c.* 15th cent.) in his treatise *A Guide to the Art of Painting* stated: "Artists of the Yuan dynasty [1260-1368] were Sheng in using the brush, Chuo* in planning the composition; consequently, profoundly significant."[24]

Indeed, most of the Yuan painters were followers of the early Sung masters (10th cent.), as were Li Cheng, Fan Kuan, Tung Yuan, Chu Jan, Kuan Tung, and Ching Hao. None of the works of these great masters were Tien, "sweet"; neither were they Shu, "overcooked," or too dextrous or polished. Their works, on the whole, are spontaneous, straightforward, Sheng, "raw," or "natural," so to speak. Regarding planning, they were meticulous about their composition. None of them was commercially-minded, and therefore they were Chuo. A Chuo work is usually imbued with a profound meaning and a lasting attraction.

Tung Ch'i-Chang, the later Ming master (16th-17th cent.), also discussed Sheng and Shu in his essay, *The Essence of Painting*:

> Painting and calligraphy have their own domain. Calligraphy may be Sheng; however, painting cannot be anything but Shu. The Sheng quality of calligraphy is beyond Shu [the sophistication of Shu], but the art of painting should be more Shu than Shu [the quintessence of Shu].[25]

The above statement, in my opinion, is erroneous. Calligraphy should be Sheng, yes. Then, it follows that painting also should be Sheng. Why? Because calligraphy and painting share the same philosophy and techniques. The only difference between them is that of form: calligraphy is abstract while Chinese painting employs recognizable shapes. If Tung were right, then, all paintings, since they possessed the very essence of Shu, would degenerate into being too decorative, too sweet, too charming, and, therefore, Su or vulgar.

Figure 72 is a reproduction of a landscape by Wang Yuan-Ch'i (1642-1715). The three characters in the sky read *Tze-Chiu pi*, meaning "in the style of Tze Chiu" (Hwang Kung-Wang's pen name), who was considered one of the four outstanding artists of the Yuan dynasty (1260-1368). On the left of the inscription is Wang Yuan-Ch'i's seal, his name, indicating that he was copying Hwang's painting. It is indeed a very close copy, and may fool even an expert. This illustration supports Ku Ning-Yuan's statement quoted above. The flavor is Sheng; the power conveyed by the combination of line, design and texture results in the Ch'i sought by all Chinese artists. The

---

*See pp. 86, 87 ff. If a painter is "Chuo," he cannot be Shu.

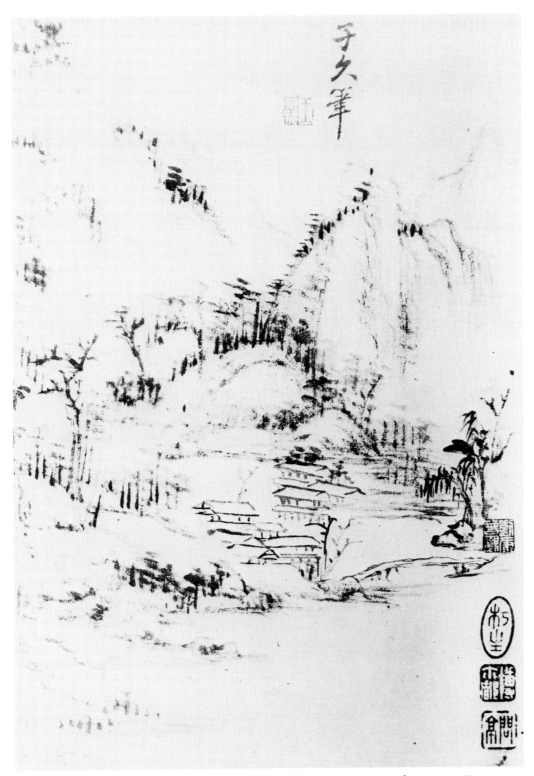

*Figure 72. Landscape,* by Wang Yuan-Ch'i: copied from a painting by Hwang Kung-Wang [Tze Chiu]. Illustrative of Sheng.

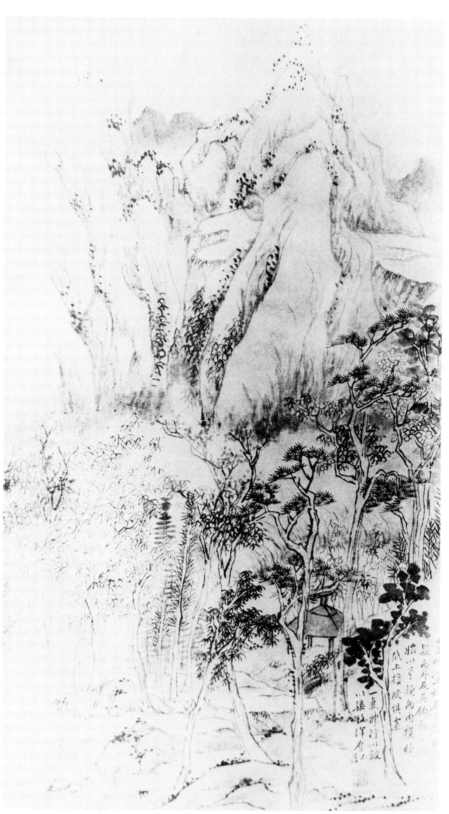

*Figure 73. Landscape,* by Chang Tseh-Ning. Illustrative of Shu.

seals on the lower right corner are those of three collectors. In Figure 43, the calligraphy by Hsu Wei is Sheng, noticeable in its heavy, bony, angular and straightforward expression.

Figure 73, also a landscape, is a reproduction from a painting by Chang Tseh-Ning of the 19th century. It is obviously by a competent hand. Its style, graceful in appearance, rich in content; the statement of each part of the composition is clear. Although more people would probably prefer to live with this kind of agreeable work, purely from an art critic's point of view, no matter how charming it is, it is too well done, and, therefore, it is Shu. It is not strong enough to be identified as a great work. The chances are nine out of ten that a Shu work will be feeble. It takes a tremendous effort to reach perfection and at the same time to be Shu. Figure 103 illustrates this accomplishment in painting; Figure 51 in calligraphy. Shu should not be considered the ultimate in excellence. Sheng may help an artist to discover a much broader road to the higher and deeper goals in the domain of art.

Figure 74 demonstrates the difference between Sheng and Shu in calligraphy. The style of writing is Kai, or type. The example on the right is by Liu Kung-Ch'uan of the early T'ang period (7th cent.); the one on the left is by Chao Meng-Fu of the early Yuan dynasty (13th cent.). Both of them were excellent calligraphers. However, their styles are quite different.

Chao's facility for diplomacy has already been mentioned. His writing style is fluid; the strokes are smooth, swaying, not angular. His lines linger at their ends; there is a trace of an "S" curve even in his straight lines. These are the qualities of Shu.

*Figure 74.* Two examples of Kai style. *(a)* by Chao Meng-Fu, illustrates qualities of Shu; *(b)* by Liu Kung-Ch'un, illustrates qualities of Sheng.

Liu, on the other hand, known for his high fidelity, a person who would never compromise his own basic principles, shows in his style a most definite, clear-cut, bony quality; above all, not "well cooked" and not smooth at all. Note the firm, angular shoulders, the cuneiform shapes. These mark the very quality of Sheng.

To be Shu is not necessarily a drawback; however, from an artistic angle, Sheng is much more expressive as far as aesthetic evaluation is concerned.

## CHIAO AND CHUO

*Chiao* and *Chuo* are two terms constantly employed in art criticism.

In its daily connotation, *chiao* means "dexterous" and "clever". Anyone who is good at doing things, especially with his hands, fixing a carburetor, picking up a new cooking technique, or learning to sew quickly, will be praised as being Chiao. However, in fine art, the term is not a compliment. It is applied usually to works which exhibit merely technical achievement but lack depth of meaning. Although the work may be skillful and clever, it is considered to be of low taste for its artificiality and showiness. A work of this type often tends to be too pretty or too well polished in its technique and, therefore, held to be merely a decorative piece. Since it is essentially superficial, it would not be considered of museum quality.

Chuo literally means "awkwardness." It is usually a derogatory term applied to something which is ugly, to someone who is slow in thinking or clumsy in action. In art, however, Chuo is held to be the opposite of sophistication and artificiality, namely, Chiao. Chuo is usually coupled with the word, Ch'ui, meaning interesting or delightful; Chuo Ch'ui is considered a rare quality in art, precious and difficult to attain. It often reflects the child-like spontaneity to be found in the paintings of Rouault and Chagall. Chuo may be found in gay and witty paintings as well as in serious and profound pieces. The value of Chuo lies in the lasting excitement which it generates in the viewer, in contrast to the transitory appeal of a Chiao work. Chuo quality is often found in a Hsieh Yi painting (see chapter 8), because of the economy of strokes used in such works. (See Figs. 76, 82, 86, 151)

In the latter part of the Ming dynasty (16th cent.) the famous calligrapher Fu Ching-Chu, commenting on the aesthetic quality of Chinese calligraphy, said: "Rather be Chuo [clumsy] than Chiao [clever]; rather be ugly than charming; rather be segmented than slippery and weightless; rather be spontaneous than elaborative."

I could not agree more with Fu in the elucidation of the true meaning of these two terms—Chiao and Chuo; the former is the result of labored effort, the latter, effortless and thus natural.

In the 18th century, the artist Wang Kai stated: ". . . in order to be free and without rules, one has to master all the rules; if one wishes to paint in an easy way effectively, he should go through the difficult training."[26]

The contemporary artist and art critic Fu Pao-Shih in commenting on Wang Kai's statement, endorsed Wang's viewpoint and added an illustration to show the route of how a successful work of art is developed:

(1) Unlikeness → (2) Likeness → (3) Unlikeness[27]

The first stage, "Unlikeness," represents a student who cannot depict successfully the likeness of his subject, as in a portrait, but after long study, he finally reaches the second stage where he is able to

do a "likeness." However, this is not the answer to being an effective artist, for likeness is only a passive copy of nature. Stage two, in fact, is merely a stage of transition, but, unfortunately, too many students mistake this stage as the final goal of artistic achievement. Instead, at this point, with full understanding of his subject, and with complete mastery of technique, an artist can move one step upward, *i.e.*, he can enter the realm of creation, where once again he produces an "unlikeness," but at this stage his work will have the real quality of art. At stage three, his work will be mature, profound, highly individualized, quite different from a photographic rendition.

It may be granted that in the visible world there is a manifest reality grasped by the mass of humanity through the senses. But there exists also a rarer type of reality, namely the artist's comprehension and distillation of that reality, attained by his intuition. It is this which he tries to convey in his creation. Between the two concepts lies a difference, which, perhaps, could well be called perceptual distance.

This perceptual distance must be present to attain Chuo. However, the perception must embody the element of truth; not only must the form convey the essence of reality but also the fact that the artist remained true to his vision—he painted what he saw without modifying that perception to please the critics, his peers, or his public. Any such posturing will incur the label of Chiao.

In calligraphy, also, perceptual distance is an important element, for artistic calligraphy cannot be stereotyped. Rather, it never ceases to surprise the reader with new variations of form. Such calligraphy is more often Chuo.

Figure 75 is an example of calligraphy by a highly creative calligrapher Ho Shao-Chi of the 19th century. The two large characters *yuen yu*, "cloud" and "rain", were written by Ho; and the small characters flanked on the left and right sides are in the Hsing-Kai and Hsing-Tsao styles respectively, which are written in the normal manner of composition. Notice how much that artist has distorted and exaggerated the structure and the form of lines. This clearly shows perceptual distance. Almost each stroke and each dot is creative, which is far away from the traditional style. Although his writing seems like doodling, yet, his solid foundation in classical training, such as the Chuan and Li styles, is clearly evident. The same situation is true with Picasso's carefree line drawings.

*Figure 75.* Hsing style calligraphy, by Ho Shao-Chi.

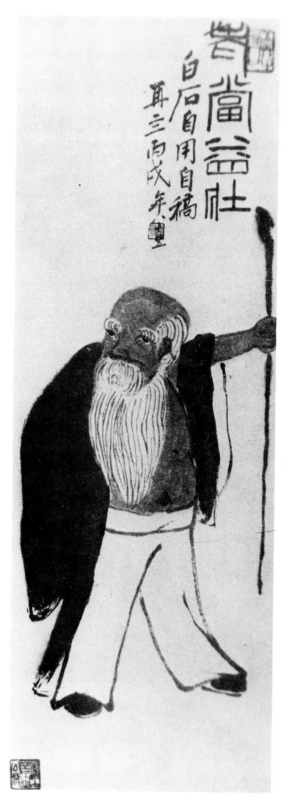

*Figure 76. The Aged Should Be Stronger,* by Ch'i Pai-Shih.

Among all the contemporary artists, Ch'i Pai-Shih is outstanding for his quality of being Chuo. Figure 76, *The Aged Should be Stronger*, is a self-portrait. A look at this painting will illustrate the element of perceptual distance. Its whimsicality, its simplicity give the cryptic twinkle of Old Man Ch'i far more powerfully than an actual photograph, as he stands grasping his cane.

## SHU CHUAN CH'I OR LITERARY FLAVOR

*Shu Chuan Ch'i*, or literary flavor, indicates a style reflecting an aura of learning and refinement, literally "an atmosphere of books and volumes," and this quality has long been cherished in Chinese fine arts, such as painting and calligraphy. Shu Chuan Ch'i within a painting implies more than a reflection of literary taste. *Shu* means to write; therefore a Shu Chuan Ch'i painting must possess also a calligraphic flavor.

T'ang Hsuan Tsung, in the second reign of the T'ang dynasty (7th cent.), was the first to recognize the affinity of the three arts—painting, calligraphy, and poetry—when he praised the artist Cheng Ch'ian's achievement in these three fields. Since then, these three arts have been widely practised and linked together through the ages.

Calligraphers use poems in their writings, either some they write themselves or they quote other poets, as a component part of their compositions. Painters, likewise, include poems or poetic phrases in their paintings as part of the total composition. But, even without a poem, a painting can be Shu Chuan Ch'i when it shows poetic qualities. A great master of the Sung period, Su Tung-P'o (1036-1101), once commented on the work of the T'ang master Wang Wei, "There is a painting in his poem, and a poem in his painting."[28] This is the essence of literary flavor.

Having been influenced by Taoism, scholars through the centuries have been lovers of nature, and have sought inspiration from mountains and rivers. Meetings among literati in a rural setting have been enjoyed and cherished at all times in Chinese history. The scholar-friends drank together, painted together, and wrote poetry and calligraphy together.

In a composition, of course, as in Figure 77*, the lines used in both the painting and its accompanying calligraphy must be harmonious. In other words, a bold style of painting needs bold calligraphy; a finer composition must be matched by delicate handwriting, so as to keep the entire composition in harmony.

A calligraphy or painting with Shu Chuan Ch'i will automatically be Ya. Tsung Ping of the 5th century once said: ". . . the learned class knows and appreciates landscape."[29]

Chang Hwai, a painter of the Sung period (*c.* 11th cent.), in his article *On Painting*, stated: ". . . the inspiring quality of a landscape is usually created by those who have real talent and are mostly hermits [scholars who preferred nature to the Court]. . . . the revelation of the wonderful quality [of nature], such as the secret elements of the woods and springs, how could Su people discover and depict them."[30]

A famous painter of the early Ch'ing period named Wang Yuan-Ch'i (1642-1715) in his *Draft of*

---

*In Figure 77, "Wine Jar," painted by me in 1950 in HongKong, the three columns on the right in the upper part are a poem written by the great master Ch'i Pai-Shih; it reads: "No longer Tao and Hsieh [Tao Yuan-Ming and Hsieh Ling-Yuen were two leading poets of the Chin dynasty in the 5th cent.] exist in mankind; for whom does the fragrance come out of the mouth of the wine jar?" The lower two lines on the left: "Da-Wei my pupil's painting is excellent; I am happy to add a few words. Pai-Shih" (his seal).

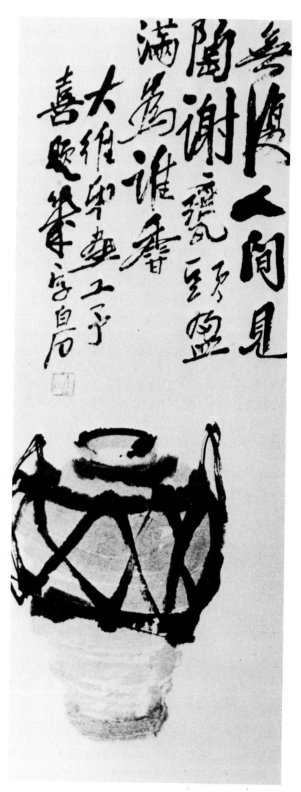

*Figure 77. Wine Jar,* by Kwo Da-Wei. Poem and calligraphy by Ch'i Pai-Shih. Collection of John B. Elliot, New York, N.Y. Notice that the shape and color of the lines of the writing are entirely compatible with those used in the upper part of the wine jar, as if they were done by the same artist. This illustrates well the close relationship between the brushwork of painting and that of calligraphy.

*Inscriptions on Paintings* stated: ". . . the art of painting is closely related with poetry and literature; therefore, only those works that possess the quality of Shu Chuan Ch'i can be considered paintings."[31]

Later, a Ch'ing painter, Sheng Ta-Shih, in his *Memoir on Landscape*, stated: ". . . there is painting by scholars; and there is painting by professional artists. The scholar's work is inspiring, although it may not be perfect; however, a career painter's work is excellent, but it may be stereotyped. Therefore, the inspired work is far better than the technically perfect works without depth."[32]

Wang and Sheng may sound too biased; however, this was the general attitude among the scholar-painters, and this attitude permeated the whole art world during the late Ming and early Ch'ing period (*c.* 17th-18th cent.). Thus, the Wen Jen school of literary painting continued to flourish. This school of painting has lasted well into the twentieth century.

Chen Shih-Tseng*, a very talented artist who died in the early 1920's, once discussed the essential elements that a Wen-Jen artist must possess: (1) Nobility of character. (2) A thorough education. (3) Talent. (4) Profound, inspiring thoughts.[33] Chen's father, Chen San-Yuan, was one of the two most celebrated contemporary poets writing in the classical style. His brothers were also famous scholars. He himself was an outstanding painter, calligrapher, poet, etcher, and seal-engraver, an important artist of the 20th century. He was one of the contemporary promoters, like Ch'i Pai-Shih, of the Wen-Jen school of painting.

However, the complete meaning of Shu Chuan Ch'i is not confined to the literary flavor in a composition. It also means the coherence that holds the whole composition in harmony. Shu Chuan Ch'i works achieve a totally balanced and harmonious expression, a blending of line and color, a continuous rhythmic flow. No work of Shu Chuan Ch'i would contain a choppy or staccato rhythm, be bold or rough in its approach, or express any violent feelings.

The painter Chiang Chi of the 19th century in his article "Secret of Vitality," said: ". . . with Shu Chuan Ch'i, there is Ch'i Yuen [rhythmic vitality]."[34]

Rhythmic vitality, in technique, is attained mainly by the continuous movement of the brushwork. The spiritual vigor of a composition is usually achieved through the completion of the work in "one breath." When one starts to write or paint, he should keep going without any hesitation, for once the continuity is interrupted, the life force is broken. Shu Chuan Ch'i represents this kind of continuous movement, and therefore is a vital element in both the execution and the critique of a piece of art, painting or calligraphy.

*The Grape,* a painting by Wu Ch'ang-Shuo (Fig. 78), illustrates best the two-fold meaning of Shu Chuan Ch'i: (1) Scholarly quality. (2) Calligraphic harmony. Traditionally, works with scholarly flavor are more highly regarded by connoisseurs.

Wu Ch'ang-Shuo was an outstanding Confucian scholar, which explains his deep Shu Chuan, or literary flavor. He was also a well known calligrapher specializing in the Stone Drum style, which is another factor contributing to the calligraphic quality of his painting. And, since *The Grape* was executed in one breath, in the manner of the Mad Grass calligraphic style, coupled with

---

*Chen Shih-Tseng, as a young artist, convinced Ch'i Pai-Shih, at the age of sixty, to change his style of painting, to become liberated from his painstaking technique and go in a free, creative direction. Ch'i took the advice of his much younger friend and became famous as a Hsieh Yi artist (writing-the-idea painting; see chapter 8). Chen promoted Ch'i's work in Japan, which eventually led to his great success.

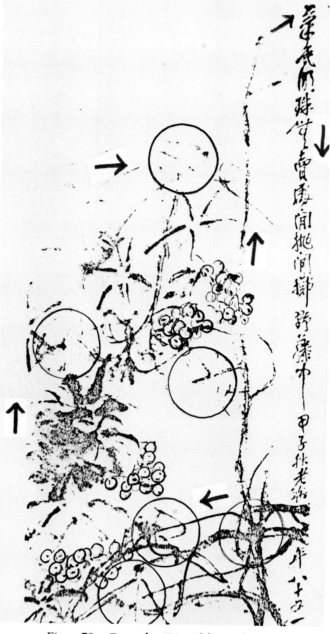

*Figure 78. Grape,* by Wu Ch'ang-Shuo.
The circles isolate calligraphic struc-
tures; the arrows indicate the move-
ment of the composition.

the fact that he inscribed his painting with a poem*, the whole painting is indeed a good blend of the three arts: painting, calligraphy and poetry.

Wu employed the Mad Grass style (see Fig. 46) in painting this vine subject. The whole composition is woven closely by spontaneous lines. Each part encircled in the illustration resembles a Tsao character (see Figs. 45a, 45b). Because of the strong Shu Chuan Ch'i revealed in this calligraphic painting, it follows that it also illustrates the quality of Ch'i Yuen, the most lively expression found in a painting. The arrows indicate the continual movement within the composition.

When one says a calligraphy shows literary taste, it means that the characters are logical in their composition— well balanced and with effective control. There is a natural flow to the lines; there is no evidence of harshness or discord. The calligraphy has a graceful and elegant air, a refined appearance, a "gentlemanly" presentation. From the structure of a word, from the shape of the lines, one can judge the person's calligraphic training. To display literary taste, one's brushwork must be perfect in its execution, but the piece cannot be a vulgar display of technique merely to show off one's mastery.

## CHUNG AND DA

Wang Kuo-Wei, the famous 19th century scholar specializing in Chinese classics, used a triad of terms, *Chung, Da,* and *Chuo,* as his measurement of excellence in evaluating literary works of the past.

Everyone is familiar with the two outstanding poets of the early T'ang period (7th cent.), Li Po and Tu Fu. One of Li's poems starts with: "Look, don't you see that the waters of the Yellow River come from heaven." The word "heaven" forces the reader to go beyond the horizon to see the river's source and, thus, effectively creates the feeling of Da. Here Li has suggested the vastness of nature and its boundless vitality.

Tu Fu had experienced the anguish and suffering of being a refugee during war time, and he fully understood the real misery of the people. Therefore, his poems are full of descriptions portraying their misfortunes, such as: "In the red gates [the homes of the rich] there is spoiled meat and wine; bones [people who died from starvation] are scattered along the roads . . ." These words force one to contemplate the grievous inhumanity of man. It is this serious expression that illustrates the quality of Chung in literature.

### *Chung*

The word *chung*, which literally means "weight" or "heavy", is used figuratively to indicate the seriousness or gravity of a piece of art.

A good example to illustrate the concept of Chung in painting is Figure 79, paintings of lotus by

---

*The column of writing reads: "There is no place to sell the pearls which are under my brush [grapes]; I throw them into the wild vines. Kia-Tze [year], Autumn, Old Foou, 81 years of age."

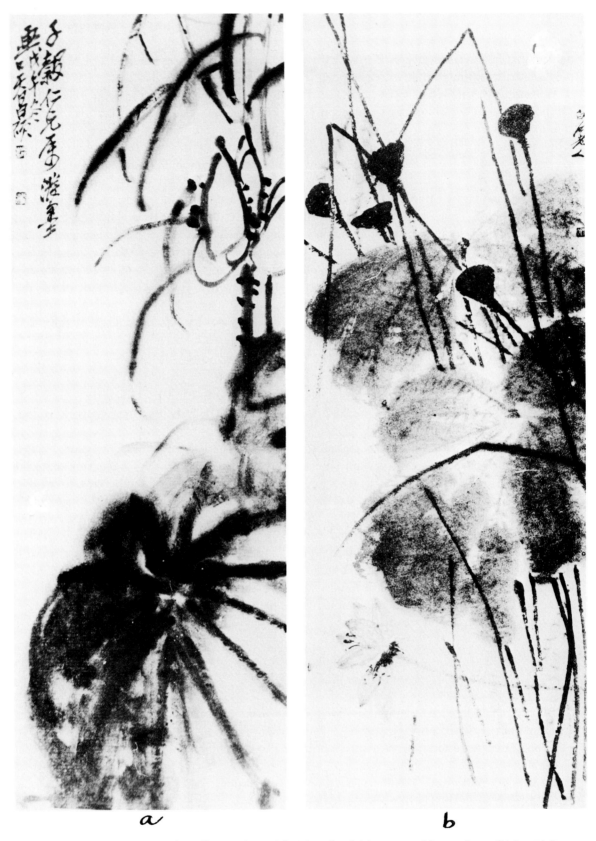

*Figure 79.* Two examples of Lotus in Hsieh-Yi style. *(a)* by Wu Ch'ang-Shuo; *(b)* by Ch'i Pai-Shih.

two leading masters of our time whose great works continue to influence modern Chinese painting. The one on the left was done by Wu Ch'ang-Shuo, and the other is by Ch'i Pai-Shih. One lotus is in blossom and the other, withered. The artists' strokes are very bold and strong and the color is heavy and solid; one cannot easily forget the powerful expression and deep feeling achieved by this strong brushwork.

The Chung quality of a piece of art can rest on the rendered form, as seen in Wu and Ch'i's works. However, this quality can be expressed also through its content or subject matter.

My painting, *Bone of Contention,* (Fig. 80) originated in the following manner. While in Hong Kong, I saw two friendly dogs, a mother and her offspring, suddenly engage in a fight over a couple of bones. I was moved and did a painting. My teacher later approved it and sent it back to me fom Peking with his comments*. In comparison with my teacher's work, this painting is not Chung enough in form, one reason being, perhaps, that I was too young and not sufficiently experienced to eliminate more details from the composition. I probably was too much involved in the anatomical structure of the subject matter and consequently neglected the importance of the solid and direct quality which a serious Chung work should possess. After twenty five years, were I to paint this subject again, I would certainly simplify the figures, modify the natural anatomy, and give more weight to the lines and colors so as to make the visual impact much stronger.

The quality of Chung can also easily be seen in the art of calligraphy. Figure 81, a good example of Dr. Tan Tsze-Chor's† handwriting, shows clearly a solemn expression which is revealed through the solid structure of the characters. As we examine this composition, we are conscious that every line and dot is well planned out and executed. The heavy look of each word is reminiscent of the grandeur of T'ang master Yen Ch'en-Ch'ing's serious expression.

The unique feature of Dr. Tan's calligraphy rests on his creative attempt at combining several styles of calligraphy in one composition, namely, Kai, Hsing, and Tsao. The result is quite refreshing and interesting. It is not at all chaotic; on the contrary, the different styles are blended very well together to achieve harmony and unity. The various forms found in the lines and dots provide an infinite source of variety which serves to maintain the enduring interest of the work.

A drama must be serious; music should be moving; and so with a painting and a calligraphy. Either form or content, or both, must carry the quality of weight and solidity, the quality of Chung. Otherwise, the life of the work of art will not be lasting.

## Da

The other quality, *da*, literally means "big," "great," or "vast." To the art critic, it refers to the dynamic expression which radiates from the rendered forms and goes beyond the limits of the composition. In other words, where Da exists, the actual composition of lines and color ends, but

---

*"The only one who paints domestic animals so remarkably is my pupil Da-Wei; if there is anyone else who can do this, I have never heard of him."

† Well known as the "Pepper Tycoon," Dr. Tan of Singapore possesses the finest private collection of Chinese arts outside of China proper, one which excels others not only in quality but also in quantity. His collection includes bronzes, jade, porcelain, pottery, seals, painting and calligraphy, all by famous artists throughout the ages. His special collection of pottery known as "Purple Sand Pot," treasured by art collectors in the East and West, is truly outstanding. He is an internationally known calligrapher, having devoted many years of study and practice to the art.

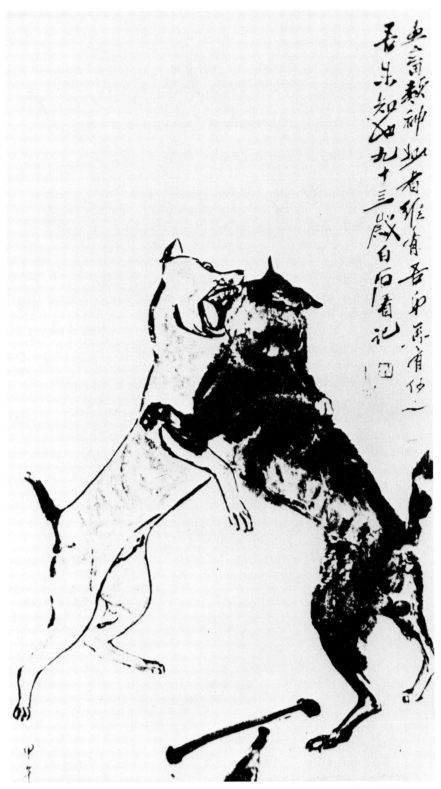

*Figure 80. Bone of Contention,* by Kwo Da-Wei. Reproduced from *Modern Chinese Painting,* by David Kwo, The Art Institute of Chicago, 1955, 18. Collection, Princeton Art Museum, Princeton, N.J.

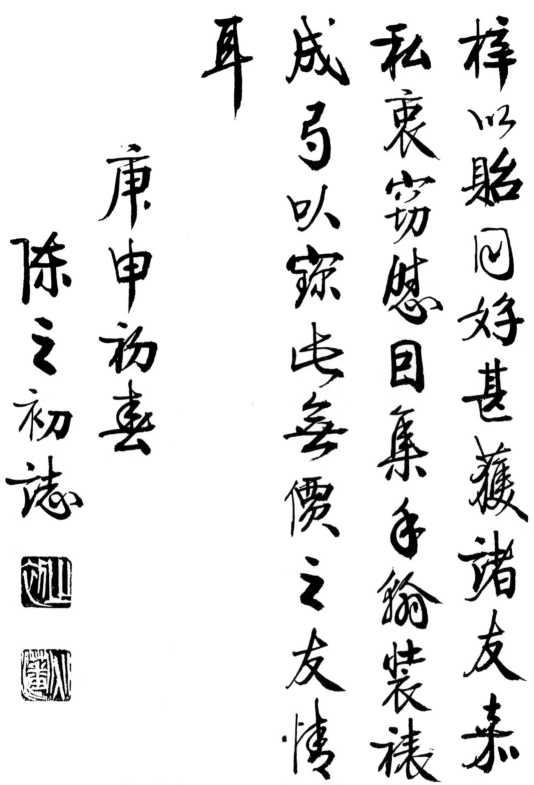

梓以貽同好甚獲諸友嘉
私衷竊感目集手翰裝裱
成弓以寐屯无負價之友情
耳
庚申初夏
陳之初誌

*Figure 81.* Calligraphy by Dr. Tan Tsze-Chor. Combination of Kai, Hsing and Tsao. Illustrative of the quality of Chung. Courtesy of Dr. Tan Tsze-Chor.

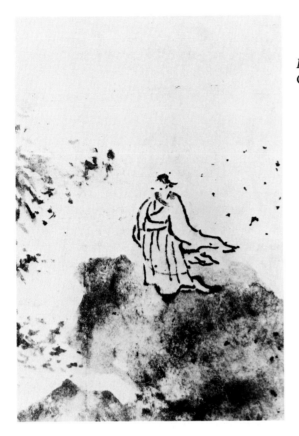

*Figure 82. Autumn Leaves,* by Hsu Tien-Ch'ih [Hsu Wei].

*Figure 83.* Examples of Mad Grass style reflecting the quality of "Da". *(a)* by Chang Hsu; *(b)* by Hwai Su.

the meaning and the expression stretch out beyond the boundary of the painting or calligraphy. It seems as if more paper or canvas were needed. A painting with the Da quality does not confine the onlooker's eyes solely to the picture, for the drama of such a work has the power to lead the viewer out to the space surrounding it. The quality of Da in Figure 79 is very evident.

An outstanding figure of the Wen Jen style is Hsu Wei (1521-1593), whose influence has been long lasting.* His *Autumn Leaves* (Fig. 82) is an excellent illustration of the concept of Da. The feeling of wind is suggested by the spontaneous dashes of lines, dots, and wash. He did not fuss in the modelling of the forms, but, rather placed importance on his brushwork and, above all, on suggesting vastness of space. The simplification of lines is used to a great extent; *e.g.*, the whole face of the scholar is indicated by only two dots for eyes, and a dry S-curve, suggesting his beard in the wind. Likewise, the entire body is gestured by just a few lines. The carefree brush strokes depicting the falling leaves and the sweeping sleeve make it seem as if the wind were a force completely outside the painting, yet filling up the entire space of the composition.

The two examples in Figure 83 are self-explanatory. If one gazes on them even for just a moment, he may subconsciously follow the movement induced by the forceful turning and rotating of the brush—the very essence of Da in calligraphy. There is an expression in Chinese art criticism associated with the quality Da, *tien ma hsing kung,* which means "heavenly horse galloping in orbit."

## BRUSHWORK AND INK

Although Westerners in the past, particularly during the Fauvist Movement in the early 1920's, did not recognize black as a color, in China, black ink, known as *Mo,* has been considered the best color, as it offers infinite gradations of color tone. Hashimoto Kansetsu, the elderly contemporary Japanese scholar, once stated: "Mo has a complexity of tonal effect which cannot be found in any Western colors."[36] Another art historian, Kosugi Misei said: "The extensive study of ink painting by the ancient Chinese and the outstanding achievements of that pursuit cannot be matched by any school of painting in any other country."[37]

Chang Yan-Yuan in his book, *Famous Paintings Through the Dynasties,* said: "It doesn't take red and green colors to make the grass and trees abounding, nor does one need white paint to portray the cloud and snow flying in the sky; . . . therefore, the effect of five colors is achieved when the black ink is properly used."[38]

Since black ink must perform the function of the whole color spectrum, the ink must be "alive," that is, the ink must show effective tonal variations. No solid ink should be used in any part of a painting in order to avoid a static area. In calligraphy, though dark ink is commonly used, it is equally essential that there be tonal effect. Since Chinese ink is a highly transparent dye, the ink work must be clear and clean so as to avoid either an opaque or muddy appearance. With colors other than black (*Ts'ai-So*), one must avoid a vulgar or strong contrast. Usually, black ink would be utilized to moderate and hold together the other hues, so that a oneness could be achieved, similar to the use of black in a stained glass window. The black ink serves as a catalyst to produce

---

*Hsu Wei painted under the name Hsu Tien-Ch'ih and Hsu Ch'ing-Teng. Cheng Ban-Chiao, a famous bamboo painter of the 18th century, admired Hsu so much that he even carved a seal, used often on his paintings, which reads: "the running dog under Hsu Ch'ing-Teng's door."[35]

the required harmony. In using colors, with the exception of non-bone technique in which no black is used, the colors should be considered "guests" and the black ink should be the "host" within the domain of color. In using either a wash technique, *Po'Mo*, or the ink-layer technique of painting, *Po Mo*, (see Chapter 15), the same criteria apply.

In evaluating brushwork, the Chinese look for economy of stroke. No greater portion of the brush should be utilized than is necessary to achieve the shape and texture desired. If one stroke is sufficient to gain an effect, why use five or three? With any unnecessary stroke, you lose freshness and spontaneity; the result looks overworked.

Ever since Hsieh Ho advocated the "bone-treatment-of-line" method, artists and critics have sought this indispensable quality in brush strokes, in order to keep the line quality strong and expressive. A strong line inevitably suggests an inner, flowing movement. There must be movement throughout a composition, achieved through the turnings and foldings of the brush. The brushwork cannot be static.

# 8 Styles in Painting and Calligraphy

## PAINTING

In order to appreciate and evaluate a Chinese painting or calligraphic work, an understanding of the major traditions in the styles of brushwork is essential.

Traditionally, Chinese painting is divided into two general categories of styles, Kung Pi and Hsieh Yi.

### Kung Pi

The word *kung* literally means "perfection"; *pi* is "brushwork". The term *kung pi* actually means "fine style," one which is painstakingly detailed, in an almost photographic approach. A Kung Pi painting may take days, weeks or even months to finish. The Chinese often describe the time-consuming effort of Kung Pi as "to finish a mountain in ten days, and a river, five." (See Fig. 84)

A student of Chinese painting usually starts his lessons with Kung Pi, for the mere reason that this forces him to analyze thoroughly the structure of what he is trying to paint. After a student has finished a painting of a fish, he will automatically have a basic understanding of its anatomy. The same result is true when undertaking a pine or a peony, etc. To be sure, before one attempts a Kung

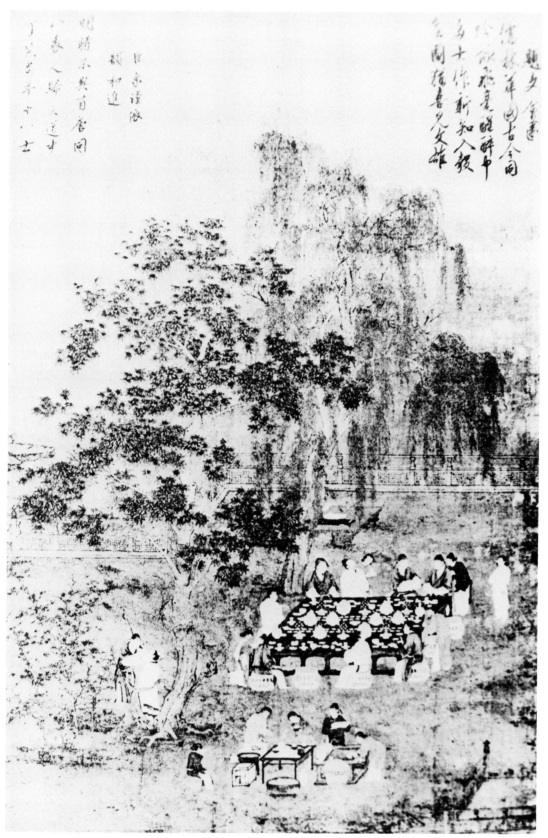

*Figure 84. A Literary Gathering,* by Emperor Hwei Tsung. Kung Pi style. Courtesy of the National Palace Museum, Taiwan, Republic of China.

*Figure 85. Lotus in One Stroke,* by Kwo Da-Wei. Reproduced from *Modern Chinese Paintings,* by David Kwo, The Art Institute of Chicago, 1955, 9. Collection of Alan Roger, London.

Pi painting, of a frog, for example, one has to make many sketches, to draw in meticulous detail the separate parts of the anatomy, and, then, to organize them into the final draft of his subject.

With respect to subject matter, Kung Pi ranges from figure forms and landscapes to flowers and birds, animals, fish, and insects.

## *Hsieh Yi*

*Hsieh* literally means "to write"; *yi* is "idea". Actually, it is painting in a simplified and free style. It was undoubtedly developed to liberate artists from the traditional Kung Pi style. The objective of Hsieh Yi is to depict as much as possible in the fewest number of bold strokes. Usually a painting in the Hsieh Yi manner can be completed in only a few seconds (as in the case of my *Lotus in One Stroke,* Fig. 85), certainly not longer than a half hour. In order to achieve a harmonious oneness, a Hsieh Yi painting has to be finished before all the strokes dry. Otherwise, the strokes will not fuse and blend together. Needless to say, to accomplish this, the artist must be a master of technique and have full knowledge of his subject matter.

Figure 86, *A Sage*, by the Sung monk Liang Kai (*c.* 1250) clearly illustrates the Hsieh Yi style. Judging from the few strokes, it must have taken him no more than a few minutes to finish this painting. The special charm of the Hsieh Yi style is that it does allow some accidental effects to occur in the brush marks, which provide surprise and excitement, and thus, in my opinion, proves more interesting than the orthodox Kung Pi style.

## *Yuan Hwa Pai or Academic Style*

Yuan Hwa Pai or the Academic style is the style developed by the court painters which varied little throughout the dynasties (see Figs. 87, 88). Han Yuan Ti (reigned 48-44 B.C.) was the first to establish an academy for painting in his court. Among his court painters, Mao Yan-Shuo was the best known artist. Sung Tai Tsu (reigned *c.* second half of 10th cent.) opened a large scale academy in his court and greatly promoted the art of painting. Six ranks were given to those who passed the entrance examination, their salaries based on skill and merit.

The Kung Pi approach was predominantly adopted by the court painters. They painted subjects dealing mostly with glorification of royal life and praise of the imperial accomplishments. Skill in handling the brush and ink was of utmost importance. Every dot and line was expected to be perfect. Most of their works were formal in appearance, rich in content, and ambitious in composition, and thus required much time for their execution.

## *Wen-Jen Hwa Pai or Literary Style*

The poet-painter Wang Wei (7th cent.) was the first painter who blended poetic taste in painting. It was the seed for the literary style of painting, called Wen Jen, the style of scholar-painters. The emphasis is laid on the expression of poetic taste, rather than the showing of technical competency.

In the Sung period (960-1279), the Wen Jen style continued to grow. Through the ages, there

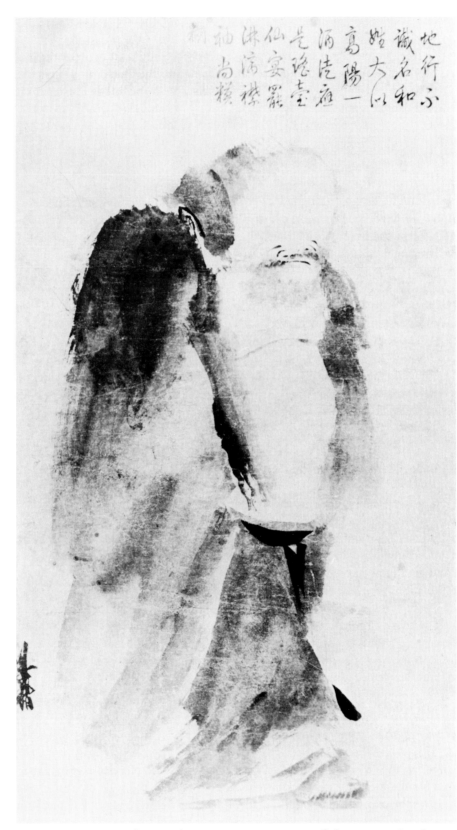

地行不識名和尚陽一洞潺庭老瑟堂仙宴罷沐滴裸袖尚横

*Figure 86.* *A Sage,* by Monk Liang Kai. Courtesy of the National Palace Museum, Taiwan, Republic of China.

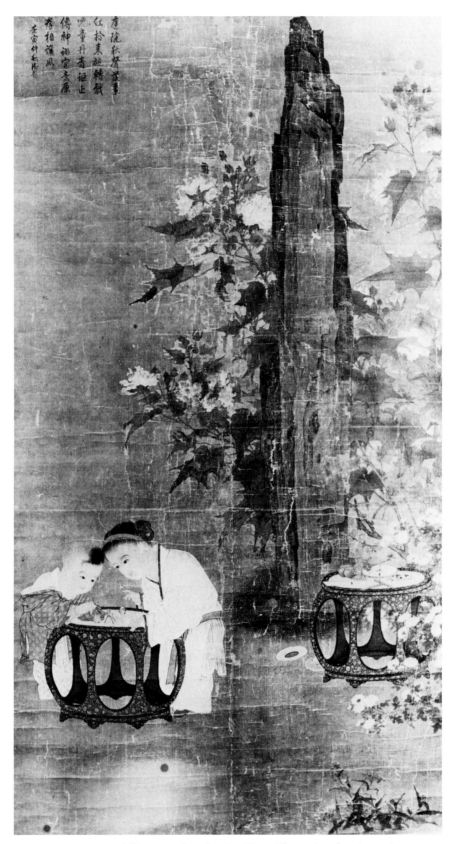

*Figure 87. Children at Play*, by Su Han-Chen. Academic style.

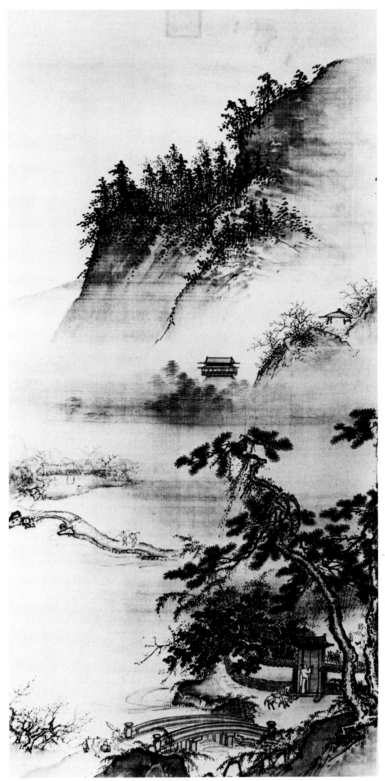

*Figure 88. Landscape,* by Tai Chin (c. 1430). Academic style. Courtesy of the National Palace Museum, Taiwan, Republic of China.

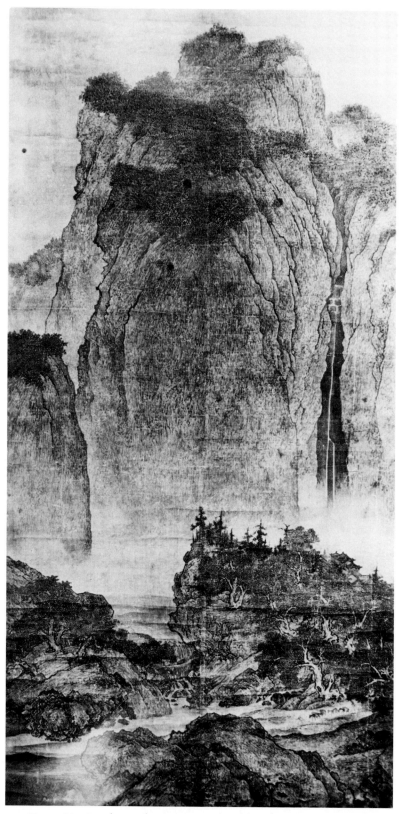

*Figure 89. Landscape,* by Fan Kuan (early 11th century). Courtesy of the National Palace Museum, Taiwan, Republic of China.

have always been artists who refused to enter into court life and shied away from the aristocratic class, so as to be completely themselves in the pursuit of their creative careers, such as Fan Kuan (early 11th cent., see Fig. 89), and Mi Fei (1051–1107), who invented the unique method of painting known as "Mi (Rice) Point." In his landscapes, Mi Fei used nothing but points or dots, no lines (see Fig. 90, in which even the gazebo is done in this manner). It was quite a break from the traditional style. These scholar-painters, however, enjoyed the same high prestige as the professionals of the Academic group.

When the Mongols seized China in 1260, the tradition of an academy at the Imperial Court was not continued. Frustrated, the scholars and professional Court artists sought solace in art. In painting, the artists turned their attention to landscapes, perhaps to avoid any subject matter that might incur political prosecution. Many intellectuals escaped from city life and retreated deep into the mountains. Thus the Wen Jen school flourished.

This style of painting is simplified and free; a vital expression is much more important than the mere rendering of form. In other words, no matter how inexactly the likeness of something is rendered, the work is considered good as long as it suggests a lively spirit. Figure 91 is an example of Shih T'ao's (1641–c.1717) work, which shows complete freedom in handling his brush. This painting was drawn to illustrate a poem by Su Tung-P'o. It is also a good illustration of the combination of poetry, calligraphy, and painting in one unit.

# CALLIGRAPHY

The styles of calligraphy may well be divided into three categories: *Kuan Ko, Shu Chia,* and *Wen Shu,* which mean respectively, academic or official, professional, secretarial.

## *Kuan Ko or Academic Style*

*Kuan* refers to institution, and *ko* indicates an office or a studio where artists work. The term Kuan Ko actually means official-writers who generally belonged to the Academy, Han Lin Yuan, composed of erudite scholars who passed the final Civil Service examination of the Palace. All Han Lin, members of the Han Lin Yuan, were high ranking officials and also excellent calligraphers. Their duties were to draft and write documents for the Emperor. Their works, usually in the form of a couplet, were in great demand. The special characteristic of this style centers around the qualities of skillful brushwork, rich in color of the ink, and perfect balance in composition. The general expression is very dignified. (See Fig. 92a)

## *Shu Chia or Professional Style*

In the Yuan (1260–1368) and Ch'ing (1644–1912) periods of foreign rule, many scholars and artists tried to find in the realm of art the political freedom which they had lost. They enjoyed this newly found artistic freedom because they were not bound by any tradition or rules of the Court. This free spirit can be seen in the example of calligraphy by Wu Jang-Chih (*c.* 18th cent.) in Figure 92b.

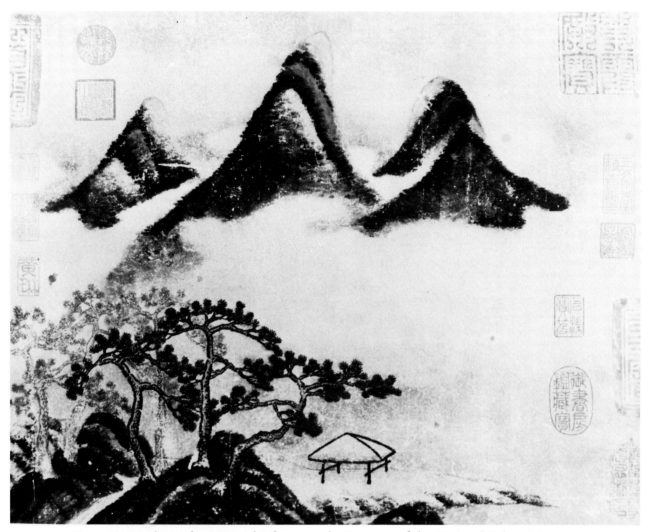

*Figure 90. Landscape,* by Mi Fei (11th century). Courtesy of the National Palace Museum, Taiwan, Republic of China.

Note that the vertical and horizontal lines are not at all rigid in composition, yet, the feeling of unity is still maintained. The two examples represent equal technical competence.

Many calligraphers who refused to tailor their style to commercial or Court needs and who preferred to work independently strove to develop their own styles, just as creative artists do. These are the professional artists of the past and the present, whose calligraphy falls into the category of fine art. Generally, each artist specializes in a particular, traditional style but amends its characteristics in his own fashion, and the style in fact identifies him. For example, in the twentieth century, Tung Tsuo-Pin specialized in the Shell and Bone style (see Fig. 9); Wu Ch'ang-Shuo in Stone Drum (see Fig. 18); others in Kai, Hsing or Mad Grass, etc.

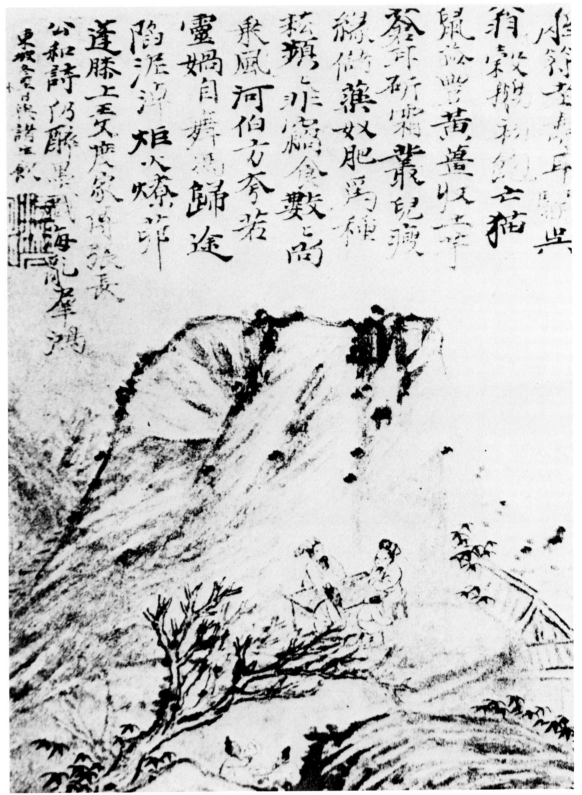

*Figure 91. Wine Party*, by Shih T'ao (17th century). Wen Jen style.

*Figure 92.* Examples of Hsing-Kai style. *(a)* academic style by Lin Tso-Hsu; *(b)* free style by Wu Jang-Chih.

## *Wen Shu or Secretarial Style*

Today, as in the past, competent calligraphers are to be found in offices as secretaries, inscribing the correspondence and official documents of business, and they are frequently called upon to prepare citations and other ceremonial pieces for celebrations, anniversaries, condolences, etc. Commercial advertisers, printers, publishers, etc. also need well qualified calligraphers. The type of calligraphy involved is usually very neat, stylized, and quite decorative for the sake of popular appeal.

## A SURVEY OF STYLES

In ancient times, art served merely as a tool for political and religious propaganda. The portraits of rulers, heroes, etc., and stories illustrating ethical standards, such as filial piety, were used to inculcate moral conduct and loyalty to the rulers. Most major works of art—for example the frescoes in the tombs, caves, and temples—were undoubtedly collectively done. Not until the Han dynasty (206 B.C.-220 A.D.) did the names of distinct artists emerge: art then began to become an

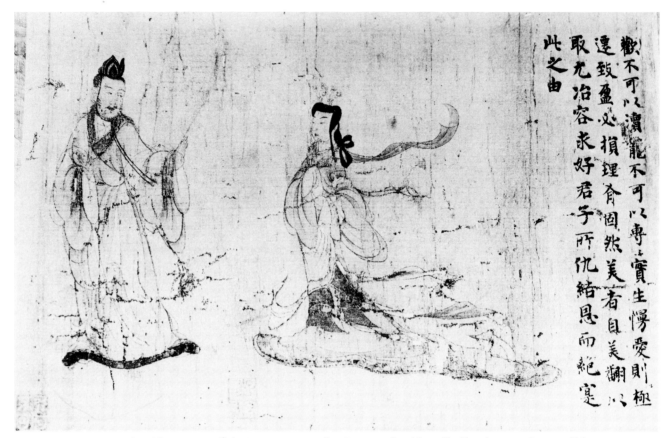

*Figure 93. Admonitions of the Instructress to the Court Ladies* (detail): "Didactic Themes," by Ku K'ai-Chih (4th century). Courtesy of the British Museum, London.

individual effort. Among the famous early names, Mao Yan-Shou was already a well known painter by the time Wu-Ti (reigned 141-87 B.C.) established an Art Bureau, and hired many artists. During the same period, Chang Chih earned fame through his calligraphy, in the Chang Tsao style of writing.

Between the 3rd and the 6th centuries, when Buddhism was prevalent, religious art predominated. Both painting and calligraphy served as a tool for promoting Buddhism: in paintings, the themes emphasized the scriptures; in calligraphy, the copying of Buddhist manuscripts was the primary occupation. In this period, the brushwork was never freed from the bondage of the traditional rules.

Thus, before the T'ang period (7th cent.), art in China served mainly as a medium to promote didactic ends. An example is the *Admonition of the Instructress to the Court Ladies* (Fig. 93) by Ku K'ai-Chih (334-406), which was intended to teach young ladies how to serve their masters. Some paintings exemplified Confucian ethics, while others dealt with Court life and religious themes.

During the T'ang period, artists began to break away from these traditional themes. With the work of Wang Wei (699-759), landscape, which had previously only served as background in

*Figure 94. Wang Chuan:* copy after Wang Wei (699–759). Landscape style, Ming Dynasty (1368–1644). Courtesy of the Seattle Art Museum.

figure paintings, became a subject in its own right. Figure 94 is a landscape by a Ming (14th–17th cent.) artist after Wang's landscape style.

Since, in these early times, most of the artists were under the patronage of the Court, the art productions were mainly for the enjoyment of the aristocratic class, and the themes glorified the luxury and opulence of this class. The art of calligraphy, too, served the same purpose, for the top calligraphers, working at the Han Lin Yuan, were writing documents or social pieces in a highly decorative style to please the Court. Figure 95 is a portrait by the court painter Yen Li-Pen (*c.* 673) which is a typical example of the court style. Figure 99 is typical of the court style in calligraphy.

However, there were some artists who did not wish to be constricted by the official life and preferred working independently, such as Wu Tao-Tze (active 725) and Chang Hsu (713–741) (see Fig. 46), who nurtured the Wen Jen, or Literary school. A liberation, in its true sense, was finally emerging in Chinese art.

In the Sung period (960–1279), the Academic, or Court style, flourished, for all the rulers were great lovers of art. Figure 96 is a fan painting in the typical Kung Pi manner, depicting a celebration of the Double Seven (July 7th) Festival. During the night, the legendary meeting of the herdsman and the spinning maid will take place when she crosses the Milky Way on a bridge formed by the magpies. The brushwork is exquisite, and the story-telling is clear. However, there is little room left for the imagination.

With respect to calligraphy, innovation was first introduced by Sung masters such as Su Tung-P'o and Hwang T'ing Chian (see Figs. 49, 39). They freed themselves from the traditional

*Figure 95.* Yen Li-Pen, *Portraits of the Emperors* (detail). Illustrative of the Court style. Courtesy of the Museum of Fine Arts, Boston, Mass.

*Figure 96. Han Palace,* by Chao Po-Chu (c. 1150). Courtesy of the National Palace Museum, Taiwan, Republic of China.

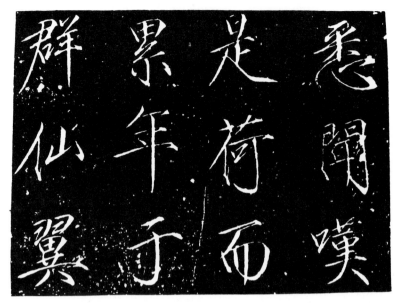

*Figure 97.* Slim Gold style by Emperor Hwei Tsung.

stylization and encouraged students of calligraphy to develop their personalized style. They themselves practiced what they preached, and calligraphers have followed their advice ever since. The outstanding painter-Emperor Hwei Tsung (reigned 1101-1125) invented a unique style of writing called *Shou Chin* (slim gold), for its slender but strong appearance, and steel-like solidity, which won many followers (see Fig. 97).

During the Yuan dynasty period of foreign rule (1260-1368), people sought comfort in art, and the Wen Jen style, in both painting and calligraphy, flourished. It was a real liberation from the traditional style. The subject matter was chiefly landscape, influenced by the Sung masters: Li Cheng, Fan Kuan, Chu Jan, Li T'ang, Ching Hao, etc. One of the four outstanding artists of this period, Ni Tsan (1301-1374), spent his lifetime travelling between mountains and rivers. His brushwork, as seen in Figure 98, shows absolute freedom; this work possesses all the virtues which a typical Wen Jen work should reflect. The expression of sentiment and thought behind the painting is far more important than showing mastery of technique.

Chao Meng-Fu (1254-1322), a leading artist, dominated the field of calligraphy during the Mongol reign. His traditional style of writing greatly satisfied the public who, under foreign dominance, missed their traditions. However, since he was such a traditionalist, his work, in my opinion, can hardly be considered creative, notwithstanding the fact that he was an accomplished artist (see Fig. 99).

Chu Yuen-Ming (1460-1530?) was inspired by the revolutionary theories of the Sung masters, and he learned much from T'ang masters like Chang Hsu and Hwai Su (see Figs. 46, 47). He became a leading calligrapher in the mid-Ming (15th-16th cent.) period. He was especially famous for his Mad Grass style.

Hsu Wei (1521-1593) was truly a giant of the Wen Jen school during this period. (See Fig. 43.) There is no trace of the old tradition either in concept or technique in his work. As he was not

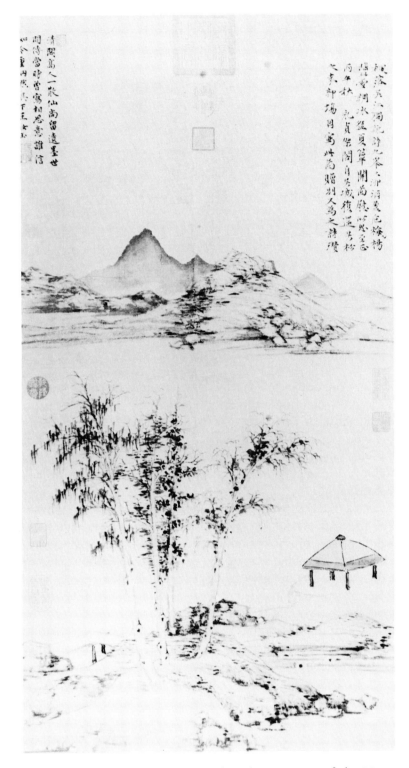

*Figure 98. Landscape,* by Ni Tsan (1363). Courtesy of the National Palace Museum, Taiwan, Republic of China.

陰闈陽闢恪守常度
集賢直學士朝列
大夫行江浙等處
儒學提舉吳興趙
孟頫書并篆額

*Figure 99.* Calligraphy by Chao Meng-Fu. Court style.

at all involved with any political or official social obligations, he could work to please himself. This, perhaps, is the secret to his being completely creative.

Chu Ta (1626-1705) and Shih T'ao (1641-1717?), supporters of the Wen Jen school, were two great stars in the art world in the late Ming and early Ch'ing time (16th-17th cent.). Ba Da Shan Jen (Chu Ta's pen name)* and Shih T'ao, both from the royal family, were friends. After the Ming dynasty fell, they both shaved off their hair and became monks, which was perhaps the best way to avoid political prosecution.

The special feature of Ba Da's work is the simplicity and forceful expression in his use of suggestive dashes of lines and dabs of dots, rather than modelled forms. On the other hand, Shih T'ao, was identified by his free brushwork, and especially his cryptic compositions, which are full of lasting interest. Like Paul Klee, Shih T'ao never repeated a composition in his life. Each painting, no matter how small, is a new surprising world. (See Figs. 100, 101)

The moving power of art is only as dynamic as the personality of the artist. This proposition is borne out with respect to the work of the famous Four Wangs†. Their works are competent, for they were, indeed, excellent technicians, but there is very little spiritual thought in their paintings which goes beyond the mere rendering of the form. In my opinion, this type of decorative and static work could only be promoted with Court patronage.

Outside the Court circles, on the other hand, were different groups of artists who had won prestige through true merit. In the 18th century, Cheng Pan-Chiao, the leader of the Yang Chow

---

*The combination of *ba* and *da* produces a character that looks like the word cry and also the word laugh. He used this ambiguous combination to express his mixed-up feelings— neither cry nor laugh—after he lost his fatherland.
†The four Wangs are: Wang Shih-Min (1592-1680), Wang Chian (1598-1677), Wang Huei (1632-1717), and Wang Yuan-Ch'i (1642-1715).

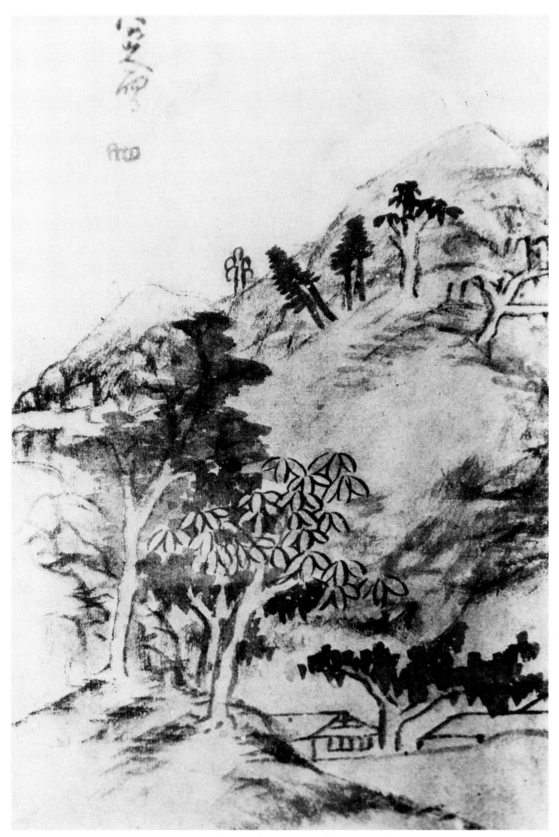

*Figure 100. Landscape,* by Ba Da Shan Jen [Chu Ta].

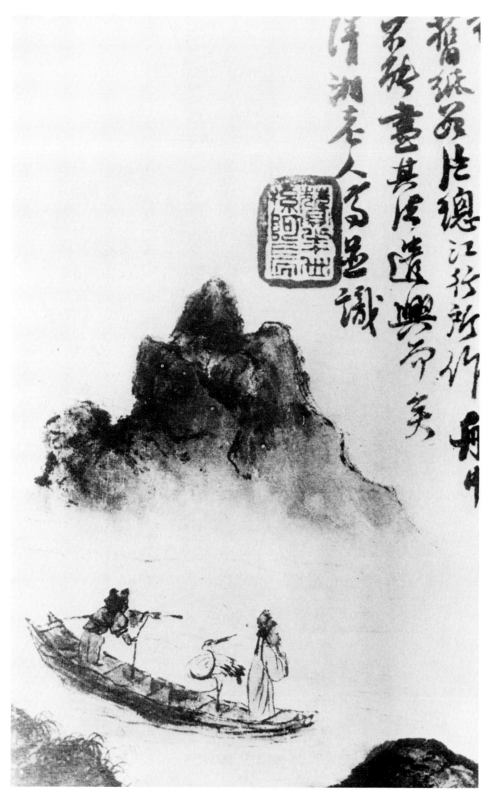

*Figure 101. Landscape,* by Shih T'ao.

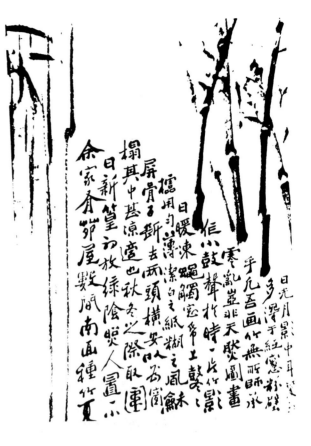

*Figure 102. Bamboo,* by Cheng Pan-Chiao.

Eight Eccentrics, surpassed others in bamboo and orchid paintings. His calligraphy also bears a strong personal identity—Figure 102 could not possibly be mistaken for anyone else's work. The inscription is integrated into the composition in an original way, appearing to suggest the sloping ground in which the bamboo is growing. Contrary to tradition, the writing goes from left to right. The translation is as follows:

> There are several reed-roofed houses in my little compound. South of them, bamboo is planted. In summer time, the young suckers are shooting out of the ground, and casting a rich green shade. Resting on a couch there is nice and cool. Between autumn and winter, it is the time to take the frame of each bamboo screen, cut off its ends and fit it onto the window. Then, paste translucent paper on the lattice. On a sunny, mild day, the cold flies will hit the window and make a sound like drums. It is so picturesque to watch the bamboo leaves cast shadows on the window. My painting of bamboo has been selftaught, mostly learned by watching the shadows on the red windows and on the white walls.

In the 19th century, Jen Po-Nien (1840-1895) was an influential artist in Shanghai. Figure 103 is a portrait of Wu Ch'ang-Shuo with his classical books and harpsichord, in his garden. Although Jen's work is full of Shu or "ripened flavor," from too perfectly wielding the brush, his unique personal style is unmistakable, and therefore creative.

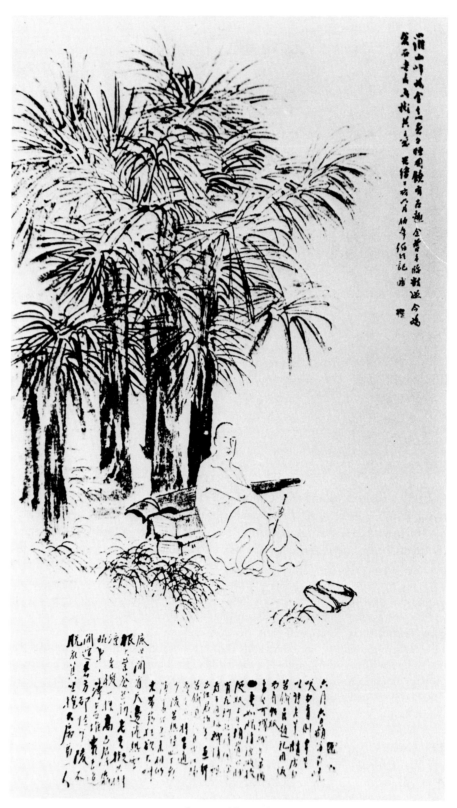

*Figure 103. Portrait of Wu Ch'ang-Shuo,* by Jen Po-Nien.

In the 20th century, in the art world in China there emerged a new group of artists who, having studied abroad, returned to China, mostly to work in educational circles. They played an important role in promoting Western art and exploring the possibilities of blending the two—East and West. The merits of this combination remain yet to be proved. Among those who studied in France were Hsu Pei-Hung and Lin Feng-Mien and in Japan, Kao Hsi-Shun. Most of them became well known art educators.

In this century, traditional Chinese painting and calligraphy developed without notable innovation. Among the most influential figures are Ch'i Pai-Shih of Peking, a follower of the Wen Jen school, and Wu Ch'ang-Shuo of Shanghai. Both won a tremendous following throughout the nation, and were quite financially successful due especially to Japanese patronage. (See Figures 69, 70, 76, 78 and 79)

# REFERENCES

1. Quoted in Hu Shih, *History of Ancient Chinese Philosophy*, Taiwan: Commercial Press, 1961, 51. [Chinese]

2. Ibid., 52.

3. Ibid., 53.

4. Ibid.

5. Ibid., 107.

6. Chu Lin Pa Hsian, *On Ch'an*, Taiwan: Chung Yi Society, 1970, 15.

7. Teng Ku, *Essays on Chinese Art*, Shanghai: Commercial Press, Ltd., 1938, 12. [Chinese]

8. Ibid., 18.

9. Ibid., 19.

10. This work was selected by the DRAWING USA 1963, a national competition sponsored by the Art Center, St. Paul, Minneapolis, Minn.

11. Fu Pao-Shih, *Theories on Chinese Painting*, Shanghai: Commercial Press, Ltd., 1936, 103. [Chinese]

12. Ibid.

13. Ibid., 104

14. Ibid.

15. Ibid., 114.

16. Ibid., 51.

17. Ibid., 26.

18. Ibid., 55

19. Ibid., 64.

20. Ibid., 67.

21. Ibid.

22. Ibid., 71.

23. Ibid.

24. Ibid., 127.

25. Ibid., 8.

26. Ibid., 13.

27. Ibid.

28. Teng, op. cit., 88.

29. Fu, op. cit., 1.

30. Ibid., 5.

31. Ibid., 13.

32. Ibid., 19.

33. Chen Shih-Tseng, *A Study of Wen-Jen Hwa*, no other information available, unpaginated. [Chinese]

34. Fu, op. cit., 57.

35. Hu Shih *et al., Chronological Biography of Ch'i Pai-Shih*, Shanghai: Commercial Press, Ltd., 1949, 44. [Chinese]

36. Fu, op. cit., 2.

37. Ibid.

38. Ibid., 115.

PART THREE

# *The Techniques of Chinese Brushwork*

Although there are numerous Chinese writings on the principles and theories of brushwork, there is not much material dealing specifically with its techniques. The best known manual, *Mustard Seed Garden*\*, when faced with explaining a difficult technical problem, often evades the issue with the sentence, "It can only be perceived, but cannot be conveyed by words." In this section I will attempt to clarify some of these puzzling aspects of Chinese brushwork. But, first, an explication of the tools of the art.

## 9 *The Tools of Brushwork*

The tools used in Chinese art are neither numerous nor complicated. The principal ones are the so-called "four gems of the study," namely, the brush, the paper, the ink and the inkstone.

---

\**Mustard Seed Garden* is primarily a manual of painting by Wang Kai and other artists of the Ch'ing dynasty (*c.* 17th cent.). It has been translated into English by Sze Mai-Mai, *The Way of Chinese Painting*, New York: Modern Library, Random House, 1956

## THE BRUSH

The major tool is the brush (*pi*). Its invention dates back several millennia. Because of its flexibility, one can produce in one stroke the form of various objects, such as a bud, a claw, or a feather.

The principal material for the brush head is animal fur. In fact, any animal fur can be used, but the most common are weasel, deer, rabbit, and goat. Some are hard furs, others, soft. Therefore, brushes are generally classified into two major categories: *Chian Hao* (hard-type furs) and *Jou Hao* (soft-type furs). The former, such as weasel, have more elasticity; the latter, such as goat, are softer and therefore weaker in their spring. Needless to say, the strong-fur brushes offer more support in making a firm line, as a steel pen would. However, many professional artists favor goat-hair brushes, for the mere reason that a softer-fur brush, though harder to control, offers more possibilities in the variations of the strokes. Non-artists may favor goat-hair for its inexpensiveness. Above all, the softer brush creates accidental effects of brushwork, thus adding much interest to the quality of the lines. Some artists (see Ho Shao Chi, Fig. 75) even used chicken feathers.

Manufacturers of brushes can be found everywhere in China. The most famous place is Hu Chow in Che-Kiang province, near the famous Lake Tai Hu, not far from Shanghai. The brushes produced there, called *Hu Pi*, are noted for their excellent quality.

Only the fur from healthy animals should be used, and the longer the hair, the more desirable. Clusters of fur with hair of equal length are used to make cone-shaped brushes in varying sizes. These hairs must be carefully degreased so as to hold ink and water and are blended with plant fibers, usually hemp, to obtain the desired degree of softness. The fibers are also used to hold the bristles together when the brush is saturated with water or ink.

The clusters are combed (with a short-toothed, longhandled comb, about 1″ × 10″, made either of wood or buffalo horn), washed thoroughly, and trimmed to eliminate all hair which is not uniform. A suitable number of these clusters are selected and treated with an adhesive to form the rounded brush head, and give it its conical shape. The root ends are cut flat. Each fur cone is encased with a thin layer of pure fur to give it a decorative sheath.

A brush head is thoroughly dried (first on a bed of charcoal ashes, then, tied onto weighted strings, air-dried) and inserted into a holder, its handle, (usually bamboo but, at times, wood, horn, ivory, or even porcelain) in which an indentation about a quarter-of-an-inch has been cut to receive the flat brush end; this is glued in with molten rosin*. Too much rosin can cause the bamboo to crack; too little, and the brush will not stay in securely. The holder should be stiff, straight, and with little defect in texture. The brush head is finally given a protective glue coating and fitted with a cap.

The most commonly used brushes fall into two major categories: those used for writing larger characters are called *Ta-Kai Pi*, and the smaller ones, for letters or documents, are known as *Hsiao-Kai Pi*. However, there are extra large ones for large sign writing and extra fine ones for such painstaking work as Kung Pi.

A professional artist is not confined to using just the regular large and small brushes. A wider

---

*The oldest Chinese brush extant, from the Warring States period, around 400 B.C., was a detachable one; the brush holder and its head were not fixed, but changeable. Tsien Tsuen-Hsuin, *A History of Writing and Writing Materials in Ancient China* [Translation by Chou Ning-Sun of *Written on Bamboo and Silk*, The University of Chicago Press, 1962], Hong Kong: The Chinese University of Hong Kong, 1975, 154.

range of brushes is needed. One needs *Ching Ts'a* for painting large trees, branches or leaves (see Fig. 104a). This brush is also an indispensable tool for a professional calligrapher to write a big sign for a school, church, or a store. Some of these extra large brushes are made of hemp or broom grass, or bamboo threads. *Dou Pi* and *Lian Pi* (see Figs. 104b, 104c) are useful for painting larger objects in the Hsieh Yi style, and also for professional calligraphers to write couplets and other large inscriptions (see Figs. 44, 92). *Kai Pi*, Figure 104d, is a medium-sized large brush, normally one and one-eighth inches long, useful to both painters and calligraphers. *Hsiao Tze Pi* (or *Kai Pi*), Figure 104e, is smaller than an inch and is used by everyone, mostly for correspondence or bookkeeping. Lastly, the extra short and small brush, sometimes called dragon's whiskers or crab's claw (Fig. 104f) is used by painters of the Kung Pi style (see Fig. 84).

A popular set, especially for the Hsieh Yi school of painting, consists of five pieces, from size one to size five, ranging from about one-and-three-quarter inches up to two-and-three quarter inches long, usually of white goat hairs, and about seven-sixteenths to ten-sixteenths of an inch in diameter.

When using a new brush, its protective glue coating must be thoroughly washed out in lukewarm water and the bristles gently loosened. The cover which comes with a new brush will not fit the head once the protective coating is washed out, and should be discarded. After each use, the brush should be washed thoroughly and hung to air dry, or wrapped in a bamboo mat.

## THE PAPER

In general, Chinese paper can be divided into two major categories: raw (untreated) and mature. The former is soft and very absorbent, somewhat like blotting paper. The best and most commonly used for painting and calligraphy is Hsuan paper,* produced in the city of Hsuan, An-Hwei province.

There are many kinds of Hsuan paper. The very thin type is called *Dan Hsuan,* or single-layer Hsuan paper. It is extremely porous and absorbent, and on it the ink runs fast and bleeds quickly. It is hard to control, yet experts love the "sensitivity" of this paper. It was the favorite paper of such masters as Wu Ch'ang-Shuo and Ch'i Pai-Shih (see Fig. 79). The double layer type is called *Chia Hsuan.* It is equally absorbent, but the water or ink does not run as fast, and therefore, the ink is more easily controlled. The half-raw and half-treated type is called *Chu-Chuei.* This is a half mature paper. "Mature" paper has been given a special kind of treatment; usually a certain amount of alum is added to seal somewhat the porous texture of the paper, so that it will be less absorbent. *Yu Ban Hsuan,* or jade slab paper, is well soaked in the alum substance and consequently slow in reacting to water or ink. It does run or bleed, but very slowly. Another kind of commercially treated Hsuan paper is *Hu Pi Hsuan,* or Tiger skin, which is dyed an orange color with a tiger-skin-like pattern. It is used for writing couplets for social occasions, such as birthdays, or the opening of an art show,

---

*Actually, only two families have been making this particular type of paper. The method and process of making it have always been kept a secret and handed down in the family from generation to generation. Some people in Japan and other countries have tried to imitate this type of paper but have never succeeded in turning out anything like it.

The Western term "rice paper" generally refers to all papers used in Oriental Art. The proper reference should be Hsuan paper.

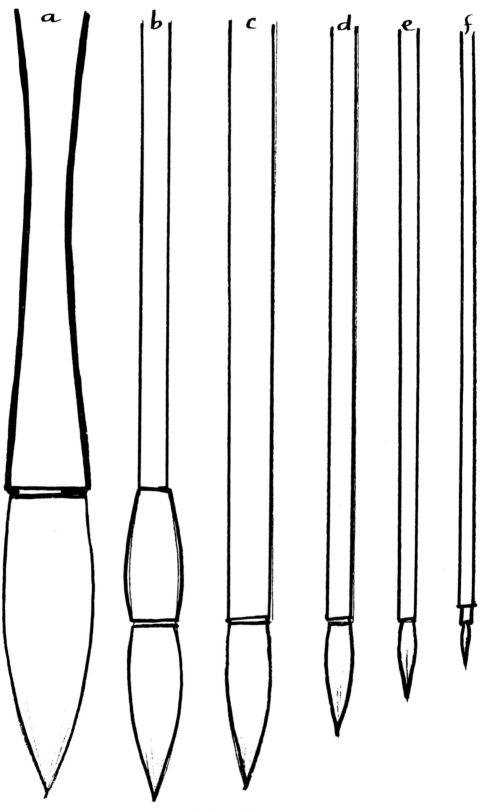

*Figure 104.* Various sizes of Chinese brushes. *(a)* Ching Ts'a; *(b)* Dou Pi; *(c)* Lian Pi; *(d)* Kai Pi; *(e)* Hsiao-Tze Pi; *(f)* Kung Pi.

etc. Artists who paint in the Kung Pi style prefer *Ping Hsuo Hsuan*, which is heavily treated with alum. It is a hard paper and its surface sparkles like snow.

Apart from Hsuan paper, which is considered orthodox, other kinds of paper are used. Among the popular ones are *Mao Bian* paper, which is made of straw or grass, and *Chu* paper, or bamboo paper, chiefly from the bamboo plant. These two are generally half treated with alum. *Kao-Li* paper, or Korean paper, has a heavy hemp mixture and is quite strong, almost like parchment. Although its common uses are for kites or covering windows in lieu of glass, for it holds in the heat well, some artists use it occasionally for both writing and painting. This Kao-Li paper is very similar to the Japanese hemp paper, which is a popular art supply in Japan. This paper, if treated with alum, will become hard and will not absorb water like Western paper.

## THE INK

In Chinese traditional art, water color has been the formal medium for both calligraphy and painting. Oil has never been used as a base in mixing pigments, except the vermillion ink for seals. Even in the cave linen frescoes, as in Tun Huang, opaque colors were used, somewhat like egg tempera, but they were all prepared in glue (undoubtedly from animals) and water.

Chinese ink, which dates back to archaic times, is made from the soot of burnt wood. The most famous ink is made of the pine in the Yellow Mountain area, in An-Hwei province, known as the Pine Smoke of Yellow Mountain. The ink is prepared by first burning the pine, then grinding the soot of the smoke, purifying it, and the resulting fine powder is mixed with animal glue. It is then molded into various shapes, either in the cylindric or in the more popular rectangular block bar. The ink sticks are often decorated with landscape designs in rich colors, such as turquoise blue and green, gold and silver. The ink comes also in other shapes, such as hexagonal, round, oblong, etc. For the purpose of collection or use for special gifts, one can have the ink made to order in whatever shape and pattern one desires, and with special inscriptions molded on the bar. Popular inks often bear brand names. Among the most popular are "Dragon Gate," "Lavender Jade Light," etc.

Ink sticks vary a good deal in size. Some weigh one "catty" (16 ounces), and are ten inches high and one-and-a-half inches in diameter, made for the use of professional artists. For everyday use two or four ounce bars are sufficient.

The superiority of Chinese ink lies in its delicate, fine, and smooth color tone. It is transparent. It is water-proof, *i.e.*, once it is used on the paper it becomes permanent and will last for centuries without fading. The ink on early scripts and paintings excavated from the Chu tomb in Ch'ang Sha (see Fig. 20) has remained unchanged, although dating back as far as the 5th century B.C. The color of the ink in the widely reproduced painting, *Admonitions of the Instructress*, (5th cent. A.D.) now in the British Museum (see Fig. 93), is still as fresh as ever, although the paper has turned a greyish brown.

## THE INKSTONE

The inkstone, or inkwell, is made of natural rock. The most common shape is rectangular or round, with a circular indentation, a well in which to grind the ink. The size varies a great deal. For

ordinary use, people choose the small ones, with a grinding well about four inches in diameter. Calligraphers and painters need larger ones, for they need more freshly ground ink.

The quality of the stone is important. If the stone is too fine, its surface will be too smooth and it would take too much time to grind enough ink paste. If it is too coarse, then, the surface would be too rough to produce an ink that is fine enough and therefore suitable for brushwork. The stone commonly used is somewhat like slate or silkstone. In China, ancient tiles, particularly those of the Han period, are treasured as excellent material for making inkstones. The well-known *Twan Yan*, a special kind of fine stone, is produced in quarries in Tuan-Hsi, Kao Yao in Kwang Tung province. Its color is liver-red. There are olive-green spots in the stone, which are called the "eyes" and considered invaluable. The edges of an inkstone are, as a rule, decorated with all sorts of carvings, such as locusts, fish, dragon and lotus flowers, done by expert carvers. Many scholars collect inkstones as a hobby. In the 17th century, when Prime Minister Ho Shen was evicted from his house, several thousand pieces of Twan Yan were found in his collection. This was quite a treasure. The most popular kind of inkstone is *Sho Yan*, a product of the Sho district in An-Hwei province, not far from Nanking.

Scholars and artists all treasure their inkstone. There is a saying, "An artist loves his tool just as much as a mother loves her son." Good inkstones are usually kept in exquisite boxes of ebony or redwood; they look highly decorative on the desk and are well worth the close care and admiration of connoisseurs.

## *How to Grind the Ink*

Chinese ink is water soluble. One must prepare the ink paste just before starting to paint or to write. The paste is made by grinding the ink stick in some water against the inkstone. How much water? It depends on how much paste is needed. For example, for writing a short note, a few drops of water and a minute of grinding will be sufficient. For painting or writing, usually one needs more ink; therefore, five or more cubic centimeters of water are required, which normally will take five or ten minutes or longer to reach the proper thickness. During the grinding, one can see that the paste is gradually getting thick to the consistency of syrup. When it leaves a dry trace on the bottom of the inkstone, as the ink stick is circling the bottom of the well, the paste is ready for use.

It is a good habit to hold the ink bar low, so as to have a firm and steady grip on it, and to keep the ink stick perpendicular and flat against the stone while grinding, otherwise the contacting surface between the ink stick and the bottom of the inkstone will get smaller all the time, and it will take longer to reach the proper consistency.

If too much pressure is used, the paste will be too coarse; if the pressure is too light, it may take a long time to get the proper paste. Experience will show the correct pressure.

Grinding ink is salutary. It calms one down; one can plan the composition, or even enjoy the reading of some poems; and, it may warm up one's wrist, too.

If the hand swirls too fast, the ink may splatter, and the paste will not be even. Therefore, "not too fast, not too slow; not too heavy, and not too light" is the secret.

In addition to the "Four Gems of the Study," there are several other items which are considered indispensable to an artist:

*Brush Holder and Rest.* The container to hold the brushes is commonly cylindrical in shape, often tumbler-like, about seven inches high, sometimes made of porcelain but more often bamboo or pottery.

In offices, where small brushes are in common use, the holder is a frame, usually white brass, about four inches high, with five or six open caps in which the brush handles are inserted (similar to a desk penholder).

The brush rest, used while painting, is often in a mountain-peak shape, generally of porcelain.

*Water Cistern.* Mostly made of porcelain, the cistern, about four inches in diameter, holds the water used in grinding the ink. It is usually accompanied by a small brass spoon.

*Brush Washer.* The ordinary size of the brush washer is about eight inches in diameter, and two inches high. The general shape is like the above water cistern. Normally made of porcelain, it is used for washing the brushes during painting or writing.

*The Paper Weight.* There are several kinds of paper weights, round, square, and ruler-like, to hold the rice paper in place. Some are made of fine wood with jade-carvings set in, some are ivory; however, the most popular kind is brass or bronze, at times with a design carved or etched on them. Known for such work is the famous artist Chen Shih-Tseng (1873-1922).

*Table Cloth.* Since the paper used for painting and writing is an absorbent type, such as Hsuan paper, the ink often filters through and wets and sticks to the desk. Therefore, a cloth must be used under the paper, which will allow the ink to run and spread freely, but at the same time, keep the table neat. The best material for this purpose is black felt, or any woolen cloth.

## THE STUDY

The life-style of literary men was established long before the T'ang dynasty. Their lives centered around congenial activities, such as drinking wine, writing poems, playing chess, and, above all, experimenting with the brush—painting and writing. Their living environment was especially important to this class for here all their artistic activities took place. Their gardens and particularly their studies were well decorated. Plum trees and bamboo were to be found in their gardens, as well as cranes in the yards and fish in the pools. In their libraries, besides good books, the orchid was often displayed. Harps and lutes often decorated the walls. Archaic bronze vessels and rare porcelains were to be found on the shelves. Excellent paintings and calligraphies were displayed in every room. Their tools, such as brushes and other professional accessories, were well made; their seal stones, expensive, collectors' items or conversation pieces. In the Ming period, the fashion of beautifying the studies and libraries reached its peak. Beautifully wrought incense burners and tea utensils were a significant part of this literary-artistic life. Though most scholar-artists were withdrawn from political activities and despised the thought of the restraints attached to being a Court painter, though seeking simple goals and an uncomplicated life-style, they prized the amenities which enriched their daily lives.

# 10  *Holding the Brush*

To achieve good calligraphic lines, it is important to hold the brush correctly. In learning to write, school children were usually taught to hold the brush between the thumb and fingers, with the index finger raised into the position of "7," the "goose head" position. The trouble with this method is that when the goose head is formed, the rest of the fingers will automatically squeeze tightly and thus the whole hand will close into a fist. Once the small finger touches the center of the palm, as shown in Figure 105a,the hold is too tight. In this position, the brush cannot move freely. Besides, a tight grip can be maintained only a short time, so how can one work for an hour or more?

It must be recognized that in any kind of performance, such as swimming, playing tennis, piano, one cannot be tight. On the contrary, all muscles must be relaxed. The natural way is best. Therefore, instead of holding the brush tightly, limiting its movement, the correct way is to loosen all the muscles of the hand and the forearm, and take a position as shown in Figure 105b, whereby the palm is so hollow that the brush may turn around in a circle of at least eight to ten inches in diameter. Since there is not a wide angle formed between the hand and the forearm, one's arm does not get tired nor the fingers cramped.

When one is taught to hold the brush tightly, as tightly as possible, to make strong lines, the

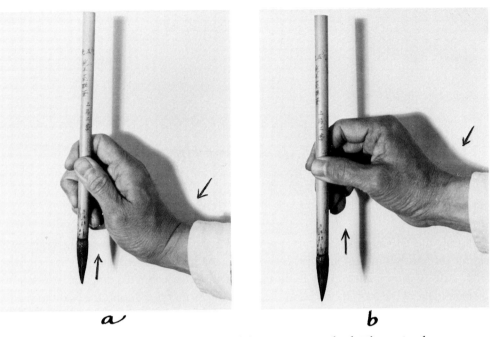

*Figure 105.* How to hold the brush. *(a)* Incorrect method. The wrist shows a folding of the skin and the thumb is tight against the other fingers. *(b)* Correct method. The wrist is relaxed and there is a hollow space between the thumb and the other fingers.

person is likely to develop the bad habit of moving the brush stiffly; his lines are likely to be stereotyped. As in singing, if there is strain, the voice will not be right. When one feels tired holding the brush, this is a warning that the grip is wrong.

The brush should be held mainly by thumb, index and middle finger. The ring finger may touch the right side of the brush; however, the little finger is not useful, and the best thing to do is to let it join the ring finger naturally. Never should it touch the brush, otherwise it will break the coordination of the grip. Some writers stick this finger out, or try to use it as a support between the brush and the paper on the table. Both are incorrect, for they impede free movement.

In the correct holding position, there should not be any "window" formed between the fingers holding the brush, usually a result of muscle tension. Figure 105b shows a complete relaxed position, but the fingers are joined together so as to ensure a firm and well balanced holding. When the brush is held correctly, the hand, arm—the entire body—are all relaxed.

There was a time when teachers would sneak up behind a student and try to snatch his brush from him, to test how tightly he was holding it, unaware that this was an improper kind of test. The tighter the hold, the more wooden the movement of the brush. In painting and calligraphy, there is need for finger work, such as rolling, twisting, and turning of the brush. This cannot be done effectively if the brush is being held tightly. A good line is the result not of a tight grip but of properly holding and wielding the brush, *i.e.*, the coordination of pressure, speed and all the other factors involved.

## 11    Body Movement in Using the Brush

Since painting and writing, like dancing, are a kind of physical performance, the body movement in wielding the brush is also significant. In walking, the left foot is balanced by the right arm and vice versa—this is known as contrary body movement. In ballroom dancing the opposite shoulder does the balancing of the foot. In wielding the brush, the principle of contrary body movement also prevails.

If one were to draw a line from left to right across the paper, one should not just move the hand that holds the brush; instead, the shoulder should start the movement by leading the arm, and the arm should lead the hand. When painting in a standing position, one should feel the gradual shifting of body weight from the left foot to the right leg. At the beginning of the line, the right shoulder should balance the brush at the left side; in the middle of the line both brush and body are in equal balance; from the middle to the end of the line, the left shoulder should gradually serve as a brake and, at the same time, balance the brush on the right. The whole body is actually doing the painting, not just the fingers. Coordination of the whole body is necessary to ensure a good line, or a good painting or calligraphy.

## 12    Three Fundamental Principles of Brushwork

### MOISTURE

The brush should be washed and retain a suitable moistness before one dips it into the ink and starts to use it. The amount of moisture depends on how wet an effect one wants to produce on the paper. This is a crucial factor when using Hsuan paper, or rice paper, for it is very absorbent, somewhat like blotting paper. Water color, or ink, does drip or run; therefore, the paper must be laid on a flat

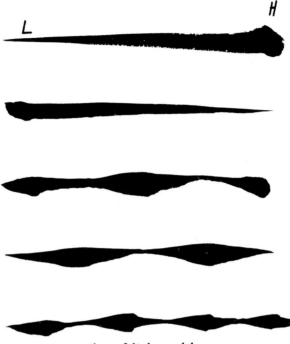

*Figure 106.* Examples of light and heavy pressure and the corresponding results.

table, with two paper weights to hold it in a taut position. If the brush is too wet, the ink will bleed too much; on the other hand, too little water will give a dry brush or a split brush result, and unless this kind of textural effect is wanted, one must avoid too dry a brush. Therefore, the controlling of water and ink in the brush is the first concern of an artist before starting his stroke.

Water serves as a lubricant to the hairs in the brush, *i.e.*, every hair can move freely in plenty of water; if the brush is too dry, then, all the hairs in the brush are crowded and thus result in much friction when in motion. This naturally causes the brush to split, resulting in a bad line, unless one is deliberately trying for a dry brush effect.

## PRESSURE

Pressure is the amount of force the artist employs in pressing the brush down on the paper, whether doing center-brush or side-brush strokes. The heavier the pressure, the wider the line. The control of pressure is the most difficult skill to master, and is considered an art in itself. The difficulty lies in the fact that it is not easy to restore elasticity to the bristles once pressure has been applied to them; in other words, the harder the pressure, the more difficult for the brush to spring back to its original resilient strength. This is important, for a strong line is the result of movement whereby the brush has its full elastic power.

How to control the pressure of the brush, to maintain elasticity during the pressing-downs and raising-ups in moving the brush, is indeed a major technique in Chinese art. This takes arduous labor and long practice before full control is gained, especially the changing of pressure while doing one stroke, such as light-heavy-light, or vice versa. (see Fig. 106)

Pressure is a significant technique for achieving calligraphic differences within a line or between lines.

## SPEED

Speed of the brush is just as important as pressure. Speed affects the flow of the ink, the texture of a line; it determines whether a line is solid or flimsy; it creates the feeling of motion within a line. For a firm, strong line, a fairly fast, consistent speed must be used; otherwise, a lower speed. If the brush moves too fast, the result will be too dry and fuzzy. On the other hand, if the speed is too slow, not only will the line show a kind of hesitation, but it may also run or bleed too much, when such an effect is not being sought. *Not too fast, not too slow is the secret.* How fast and how slow? Again, it takes a great deal of experimenting and practice. (See Fig. 107)

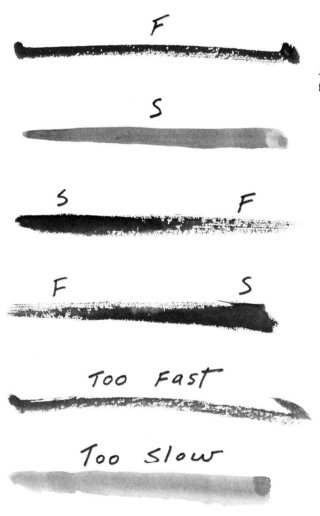

*Figure 107.* Examples of lines result-from different brush speeds.

# *13   Two Major Angles of the Brush*

## POSITION ANGLE

Position angle refers to the angle of the brush in relation to the painting surface, the paper. When one uses center brush to draw a line, the brush is kept in a perpendicular position. As one tilts the brush, thus narrowing the position angle, a wider line is obtained, for there is more contact between the brush and the paper. In such tilted positions, the side of the brush is doing the painting. The lower the brush, the wider the line. If the brush is lowered to a ten degree angle, one can get

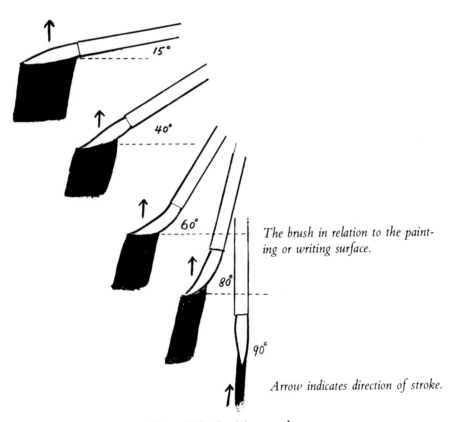

*The brush in relation to the painting or writing surface.*

*Arrow indicates direction of stroke.*

*Figure 108.* Position angles.

the use of almost the full side so that, if the brush is two inches long, the line will be nearly two inches wide. Figure 108 shows the different results using different position angles of the brush.

## MOVING ANGLE

Only when the brush is in a tilted position (side brush) does the moving angle come into play. Let us consider a two-inch brush, which, of course, is two inches in length, and approximately one-half inch wide. Assuming a normal pressure, if held at a 45 degree position angle, about one inch of the side of the brush is touching the paper. But one can get a one-inch line only if the brush is moved at a 90 degree angle in relation to the *direction* of the line, hereafter to be called the "line of direction" (see Fig. 109). For example, if the line of direction is directly north, the brush must move at a 90 degree angle to that line (positioned at a "three o'clock" angle) to get a one-inch line. In other words, the brush must move "cross-ways" in relation to the line of direction.

If the brush is held so that it parallels the line of direction (at a "12 o'clock" position), the width of the stroke will be much smaller; it will be only as wide as the width of the brush, or about one-quarter inch. Here, the brush is moving "straight way" in relation to the line of direction (see Fig. 109). In a straight way moving angle, by changing the position of the brush, *i.e.* raising its position angle, the line will become narrower. This is an especially useful technique in painting branches.

If the brush crosses the line of direction at a slant, say the "one o'clock" angle, then the line will be about three-quarters of an inch wide. If one were to make even the slightest change, say to a 65 degree position angle and a "two-o'clock" moving angle, the resulting line would be noticeably different.

The principle is that the *lower the position angle of the brush, the wider the line; the sharper the moving*

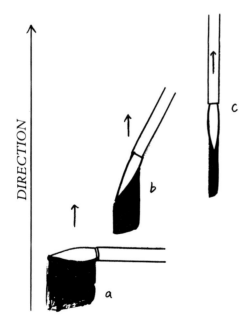

*Figure 109.* Three basic moving angles. *(a)* Cross way: 3 o'clock moving angle; *(b)* Slant way: 1 o'clock moving angle; *(c)* Straight way: 12 o'clock moving angle.

*angle, the narrower the line.* In side brush, to get a desired stroke, there must be constant adjustment of the moving angle. The significance of this statement can be demonstrated visually.

For example, in drawing a branch, one wants to get a thinner line at the end of the branch to show its tapering. Also, one wants to show the changes in direction in the growth of the branch. The brush must cope with all these changes within the line. Thus, if one fails to adjust the moving angle of the brush in relation to the new direction of line, the result will be as in Figure 110a— unwanted fat or thin strokes. Figure 111a illustrates why, using the side branch for analysis. The arrows indicate the line of direction. The brush at first is straight-way; when the direction is changed at (1), there is no adjustment in the moving angle, so the brush is suddenly painting in a crossway movement, resulting in a thicker line than desired. With the change of direction at (2), the brush is again straight-way; no adjustment in the moving angle resulted in a thinner line than desired. At (3), the brush is again cross-way, and at (4) straight-way, giving unwanted lines. In Figure 111b the necessary changes in the moving angles have been made; however, since the position angle remained constant, the lines are more or less the same width. Therefore, while correcting the moving angle, one must at the same time adjust the position angle, as shown in Figure 111c. Figure 112a illustrates that even with both moving and position angles corrected, the factor of pressure control is also essential. To show the tapering of the branch, one should start with a heavier pressure (to secure a wider line) and, then, gradually reduce the pressure to suggest the tapering end. Figure 112b indicates full control of the brush.

*Figure 110.* Moving angles. The arrows indicate the direction of the stroke. *(a)* incorrect; *(b)* correct.

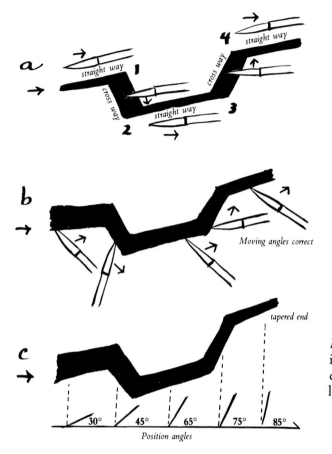

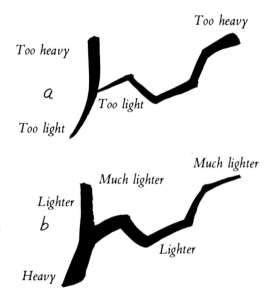

*Figure 111.* The control of both moving angles and position angles. *(a)* incorrect; *(b)* even lines; *(c)* tapered lines: adjusting position angles.

*Figure 112.* The control of pressure. *(a)* wrong; *(b)* correct.

# 14   *The Principal Brush Strokes and Their Application in Painting and Calligraphy*

## CENTER BRUSH, CHUNG FENG*

Center brush is the foundation of Chinese art, for it is the tip of the brush that produces the greatest linear effect. A center-brush line is hard-edged on both sides; therefore, it looks clear-cut, neat, and striking.

The expression of a healthy line is not confined merely to the outward appearance of a line; in fact, the built-in bone structure within the line is even more significant. This structure is primarily shown in center-brush work. However, some bone-like effect can also be achieved by side brush. How to achieve the "bone treatment of line"? The Chinese writings never indicate how. From a study of the Greater Chuan and Lesser Chuan lines (see Figs. 14a, 14b, 17b and 21), I found the solution to the problem. The emphasis is on the two ends of the line. The ends should be rounded, not pointed. In order to make this kind of end, a "hidden tip," actually a folding of the tip of the brush, has to be used. The process is as follows: (see Fig. 113)

With the brush held upright, start from a, and in order to get the effect of a solid inner support, move the brush in the opposite direction to that which the line will finally take. This is just like a pitcher swinging his arm backwards before he throws the ball forward. While gradually increasing the pressure, paint to b, halt, no longer than a quarter of a second (or the water and the ink in the brush may run too much), fold the brush, and without delay move it in the opposite direction; the tip, now, while moving, is pointing to the left while the brush is going to the right. Maintaining an even pressure and speed, paint to c; as soon as the brush reaches c, flip back the brush, upward, at about a forty-five degree angle, to d, actually a backlash, caused by the momentum of the stopping movement, like the braking applied suddenly to a moving car.

To explain the procedure is not difficult; however, to execute the line correctly, is. It calls for patience in perfecting the technique, for all the factors involved—pressure, speed, balance of the body—must be in perfect coordination.

Since there is a momentary but definite stop at each end of the line, at which time extra ink is deposited on the paper, this naturally results in two knob-shaped ends, and the whole line looks like a piece of bone.

The result is that there seems to be a tension built up between the two knob-like ends, as if the line were being pulled taut. Psychologically, the viewer may sense the elasticity of this line, and unconsciously feel excited; the Li effect is thus created.

Even without the bone-like ends, a line must convey the spirit of "bone treatment"—that is, the line must reflect the unwavering movement of the brush, which must be consistent in its speed to

---

*The word *feng* means "blade". Here it refers to the part of the brush which touches the paper.

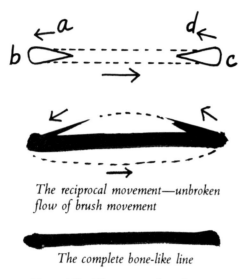

*The reciprocal movement—unbroken
flow of brush movement*

*The complete bone-like line*

*Figure 113.* How to make a bone-
like line.

capture bone structure. Even though a line may be pointed at its end, as with "rat's tail" stroke or the tip of the bamboo leaf, the technique of steady speed will give the appearance of bone-treatment.

## Application of Center Brush in Painting Bamboo

To demonstrate the art of brushwork in using center brush, bamboo, one of the most popular themes of Chinese painting,* is a most suitable subject matter. It illustrates well the Hsieh Yi style of painting.

Before drawing, one seeks a deep understanding of the subject, for, without such knowledge, one cannot hope to express its Ch'i. Bamboo, of course, has all along been closely identified with the daily life of the Chinese. It is the common material for a hut, fence, chair or table, the measuring spoons and chopsticks, a hat, a bed and its mat, the brush holder, the water pipes, etc. Bamboo shoot is also a favorite Chinese food.

To understand the structure of bamboo, one starts with its roots (see Fig. 114) which tell us that its joints and its branching correspond to the pattern of growth above ground. The special characteristics of this plant center around its joints. The word "joint" in Chinese, pronounced *chieh,* means "high fidelity." (Great heroes have given their lives to earn the honorific of Chieh.) Inside, the bamboo is hollow; it is described by scholars as *hsu hsin,* which implies that a man's heart is so spacious and modest that he is ready to receive advice at any time. When painting bamboo, therefore, one will have to remember that it is its hollowness that provides the ability of

---

*Bamboo is one of the "four gentlemen" of Chinese painting. The other three are orchid, plum blossom, and chrysanthemum.

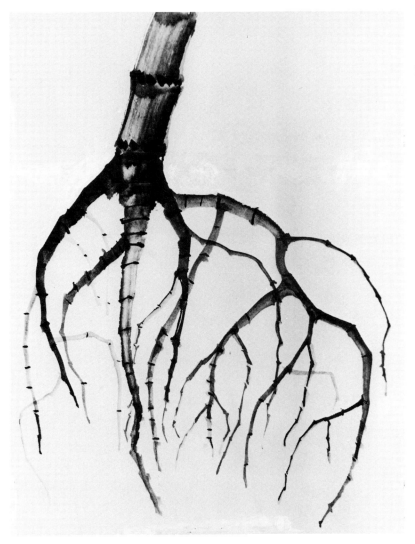

*Figure 114.* The root of bamboo.

bamboo to bend and spring back under a strong wind. Branches shoot out at each joint, numbering from one to five. At a distance, its whole contour is like that of a slim red pimento with the head tilted, bending under its weight or the force of the wind.

In planning his composition, the artist must decide how many branches to include and what to leave out, and to arrange the branches and leaves according to the principles of composition. (See Chapter 6.)

The traditional way of painting a trunk of the bamboo is to use broken lines (see Fig. 115a); between the lines, which represent the sections of the bamboo, ample white space is left for hook-like horizontal short lines which fill in the spaces representing the joints. To me, the traditional series of broken lines can hardly achieve the coherent continuity—Ch'i, or the one-breath feeling; moreover, the hooks are added "things," which do not really belong to the bamboo body, adding feet to the snake, as it were.

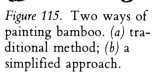

Figure 115. Two ways of painting bamboo. (a) traditional method; (b) a simplified approach.

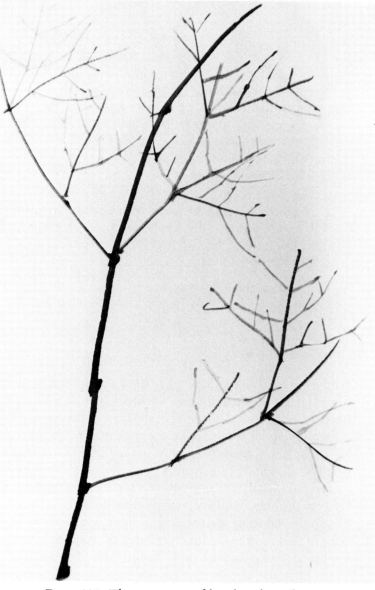

Figure 116. The structure of bamboo branches.

As a result of many years of experimenting, I believe that the best way is to stress the ends of each section of the bamboo, as shown in Figure 115b. To achieve this, start with side-ink. At each end of the section, hesitate—a definite halt—and exert extra pressure to produce the heavy joints. Since side-ink is being used, the end joint of each section will have an oval shape. In painting the beginning of the next joint, overlap half of the oval of the preceding end joint, and a solid connection will be achieved. Thus, a natural, articulated and strong bamboo is easily accomplished. This approach is simpler, more direct in expression, livelier and, certainly, there is more economy of line. In art, the search should be for simplification. Traditional methods do not hold forever as truth. One has to seek the better way to solve problems, whatever the field.

Figure 116 shows how the branches grow. For the small branches, one will find pulling brush very useful (see Fig. 123). It should be reiterated that in doing any kind of branch, the brush starts out in a low position and gradually is raised to ensure the tapered end.

On the whole, the bamboo leaf is the most difficult to handle. It is a good test of the merit of an artist in so far as his brushwork is concerned. The structure of a bamboo leaf is shown in Figure 117. The main parts are three: a triangle with its apex pointing north, followed by a rectangular body, and then a long triangular form, with a tail-like apex, as shown in Figure 117b. These three forms must be connected together with the tiny stem of the leaf, all in one stroke—not an easy task.

Figure 118 shows three common mistakes in doing this leaf:

(a) The much too-pointed start, with a feathery end, was caused by a "rocking" movement, that is, the brush was tilted at both ends, when actually it should have been kept in a perpendicular position.

(b) Here, although the start is a proper center brush, at the other end, the brush is rocking again, the result of a slip brush, and thus, too light.

It is regrettable that many manuals on Oriental art are full of bad examples of bamboo as well as orchid, with too many slip brush marks, which are indeed serious mistakes, giving the strong, energetic thin leaves a weakness bamboo does not have. However, to some degree, split brush can be used, for some leaves do split in the winter or in a storm, but unless the painting is of bamboo in a storm, or of withered bamboo, the bamboo leaves, like those of the orchid, should never look like cotton or silk, done with a slip brush.

(c) Here the lifting of the brush was incorrect. The brush had been pressed so hard that it could not spring back again, and therefore became "dead." As a result, the end of the bamboo leaf is a blunt rounded shape instead of a tapered point. The brush had been "punished." It could not move any further to form a proper end to the line. When the brush was lifted, an awkward line was evident.

For everyone there is a limit to the amount of weight he can carry before collapsing. The same is true with the brush. To perform the duty of center brush, a brush can easily regain its springing power if pressed down only about a quarter of its length (if the brush is an inch or longer), as shown in Figure 119a. If the brush is pressed down one third of its length, unless the brush is fairly wet and the speed slow, it is difficult to get a solid point at the end of the line. In most cases if the brush is pushed downward half of its length, the chances are that the brush will be unable to bounce back and thus will become "wooden," dead.

If a heavy pressure must be used, as in making a tapered line, the remedy is to use extra water and ink; in other words, to add more lubrication to the hairs, thus reducing the friction between them and helping the hairs to spring back to their original strength. With more water, the hairs may

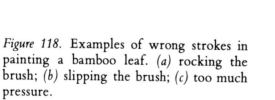

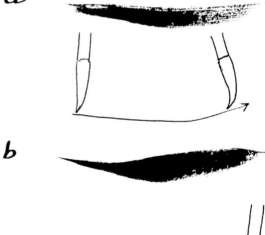

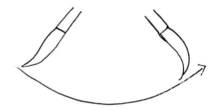

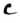

*Figure 117.* The structure of a bamboo leaf. *(a)* outline; *(b)* principal parts; *(c)* completed leaf.

*a*

*b*

*c*

*Figure 118.* Examples of wrong strokes in painting a bamboo leaf. *(a)* rocking the brush; *(b)* slipping the brush; *(c)* too much pressure.

swim freely and maintain their elastic power. Therefore, whenever a solid line or a tapered shape is required, plenty of water in the brush is a necessity.

At the same time, speed is a crucial factor, a speed allowing sufficient time for the brush to restore its resiliency. It takes time for the fur, after being pushed down, to stretch back and stand up again. Therefore, a suitable speed should be maintained. For example, under average conditions of water, pressure, and speed, one has to spend a second or so to do an average bamboo leaf. There is the risk of a split or even slip brush if the brush moves too fast; swelling, if too slow.

Through experimenting, I have discovered a good way to execute the bamboo leaf:

Instead of holding the brush at a 90-degree position, the brush may be tilted a few degrees, say to 85 degrees, and moved crossways from one end to the tip. The position of the brush in relation to the line to be drawn will form a "T." (see Fig. 120a) From a to b is the short triangle, from b to c is the rectangular shape, and c to d is the tapered triangular form. The advantage of this approach is to make the two ends sharper, and it is also easier to keep an eye on the tip of the brush, as clearly seen in the illustration. This is an example of using side brush to secure a center-brush effect.

In order to ensure a good beginning of a leaf, the movement of the brush should start (in the air) about three inches ahead of the point and about an inch above the paper, like an airplane gliding down and touching the runway at the point of $t_2$, as shown in Figure 120b. When the brush reaches $t_3$, the movement continues up into the air towards $t_4$. The bamboo leaf as drawn on the paper will be three or four inches long, but the whole movement will be longer, perhaps 10 inches or more.

(The brush is foreshortened)

**A**

**B**

*Figure 119.* Different pressures in center brush.

*Figure 120.* Painting a bamboo leaf in the "T" movement.

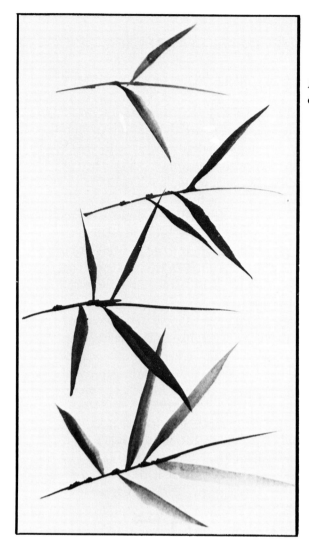

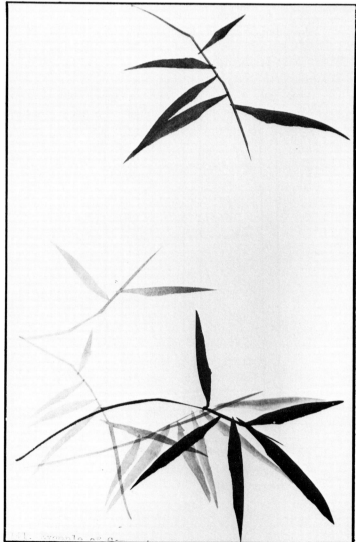

*Figure 121.* Bamboo leaves in groupings of two, three, four, and five.

*Figure 122.* Example of composing bamboo leaves in "Shu" and "Mi" contrast.

The speed of the brush should be the same for each inch of that total movement in order to avoid a feathery, split end.

In the manuals on bamboo, the illustrations are generally very misleading. For instance, the structure of the leaves in relation to the stems and branches is not at all clear. Unless one has observed well the actual growth of bamboo, it would seem that the cluster of leaves grows out of one point. Actually there is a space between each leaf, about a quarter or a half inch, as shown in Figure 121. They decrease in size, the closer the leaves are to the tree trunk; they become longer as they approach the tip of the branch. Each cluster differs in number, from two, three, five, nine or more leaves in a group, depending on the kind of bamboo. Some are larger leaves, others quite small. Four- or five-inch long leaves are about the common size. For a painter, it is advisable to study and memorize the growth pattern of a few basic leaf groupings, and master their structure. Then, whenever a composition is desired, one can subjectively recall the growth, and arrange the groups according to the principles of composition, so as to effect a Shu and Mi contrast, etc., as in Figure 122.

## PULLING BRUSH, TUO PI

To make thin lines in the manner of center brush, "Pulling Brush" is a very practical technique; it is a method I developed as a result of years of studying and teaching brushwork. In pulling brush, one lets the brush itself, as it were, draw the line. Actually, it is the weight of the brush which supplies the even pressure; the artist need only lead the brush in the desired direction (see Fig. 123). The secret is not to control the brush as in center brush with your fingers but to hold the brush very lightly, just enough to keep it from dropping out of your hand. Then, just head the brush in the direction desired. The top of the brush handle should always be ahead of the brush and headed in the direction in which the brush is moving. Varying the position angles will vary the thickness of the line—the higher the position, the thinner the line.

This technique may be used for drawing the small stem of bamboo as well as any other linear subject. The line quality in comparison to that of center brush is quite satisfactory. It is a convenient "short-cut" for achieving a center-brush effect.

## POINT BRUSH, CHIEN PI

With a two-inch brush, how does one secure a hairbreadth line—those most fine lines of center brush—needed, for example, to paint the whiskers of a squirrel or cat, the antennae of insects and crustaceans? The answer, of course, is to make a small brush out of the larger one. How? It took me years of experimenting to discover the following method of controlling the brush.

First, immerse the brush in your brush washer, touching the bottom of the container; hold the brush in a slanted position and bounce it with some pressure (but don't punish the brush) against the bottom of the container in order to force out the air from the brush head. While bouncing, rotate the brush handle slightly to the right and left. When the brush is pulled out of the water, since there is no air in it, the brush head will hold to a point. Let the water drip from the brush. To eliminate remaining water in the head, wipe one side of the brush against the rim of the container;

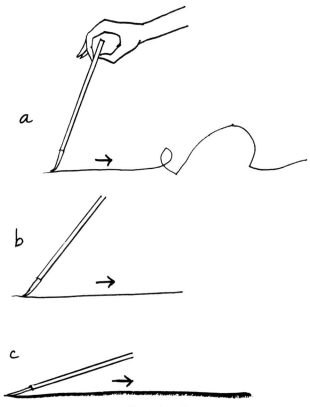

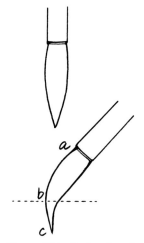

*Figure 124.* Point brush.

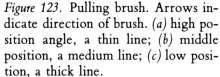

*Figure 123.* Pulling brush. Arrows indicate direction of brush. (*a*) high position angle, a thin line; (*b*) middle position, a medium line; (*c*) low position, a thick line.

however, be certain that your starting point is the bottom rim of the brush handle, not the middle of the brush head, so that no water will be left in the tail of the brush. Pull the brush straight off the rim, as you are wiping out the water. Be certain that you rotate the "swipes," alternating the right and left portions of the side of the brush that you are scraping against the container's rim. As you continue, you will note that the hairs of the brush have come to a distinct, sharp point, similar to a newly-sharpened pencil or the piercing point of an awl. The head can then be slightly curved by pressing it gently against the rim of the brush washer (see Fig. 124).

Only a third—or a quarter—of the brush is moveable; the rest of the head has become "wooden," since all the hairs are without their lubricating water and are almost glued together by the friction. It is only the live part of the brush (as shown under the dotted lines in the illustration) which is used in painting. This live section becomes the smallest of brushes, capable of creating the lines of a Kung Pi brush.

Since the brush head is curved, the brush and handle are not in a straight line. Therefore, to secure the very fine center-brush lines, be sure the tip (not the handle) is perpendicular to the paper; the handle will be in a tilted position.

## SIDE BRUSH, PIAN FENG

Side brush, used in both painting and calligraphy for broader strokes, is a most useful process, but, as we have seen above, in the discussion of position and moving angles of the brush, its technique is not as simple as merely utilizing the side of the brush, for there must be constant adjustment of the two angles as well as pressure to achieve a desired result. In painting, side brush would be used when doing big leaves, larger branches, a broad sweep of wash—sky, plain, field, etc.

### *Application of Side Brush in Painting Lotus*

The lotus flower is the best subject for illustrating the side-brush technique. It is usually done in the Hsieh Yi style. In China, one finds lotus flowers in every district. In many villages, acres of this flower crowd ponds.

The famous scholar of the Sung period (11th cent.), Chou Tuen-Yi, once published an essay on lotus, and praised this blossom as the gentleman of the flower world. For, though it grows out of dirty mud, it emerges beautiful and fragrant, like a man of high principles in an ugly society.

Lotus is an important Buddhist design, as it is often used with the images. The different Buddhas and deities are often depicted standing or sitting among lotus petals. Lotus is a symbol of purity.

In art, lotus is indeed a superb subject. The stem is a long line, in contrast to its massive leaf, which is clearly done by side brush.

The lotus root grows in the mud under the water, as shown in Figure 125. From each joint grow two stems, one bud and one leaf. As it grows bigger, the rolled-up young leaf will start to open, as shown in Figure 126. Sometimes the leaf or the flower may be as high as seven feet above the water. A normal size for the lotus leaf is about 18 inches in diameter, and a flower in full bloom may be nine inches from side to side. The color varies—white, pink, yellow, pale green and dark red. The pink are the most popular.

The brushwork for painting the flower is quite interesting. (see Fig. 127) Since the general shape of each petal is like a spoon, the brush has to be twisted to produce this particular shape. Utilizing this technique, the complete lotus flower is drawn, as shown in Figure 128.

Lotus leaf is a mass form. The ink should be used in the Po' Mo, or wash manner. In Figure 129, the painting of the leaf should begin from the center. The diagram of this leaf is shown in Figure 130.

In Figure 131, the "a" stroke starts at point O; the brush is held at about a 30 degree angle and moved back straight-way, very fast (or it may deposit too much water on the paper, thus causing bleeding). If every tip of the succeeding twenty strokes all converged at point O, there would be chaos from the merging ink. Therefore, the tip of each stroke must be executed very fast and kept distinct. As the brush is moved, it should gradually turn to the left, and take a slanted position. One increases the slanting angle all the way until the brush reaches a, where the brush should be in a crossway position. Thus, the entire stroke is triangular in shape. With this same method the rest of the strokes—b,c, and d—can be done.

The other quadrant of this leaf, the e, f, g and h strokes (see Fig. 132), can be done in the same

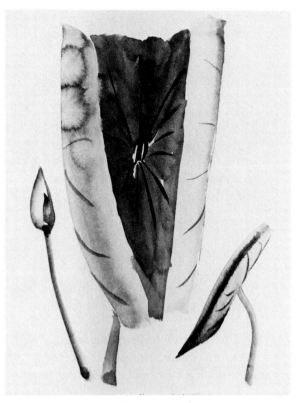

Figure 125. Lotus root. Top dotted line indicates water level; bottom dotted line indicates mud.

Figure 126. Young lotus.

Figure 127. Example of lotus petal. The petal starts from a, the brush held in a low position angle, about 30 degrees; it is moved straight-way, down, towards "5 o'clock." When the brush reaches point b, the pressure is increased to the full extent possible, without woodening the brush. Here, the brush is twisted a quarter turn and moved slant-way towards point c; during the movement, the brush starts to rise from a 30 degree position angle to 45 degrees, thus narrowing the line, and the line of direction is changed back to "5 o'clock" from c to d. While moving the brush to d, gradually raise its position angle to reach an 80 degree position at point d, in order to get the pointed end. This is the basic technique of painting petals.

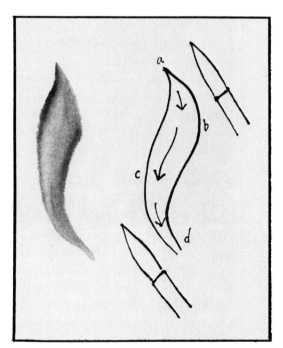

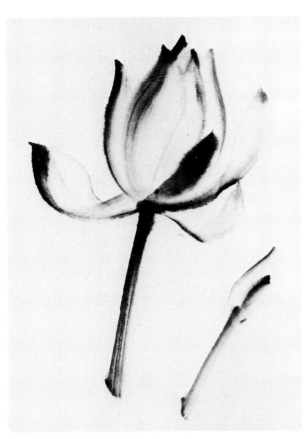

*Figure 128.* Lotus flower.

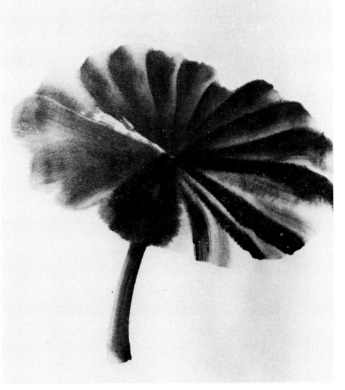

*Figure 129.* Lotus leaf.

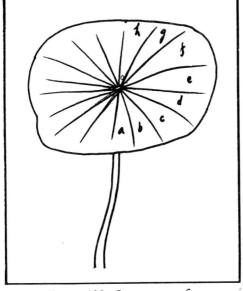

*Figure 130.* Structure of a lotus leaf.

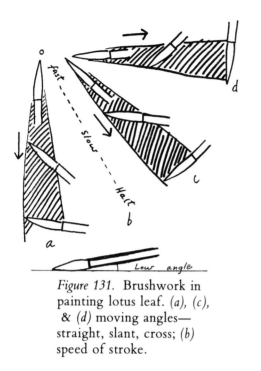

Figure 131. Brushwork in painting lotus leaf. (a), (c), & (d) moving angles—straight, slant, cross; (b) speed of stroke.

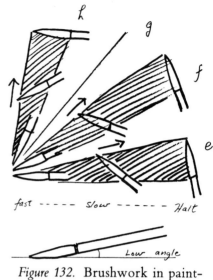

Figure 132. Brushwork in painting lotus leaf.

manner, but the direction of turning is changed, to the right instead of the left. The result will be exactly the same. The other two quadrants are done in a similar manner. In the quadrant left of a (see Fig. 130), turn your brush left; in the last quadrant, the brush turns right.

## DRY BRUSH, KU PI

A brush with scant moisture is used to achieve a dry texture within a line. The line may be fairly dry, or very dry, depending upon the kind of effect that the artist wants to attain.

Dry brush is mainly employed in landscape painting. In calligraphy, also, many artists like to use this technique to enrich the textural effect. Figure 133 is an example of Hsing script by the well-known calligrapher, Chen Hsian-Chang of the 16th century. The dry lines suggest a mature and straightforward expression; in other words, none of the lines are "prettied up" at all. (This artist, it can be seen, was deeply influenced by Yen Ch'en-Ch'ing; see Fig. 32). Generally, a dry texture in calligraphy indicates a deep feeling, like the thoughts of a person mellowed by age and experience. It would be difficult for a young person to produce the kind of rugged and direct lines in Figure 133. Each dot is full of vitality.

In the painting of landscapes, especially when the Po Mo or layered ink method is used, one usually starts the rough draft of the composition with a very vague outline done in dry brush, or very dry brush, so that there is plenty of room for alteration. Figure 134 shows some examples of the drafts of rock formations.

In using dry brush, no matter how dry the brush is, the line must be kept quite clear. It will be muddy if one tries to go back over the line. In order to maintain the clarity of the line, the speed

*Figure 133.* Hsing style of writing with dry brush by Chen Hsian-Chang.

must be kept very low; otherwise, the line quality will be feathery, lacking an expression of strength.

The bark of some mature trees is rough; therefore, it is appropriate to use dry brush to inject that effect of coarseness (see Fig. 135).

The color and the degree of dryness can be controlled. Figure 136 illustrates this. The darker color indicates proximity; it gives the feeling of depth.

## SPLIT BRUSH, PO PI

Split brush may also be considered as a kind of Ku Pi, or dry brush, for the effect of the line is caused by the paucity of water in the brush. This kind of brush stroke usually serves to provide a certain dry textural effect in both painting and calligraphy, and is especially useful in painting such subject matter as dry grass, feathers and fur.

Split brush is achieved by a forced twist of the brush, where the bristles, instead of holding to one point, are parted into many points; actually, the brush is divided into many small brushes. The advantage of split brush is that many lines or dots can be achieved by a single stroke.

Figure 137 is an example of painting a tassel of reed in just a few strokes. The illustrations on the left show how much can be accomplished by one split-brush stroke. The one stroke, 137a, represents many seeds. The stroke is done by a stabbing movement of the brush. The other stroke, 137b, shows a series of lines representing the stems which are holding the seeds. With proper control, each split-brush line can be divided into five, ten or more lines; however, the effect goes

*Figure 134.* Examples of rocks by using dry brush.

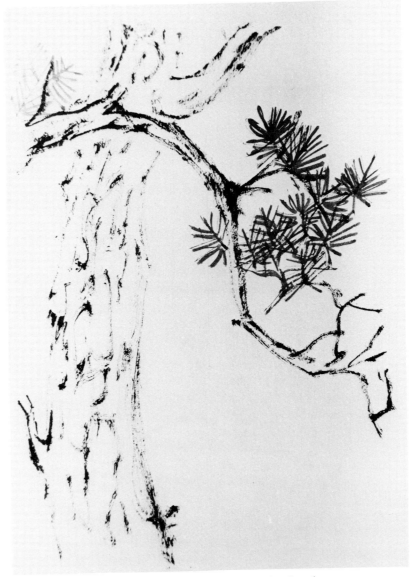

*Figure 135.* Pine tree by using dry brush.

beyond the mere rendering. With this technique the artist can create the illusion of many lines—suggesting much more than has actually been painted.

To obtain a split brush, one should first get rid of most of the water contained in the brush; then, push the side of the brush with some pressure against the edge of the ink stone, or any other hard surface such as a palette or dish. While the brush is in close contact with the hard surface, twist it slightly to the left and move the brush downward; this forces the brush to open, and form a comb-like brush, like many tiny brushes linked together (see Figure 138a). It will stay that way, for the brush is dry, and the friction between the hairs holds the brush and keeps it from springing back to its original state. One can keep this split state as long as the water and ink in the brush are adequate. Too little ink makes the brush too dry to obtain a sufficient image on the paper; if too wet, the brush may spring back, and the split state is broken.

If one moves the brush in a straight-way direction, the result will be a wide line, actually made

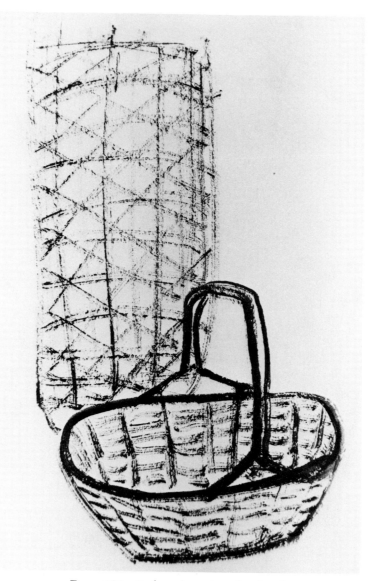

*Figure 136.* Baskets by using dry brush.

up of a group of lines (see 138b). If the brush were to be drawn crosswise, then a narrow line would result (see 138c), a line more easily achieved through center brush. By changing the direction of the line, as seen in 138d, many variations can be effected. Notice that in the first and last strokes of 138d, a folding split brush was used. One can paint in any direction with a split brush, but the split, as originally made, must always be maintained. Therefore, one must constantly maneuver the brush so that it is moving in a direction that will not disturb or alter the original split. Otherwise, the split state will be ruined. These are the basic elements of split-brush technique.

Figure 139 shows how the suggestion of feathers can be attained. In using this technique, very little pressure is exerted. The speed is very fast. Thus, the light feathery effect is produced.

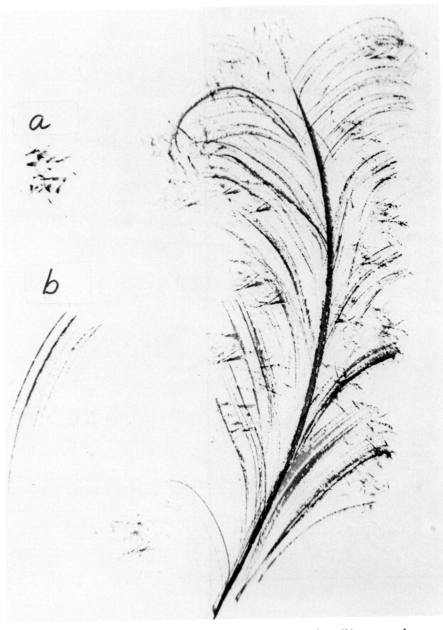

*Figure 137.* Tassel of reed by split brush. *(a)* one dot; *(b)* one stroke.

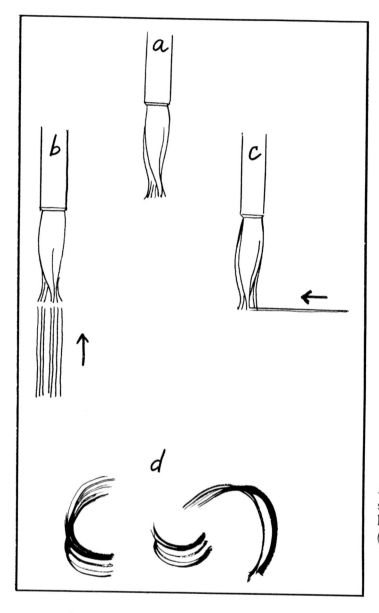

*Figure 138.* Split brush. *(a)* the shape of a split brush; *(b)* painting straight way, a wide line; *(c)* painting crosswise, a narrow line; *(d)* turning and folding with a split brush.

To illustrate further the use of split brush in depicting feathers, a bird's wing is shown in Figure 140. By varying the moving angles, thus twisting the split brush, different shapes and types of feather are produced. Some softer and shorter; the others, longer and stiffer. Also, by changing the pressure of the brush, some feathers are narrower, some much wider.

Drawing and painting do not mean merely a combination of lines; they imply form, texture, light and dark contrast—an entire structure—above all, a unity and lively expression. Split brush is often used to achieve these results.

In calligraphy, especially the "Grass Style," because of the exhausted ink in the brush or a fast turning, split brush occurs often, adding to the textural effect (see Fig. 50). In calligraphy, the term

*Figure 139.* Bird by split brush.

*Figure 140.* Example of split brush. A bird's wing. *(a)* light pressure, slant-wise movement of the brush; *(b)* cross-wise movement of the brush with heavy pressure; *(c)* five o'clock moving angle with medium pressure.

*Figure 141.* Example of Fei Pai by Monk Hsu T'ang.

*Figure 142.* Dog by using split brush.

*Fei Pai*, or "flying white," is employed. It suggests the feeling of inner space within a Po Pi line (see Fig. 141). In Figure 75, note that whenever a split brush effect is achieved, that portion of the stroke was preceded by a sudden, heavy pressure of the brush, which caused the brush to split, and gives interest to the expression of the line.

Split-brush technique is especially useful when one paints animals. The pressure must be very light, and the speed, as in painting birds, must be quite swift, so as to achieve the fluffy effect. The brush should be kept fairly dry, yet, at the same time, each stroke must be definite and strong (Fig. 142); otherwise, the whole image can be ambiguous, and lack strength.

Split brush should not be confused with "slip brush" (see the third line from the top in Figure 107). Slip brush is the result of too much speed, especially at the end of a line. It is not a solid line, and the

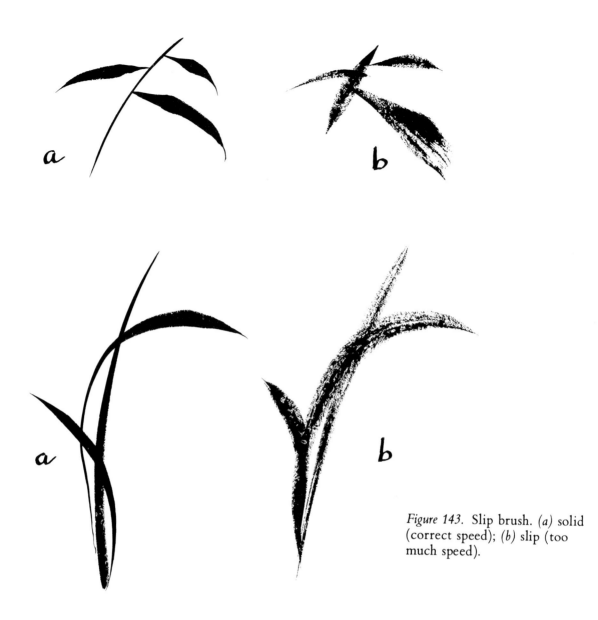

*Figure 143.* Slip brush. *(a)* solid (correct speed); *(b)* slip (too much speed).

shape is obscure. It is without strength, and consequently not alive. However, slip brush is useful for painting fluffy feathers and furs. It would be an absolute mistake in painting bamboo or orchid leaves (see Fig. 143) which should be done at a slower speed than slip brush to achieve solidity.

## TURNING AND FOLDING BRUSH

The turning and folding of the brush, movements which effect a change in the direction of the line, are as important as the changing tempo, the rising and falling rhythms, in music and dance. Each change will inevitably involve a momentary halt, and the halt is a preparation for the succeeding movement. As a line is being drawn, the bristles are bent to some degree; turning or folding brush serves as a rest, at which time the brush springs back and regains its elasticity and is thus ready to make a new line. In painting and calligraphy there are bound to be many such fleeting hesitations

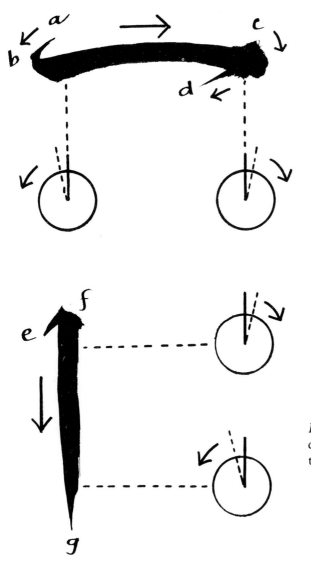

*Figure 144*. Turning of the brush. The circle represents the "bird's eye view" of the brush.

and halts, which, owing to the changes of pressure and speed, produce variations in the lines. In calligraphy, this technique is used in almost every word to give character and interest to a line or to the composition as a whole.

### Turning Brush, Chuan Pi

Turning brush is the movement of the brush as it is twirled on its axis. If the brush is in a side position, its turning is called rolling. Turning involves two actions, a twist of the brush holder, and a change in the position angle of the brush.

Figure 144 shows how the brush is turned in making a line. The horizontal line starts from a and

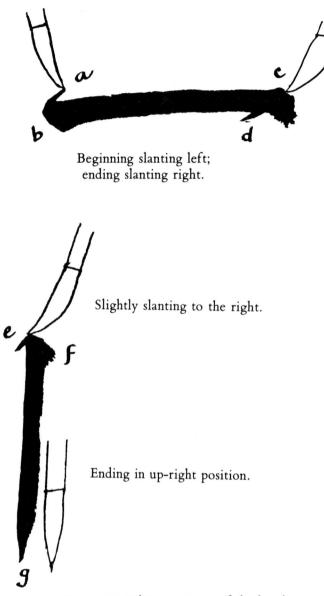

Beginning slanting left;
ending slanting right.

Slightly slanting to the right.

Ending in up-right position.

*Figure 145.* Tilting position of the brush.

halts briefly at b where the brush handle is rotated slightly to the left. The next movement is from b to c, where again there is a halt; here, the brush handle is twirled slightly to the left and downward to d, but d usually exists "in the air," above the line itself. Note that the handle was turned right during the movement from b to c, but left at c. As to the vertical line illustrated in Figure 144, the line goes from e to f, where at the halt the brush holder is rotated to the right; as the brush moves downwards, the handle is slightly turned left all the way down.

The next factor involved in turning the brush is the change in the position angle of the brush during the turn. For example, in Figure 145, the horizontal line starts from a, with the brush leaning first to the left, at about an 80 degree position, pointing to "8 o'clock." At b, the brush is

*Figure 146.* *(a)* Folding brush; *(b)* Rolling brush.

brought to a perpendicular position, and moved to c, where at the end of c the brush will be leaning in an 80 degree position again, but this time pointing to the right toward "2 o'clock."

## Folding Brush, Cheh Pi

Folding brush is used when a sudden change of direction is desired, usually when the brush is in a tilted position. The brush tip is actually folded over, resulting in a sharp shape, a stroke used for example to capture the abrupt twist of a blade of grass or reed. This technique is essential particularly for a calligrapher, for within every word there is Cheh Pi (see Fig. 50).

Figure 146 illustrates the effect of folding brush. (See also Fig. 2) Usually the brush should take a tilting position and move slantwise, halt, and head in the opposite direction. It is best to use split brush for good results. Figure 146a is an example of sharp folding. Figure 146b shows the result of a slow, or gradual folding; this is an example of rolling brush. (See also Fig. 2)

In painting, turning, rolling and folding brush are often employed to portray vine subjects, such as grapes, squashes, gourds, morning glories, etc. Figure 147 is an illustration of a wisteria vine. Both center and side brush were used. In painting vines, the brush should be used freely, as if a horse were galloping in a field. However, the rider must be in full control, and lead the horse in the right direction. In other words, all the free arrangement must be under discipline, *i.e.*, the principles of composition. Notice the joints, wherever a change of direction occurred. Every new direction is indicated on the illustration by an arrow. In the Mad Grass style, this turning technique is most evident. Turning, rolling and folding techniques are important means of bringing out the dancing spirit of the lines, the vigor and vitality of a work of painting or calligraphy.

———————

The above analysis of the major strokes by no means exhausts the range of Chinese brushwork, for the art combines and utilizes the various strokes and techniques in a myriad ways, just as in music, infinite and widely varied sounds are produced by the combination of the seven basic notes.

Watching a true master at work, as his brush tips, rises, twirls, halts, glides—all in one continual, flowing movement—an onlooker will inevitably conclude, "Why, the brush is actually dancing!" I have experienced this reaction many times.

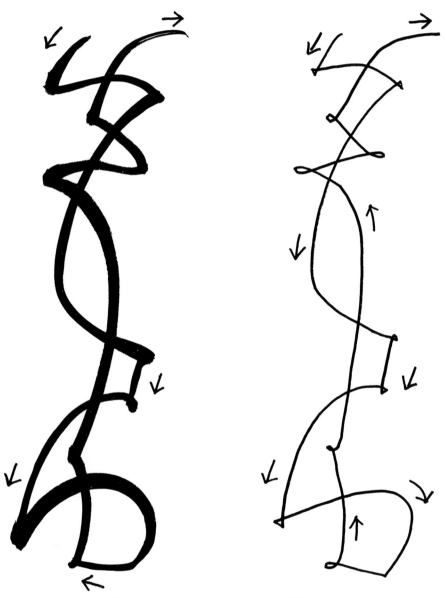

*Figure 147.* Example of turning brush: Wisteria vine.

# 15   *Principal Ways of Using the Ink*

People usually admire an outstanding artist's work and say, "What a marvelous Pi Mo!" Since Pi means brush, and Mo ink, they are referring to a superb control of the brush and ink—a mature technique. The handling of ink is as important as the art of wielding the brush.

## SIDE-INK, PIEN MO

In 1967, Dr. K.C. Yeh, a former ambassador to the United States, took me to visit Mr. C.P. Huang, a leading artist in Taiwan. Mr. Huang queried me about my painting *Balance* (see Fig. 148), wondering how it was possible to paint the lever of the balance in both light and dark ink in one stroke. Mrs. Huang ground some ink, and I demonstrated the "side-ink" technique. Mr. Huang clapped his hands and was indeed satisfied with the demonstration.

Side-ink in one-stroke painting is a most important technique, one which has been almost completely neglected by artists. The reason for its use in one-breath painting is obvious. Without this technique, the ink in the brush would be evenly blended, and when put on paper, would result in an even color, light gray or dark gray—flat, static, and lacking tonal effect, thus a dead color. In order to produce a vivid liveliness, tonal color is necessary, and when painting in the Hsieh Yi manner, it is achieved only by using side ink.

The side-ink method is rather simple. One first rinses the brush in water and while it is wet, its side (usually about one-quarter to one-third of its length) is dipped in ink and immediately brought to the paper. The result is that one side of the line will be dark while the other side light (see Fig. 149a), giving a three-dimensional effect. It is also possible to dip both sides of the brush, for drawing the stems of flowers (see Fig. 149b). In fact, one can take on color at various portions of the brush. After dipping the brush in the ink, one must use the brush at once, for as soon as the brush picks up the ink, it starts to run within the brush. If one waits too long, the ink will become completely blended.

The possibilities of side-ink technique are quite unlimited. Figure 150, from a to b, shows a wide range of color tone while the brush is twisting and rolling. This technique can be used for drawing many things, such as stems, leaves, petals, vines, rock, grass, etc. Even with a dot, which is to represent a tadpole, a cherry, or a lady bug, in order to achieve roundness of body, the side-ink method is a necessity.

This approach is by no means limited to black ink. In using colors, too, the same sort of contrasting effect can be achieved in the same stroke. For instance, if one saturates the whole brush

鉤上加一鼠屈之為自稱
予常有告做法吾不用自贈白石題

*Figure 148. Balance* by Kwo Da-Wei. Calligraphy by Ch'i Pai-Shih. Collection, Princeton Art Museum, Princeton, N. J.

170

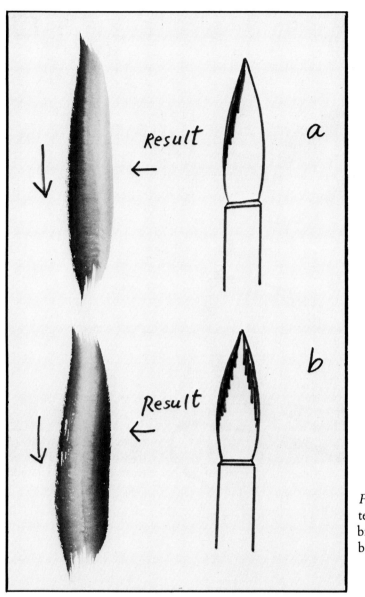

Result

Result

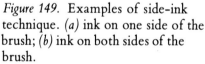

*Figure 149.* Examples of side-ink technique. *(a)* ink on one side of the brush; *(b)* ink on both sides of the brush.

with green color, and then takes on some yellow on about half of the brush at the tip end, and at the tip itself finally picks up a little bit of red, then, when the brush is put to the paper, by increasing the pressure as the line is continued, the result will be a pimento with a red tip, then some yellow, finally the green body. It almost looks magical, but it is not difficult if one knows the secret.

In side-ink painting, if the brush becomes too dry and more water is needed, one should add the necessary water not by dipping the tip but by immersing the side or that portion of the brush which has not taken on any ink. This prevents the ink from becoming too blended or diffused. This I call side-water technique.

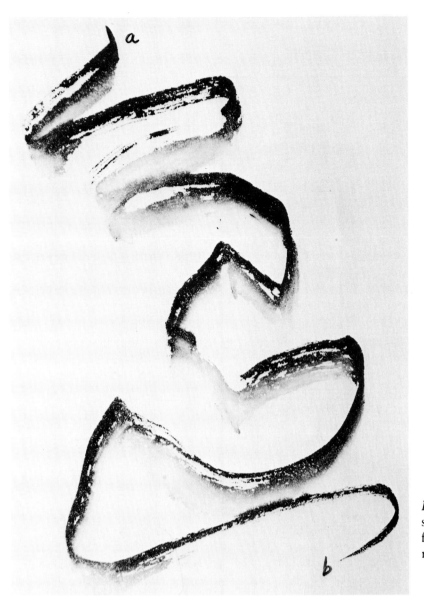

*Figure 150.* Variations of side-ink effect. The line from *a* to *b* shows a wide range of color tone.

## PO' MO OR WASH*

The wash technique used in Chinese painting differs from the Western approach, which generally refers to the spreading out of colors as a general background or under-coat of a base tone. Po' literally means to pour or splash. It is obviously a wet execution, with plenty of water in the brush, and the brush is applied to the paper in a very spontaneous manner. Po' Mo, naturally, is used for making a surface, not a fine line. The complete surface is finished in one breath while the ink is wet.

Figure 151 is an excellent illustration showing this one-application method of using the ink.

*The two major ink techniques, Po' Mo and Po Mo, are pronounced the same (such as in English, bow to bend, bow of a boat, bough of a tree) but are pronounced in different tones to differentiate their meaning. Po' Mo is in a high pitch, whereas Po Mo is a low tone.

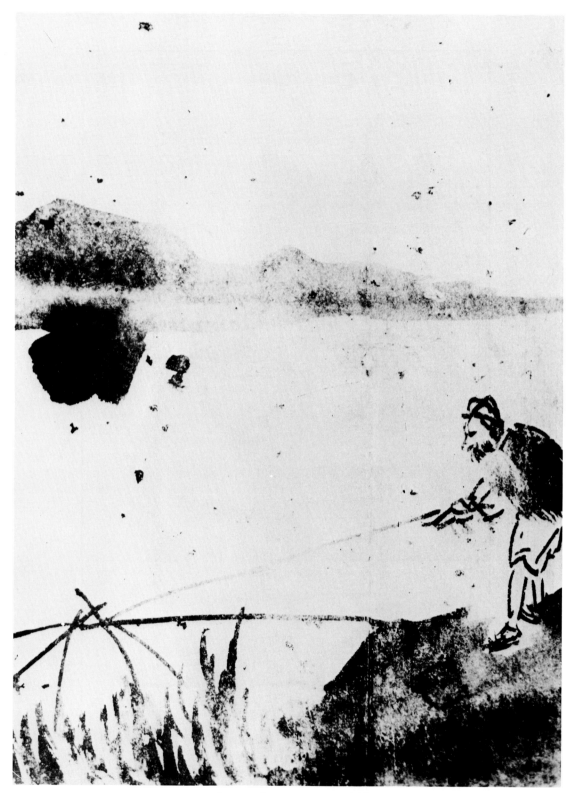

*Figure 151. Fisherman*, by Hsu Tien-Ch'ih [Hsu Wei].

*Figure 152. Kim* by Kwo Da-Wei.

Both the hill in the distance, the rock in the middle of the lake, and the boulder on which the fisherman stands were all done in one quick wash; the lines of the grass and the frame of the fishing net are all blended harmoniously with the Po' Mo. Other good examples are *The Grape* (Fig. 78), *Bottle Gourd* (Fig. 69) and the two lotus in Figure 79.

Figure 152, *Kim,* the black cat, is another example of the Po' Mo technique. Though it was done by only a few strokes, because of the watery effect, the suggestion of fluffy fur is very evident.

## PO MO OR LAYERS OF INK

Po literally means broken, and unlike Po' Mo where everything is done in one breath, Po Mo is done layer by layer: after the first layer of ink dries, another layer is added over it. This technique is used almost exclusively for the art of landscape. A mountain may need ten layers of ink before it is finished. The landscape painter must be very patient, for generally an additional layer cannot be added until the previous layer is dry, or the blending will cause muddiness. (see Fig. 153)

In Figure 154, the contours of the "five old men" as well as the rest of the rocks, were drawn with light ink, then tinted by darker ink. Afterwards, a still darker ink was added, and, finally, high-lighted by black dots and lines. Po Mo gives an effect of dry texture, such as that of rough carpet or burlap.

## MO GU OR NON-BONE TREATMENT

Since black ink is considered the sinew color in Chinese art, painting in color in which no black ink is used is called non-bone painting or *Mo Gu.* Yun Shou-P'ing (1633-1690) promoted this type of painting. Realizing that he could not excel his friend Wang Huei (1632-1717) in the realm of landscape, he embarked in a new direction, painting without black ink. Western art experts sometimes erroneously apply this term to a form which has been painted without a contour line added to it, such as, for example, a Po' Mo wash rendering of a leaf or a frog's leg, all done in one stroke. Non-bone treatment is painting without black ink, not without outline.

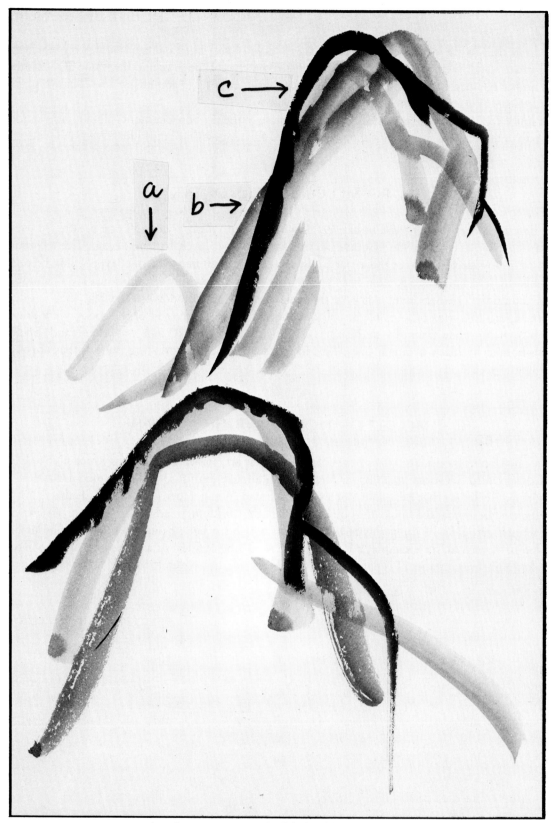

*Figure 153.* Example of Po Mo approach. *(a)* third layer of ink; *(b)* second layer of ink; *(c)* first layer of ink.

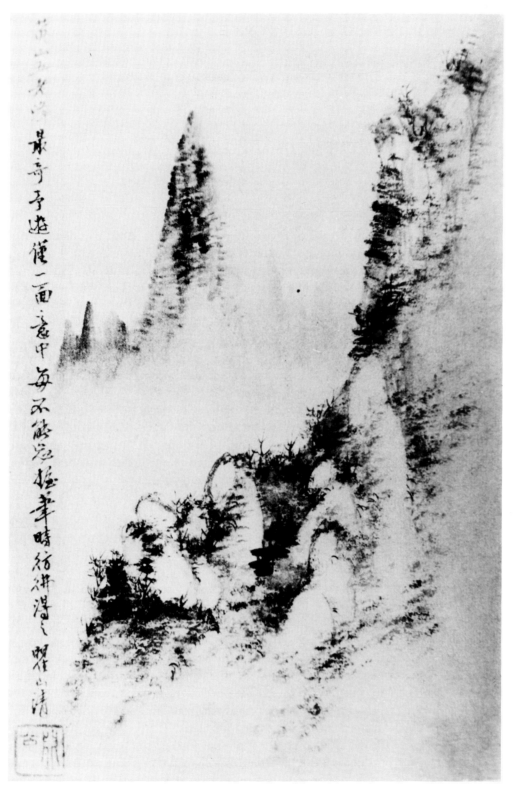

*Figure 154. Peak of the Five Old-Men,* by Mei Chu-Shan.

# 16    Pi Li, or Strength of the Line

The Chinese have a saying, "It is hard to reveal the bone structure when one paints a tiger." It means that the fur is easy to reproduce, but the inner structure is difficult to depict. The importance of bone-treatment to achieve a vigorous and vital line has been discussed above. This provides the imbedded structure which allows the line to stand up with energy. The effect of tendons and muscles lies in the tension generated between the two ends of a bone-treated line. The blood is the energy or movement pulsating through the line or lines. The flesh is created by the water and ink or color. Therefore, how one handles pressure and speed will make all the difference in relation to what kind of flesh is produced. For example, more water and lower speed will produce a fat line or dot. A well blended line executed with proper skill, such as the correct pressure and speed, will appear to be solid and strong.

If a line is well organized, the liveliness comes naturally. Consistency of line quality is the secret. In executing a line, one should feel confident, and at no time should one hesitate, or the Ch'i or spirit will be broken. I must reiterate: One column of writing, or in painting, one branch of blossoms—in fact, the whole composition—must be finished in one breath or concentration, so as to gain a harmonious oneness. Motion and emotion are the fundamental forces of life. Therefore, these basic elements must be imparted in the work of art.

## ELASTICITY

How does one make a strong line with a soft brush? The key word in answer to this important question is "elasticity" or "resilience" of the brush. A good line must show its solidity. It should show that it has a hold on the paper. It must not look as if it were just resting on the surface, so that one could blow it right off. Many art critics in the past have described this strength in these words: "The line is so strong that it penetrates to the back of the paper." This does not mean that the brush is strong enough to pierce the paper. It means instead that the line is seriously made, and that every part of the line is securely in contact with the paper. Both edges of the line are clearly depicted; at the same time, the tonal effect of the line helps to show the roundness of the line. The elastic look of a line is indeed a crucial factor in making the line look alive.

The most crucial rule for the artist to master is always to keep the brush alive by utilizing its resiliency whenever the brush is at work, whether making a dot or a line. In other words, after pressing the brush down, it should be given a chance to spring back again by releasing the pressure on it. Only a brush with its springing power restored can push the ink solidly onto the paper, and make a line look strong. Otherwise, the edges of the line will be ragged and uncertain, and therefore weak.

In order to maintain the springing force of the brush, all the fundamental principles should be properly observed, such as moisture, pressure, speed, etc. The brush should not be "punished." When all the theories and principles of brushwork are boiled down, the word "elasticity" is the essence. The resilience of the brush is the secret of Pi Li, the strength of a line.

# The Role of the Seal (Yin) in Painting and Calligraphy

A seal plays an important role in the composition of a painting or calligraphy. It does not serve merely as personal identity, but is an integral part of a work of art.

What is the function of a seal? Often, it serves to provide balance in a composition, and adds additional interest by its own intrinsic merit. Its style should be harmonious with the lines of the calligraphy or painting.

A seal enriches the content of a work—just as dessert does dinner. Although its size is small, it provides infinite pleasure as one examines it. Its lines are as beautiful as the lines in painting or calligraphy. The design of a seal can be compared to that of a miniature painting. Every tiny space must be thought out very carefully. Every dot is crucial in the harmonious oneness of the design.

In Figure 76, the seal in the lower left of the composition serves as a balance to the writing on the upper right. Without the seal, the entire lower space would have been empty. When a seal is so used, it is called a "balancing-foot" seal— a compositional seal.

In Figure 155, a calligraphy by Ho Shao-Chi, two seals are used. The one on top reads *Ho Shao Chi Yin*, or the seal of Ho Shao-Chi, executed in positive lines (red words or *Chu Wen*); in the one below, the two words are *Tze Chen*, his pen name, executed in *Pai Wen*, or negative lines (white words). The second seal is a bit heavier than the upper one, but balances well the column of writing. Without the second seal, the first would appear to be too light for the heavy writing.

Improper use of seals can damage an art work. Figure 156 is an inscription by Wang Yuan-Ch'i of the 17th century. His style of writing, compared with that of Ho Shao-Chi, is rather delicate; therefore, the seals he used are slender and match his calligraphy suitably. One is his name seal, the other, his pen-name seal, which reads *Lu Tai*. Above his signature, there are two seals by critics who thus expressed their approval of the art work, called "appreciation" or "connoisseur" seals. On the left side, there are four other seals, which are both appreciation seals as well as collectors' seals. The two on top obviously are not appropriate, as they block the picture space, and look quite intrusive or aggressive. However, those on the left are much better placed in this composition, although by comparison they overpower the artist's seals. A collector has the right to add his seal to a painting; however, he should not invade the original composition, lest he spoil it by his bad taste.

*Figure 155.* Calligraphy by Ho Shao-Chi.

Another example of poor taste in the use of seals is on the landscape by the famous Yuan painter Ni Tsan (1301-1374) (see Figure 157). The numerous seals on this painting are a result of its passing through so many hands. Though some are appreciation seals, most of them are collectors' seals. This painting ultimately ended in the Emperor's palace in Peking.

Ethically, the collector should be modest and place his seal[1] at the lower corner, or in any hidden position in the composition so as not to affect the original work in any way. However, most of the pieces at the palace collection unfortunately were marred by the Emperors, especially Chian Lung (reigned 1736-1796). Since his seal was set in the center, right on top, many compositions suffered this intrusion. The Emperor apparently liked Ni Tsan's painting, for he also added seals in the sky of this landscape, thus blocking the air from flowing freely. The poem of the artist suffered even more, having been partially covered by the heavy royal seal. In my opinion, the only seal in proper position is the lower one in the middle of the composition on the left, for it links the main mountain with the peninsula, helping to unify the composition; otherwise, the picture seems to be cut into two halves at the waist line. (see also Fig. 77)

Seal-carving is another form of writing. No line, once done, allows for any re-touching, otherwise, the line becomes muddy, just as when one goes over his own signature. In the art of iron-brush, Ch'i Pai-Shih is especially famous for his technique of "single-stroke treatment." One

古雖嘗學古者列遊日不敢懈之　　法嘗不可泯而心或遇之若謂余

先生以為然否

王原祁題

*Figure 156.* Calligraphy by Wang Yuan-Ch'i.

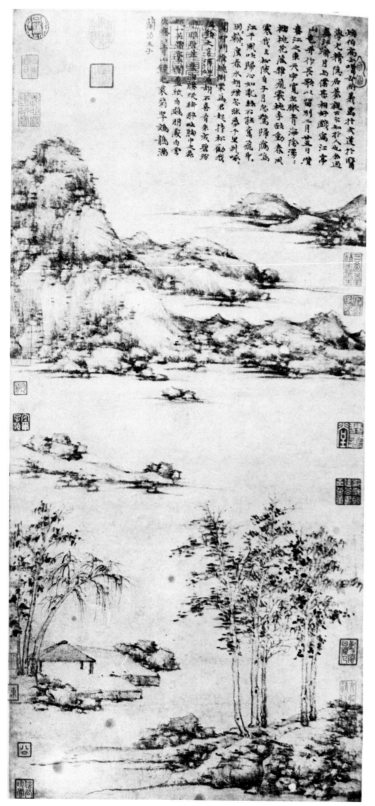

*Figure 157. Landscape,* by Ni Tsan. Courtesy of the National Palace Museum, Taiwan, Republic of China.

may use the "double-stroke" technique*, but, one can use only one stroke for each edge of the line; no cheating is allowed—it would be clearly detected.

Every Chinese artist tries to get his personal seal or seals engraved by a good hand, a famous hand if possible. Nine of my personal seals were done by Ch'i Pai-Shih.

# *Conclusion*

Once, after lecturing before the Malaysia Art Council, I was asked by an English curator, during the question period, why all Chinese paintings looked alike. I replied that the reason was the same why Orientals, when first coming to the West, are unable to differentiate between the various European nationalities—lack of exposure and not being familiar enough with the subject to know where and how to look for the variations and telling characteristics. May this study help prevent you from ever making such a *faux pas*.

Often I am asked, "Does a Chinese artist ever paint an abstract painting?" Of course—calligraphy is nothing but abstract painting. A piece of calligraphy possesses all the elements of a painting—form, space, line, color, texture, movement, composition, etc.

A Sung calligrapher, a thousand years ago, named Lei Chien-Fu, once, while resting on his studio couch during the day, heard the roar of the incoming tide. He started to visualize the chase of the waves—high and low, fast and slow—and was moved to capture this motion on paper. He grasped his paint brush and wrote a piece of calligraphy. Thus, he exhausted his inspiration of the moment within this writing. That rendering was nothing but an abstract painting.

May you experience, at least once, in viewing a Chinese calligraphy, the aesthetic excitement of being conscious of the artist's sentiment and feelings at the time when he was creating his work. The secret is to imagine or, better, actually to follow with a brush, the brush strokes of the work of art. From the turnings and movements of that brush one should be able to sense the sentiment being expressed by the artist.

In viewing a Chinese painting, may you soon come across one that will compel you to come back, again and again, to view it, and each time that you do, may you discover within it some new meaning, some new interest, some new detail that escaped you previously. Chinese painting, with its economy of line, simplicity of form, imaginary perspective and light source, leaves much room for the imagination of the onlooker to fill in the details. That is your task.

I am certain that many of my readers have already tried or might now be tempted to wield the

---

*Double-stroke is to carve a line by two strokes, one cutting on each side of the line.

Chinese brush—an excellent way to appreciate what brushwork is all about. If you do, perhaps the advice given me by my teacher Ch'i Pai-Shih will also fruitfully guide you:

> Be bold but careful
> Diligence will bring perfection
> With these eight words
> A man can travel successfully
> Anywhere under the sky

*Figure 158.* The advice of Ch'i Pai-Shih.

# *Appendix: Chronological Charts*

I.  Chronological Periods

| CHINA | | B.C. | EUROPE |
|---|---|---|---|
| Ideogram<br>Red Pottery<br>Black Pottery<br>c. 7000-1600 B.C. | | 7000<br>6000<br>5000<br>4000<br>3500<br>3000<br>2500<br>2000<br>1500 | Cretan Art |
| Shang Dynasty<br>c. 1600-1027 B.C. | | | Mycenaean Art |
| Western Chou<br>1027-722 B.C. | | 1000 | Archaic Greek |
| Eastern Chou | Spring and Autumn<br>722-481 B.C. | 500 | |
| | Warring States<br>481-221 B.C. | | Hellenic Classical |
| Ch'in Dynasty 221-206 B.C. | | | Hellenistic Art |
| Western Han 206-9 B.C. | | | |
| Hsin Dynasty 9 B.C.-25 A.D. | | 0 | |
| Eastern Han 25-220 | | | Art of the Roman Empire |
| Three Kingdoms 220-280 | | | |
| Six Dynasties 280-580 | | 500 | Early Christian and Byzantine |
| Swei Dynasty 581-618 | | | |
| T'ang Dynasty 618-906 | | | Carolingian and Ottonian |
| Five Dynasties 907-960 | | 1000 | |
| Northern Sung 960-1127 | | | Romanesque Art |
| Southern Sung 1127-1279 | | | Gothic Art |
| Yuan Dynasty 1279-1368 | | | |
| Ming Dynasty 1368-1644 | | 1500 | Renaissance Art |
| | | | Baroque Art and Rococo |
| Ch'ing Dynasty 1644-1912 | | | Modern Art |
| | | 1900 | |

A.D.

II.    Chronological Table of Calligraphic Styles

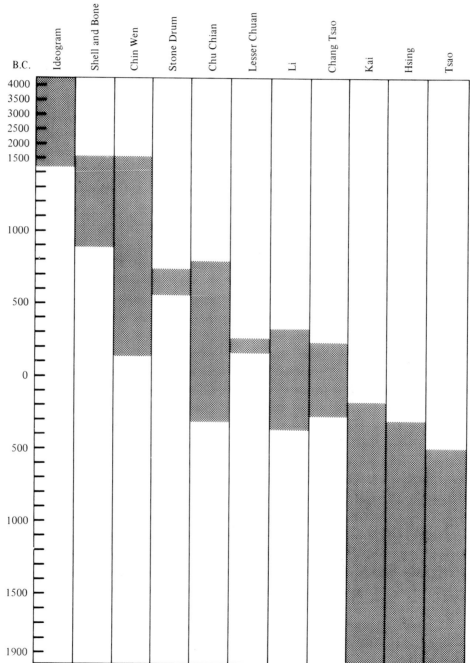

III. Chronological Table of Dominant Painting Subjects

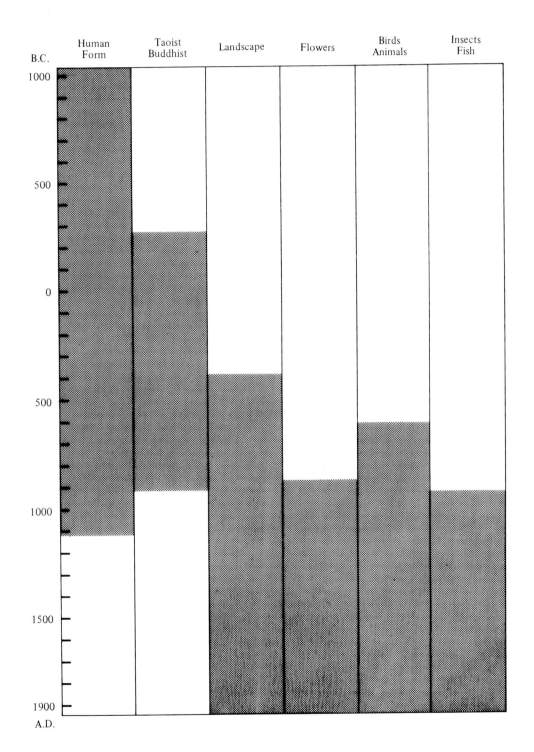

# Chinese Terms Found in the Text

| ENGLISH | ROMANIZED | CHINESE |
|---|---|---|
| Academic or court (style) | *Yuan Hwa Pai* | 院畫派 |
| Artificial sophistication | *Chiao* | 巧 |
| Ba Fen (style) | *Ba Fen* | 八分 |
| Balance | *Chun Heng* | 均衡 |
| Balancing-foot seal | *Ya Chiao Chang* | 壓脚章 |
| Bamboo Tablet (style) | *Chu Chien* | 竹簡 |
| Bell and Pot (style) | *Chung Ding* | 鐘鼎 |
| Bird (style) | *Niao Shu* | 鳥書 |
| Bird's eye view | *Niao Kan* | 鳥瞰 |
| Bone | *Ku* | 骨 |
| Bone treatment | *Ku Fa* | 骨法 |
| Brush | *Pi* | 筆 |
| Center brush | *Chung Feng* | 中鋒 |
| Chinese Buddhism | *Ch'an Tsung* | 禪宗 |
| Composition | *Chang Fa* | 章法 |
| Density | *Mi* | 密 |
| Depth | *Shen Du* | 深度 |

| | | |
|---|---|---|
| Detailed painting | *Kung Pi* | 工筆 |
| Double stroke carving | *Shung Dao* | 雙刀 |
| Dry brush | *Ku Pi* | 枯筆 |
| Dynamic expression | *Da* | 大 |
| Eight Eccentrics | *Yang Chow Ba Kuai* | 揚州八怪 |
| *Elasticity | *Tan Li* | 彈力 |
| Elegant | *Ya* | 雅 |
| Folding brush | *Che Pi* | 折筆 |
| Form | *Hsing Hsing* | 形象 |
| Grass script | *Chang Tsao* | 章草 |
| Grass (style) | *Tsao Shu* | 草書 |
| Greater Chuan (style) | *Da Chuan* | 大篆 |
| Harmonious life-force | *Ch'i Yuen* | 氣韻 |
| Harshness | *Ban K'o* | 版刻 |
| Hollow (negative space) | *Hsu* | 虛 |
| Host-and-guests concept | *Ch'u Bin* | 主賓 |
| Ideograms | *Hsiang Hsing Wen Tze* | 象形文字 |
| Ink, black | *Mo* | 墨 |
| Ink, non-black | *Ts'ai-So* | 彩色 |
| Inkstone | *Yan* | 硯 |
| Interlaced book | *Bien Chien* | 編簡 |
| Iron brush | *Ti Pi* | 鐵筆 |
| Layered ink | *Po Mo* | 破墨 |
| Lesser Chuan (style) | *Hsiao Chuan* | 小篆 |
| Li (style) | *Li* | 隸 |
| Light-and-dark | *Kuang An* | 光暗 |
| Line | *Hsian* | 線 |
| Literary flavor | *Shu Chuan Ch'i* | 書卷氣 |
| Looseness | *Shu* | 疏 |
| Mad Grass (style) | *K'uang Tsao* | 狂草 |
| Metal (style) | *Chin Wen* | 金文 |
| *Moisture | *Shuei Fen* | 水份 |
| *Moving angle | *Yuen Pi Chiao Du* | 運筆角度 |

| | | |
|---|---|---|
| Negative | *Yin* | 陰 |
| Non-bone treatment | *Mo Ku Fa* | 沒骨法 |
| Official writer | *Kuan Ko Ti* | 館閣體 |
| "One breath" | *Yi-Ch'i* | 一氣 |
| Perspective | *Tou Shih* | 透視 |
| *Point brush | *Chian Pi* | 尖筆 |
| *Position angle | *Kao-Di Pi* | 高低筆 |
| Positive | *Yang* | 陽 |
| Positive Space (Solid) | *Shih* | 實 |
| *Pressure | *Ya Li* | 壓力 |
| Print (style) | *Kai* | 楷 |
| Professional calligrapher | *Shu Chia* | 書家 |
| Profound art work | *Chung* | 重 |
| *Pulling brush | *Tuo Pi* | 拖筆 |
| Raw | *Sheng* | 生 |
| Reciprocal motion | *Wang Fu* | 往復 |
| Rice paper | *Hsuan Chih* | 宣紙 |
| Ripened | *Shu* | 熟 |
| *Rolling brush | *Kuen Pi* | 滾筆 |
| Scholar-painter (style) | *Wen Jen Pai* | 文人派 |
| Seal | *Yin* | 印 |
| Seemingly awkward expression | *Chuo* | 拙 |
| Shell and Bone (style) | *Chia Ku* | 甲骨 |
| Side brush | *Pien Feng* | 偏鋒 |
| *Side-ink | *Pien Mo* | 偏墨 |
| Simplified painting | *Hsieh Yi* | 寫意 |
| Single stroke carving | *Tan Dao Fa* | 單刀法 |
| Six Methods | *Liu Fa* | 六法 |
| Slim-gold calligraphic (style) | *Shou Chin* | 瘦金 |
| Slip brush | *Piao Pi* | 飄筆 |
| Sluggishness | *Chieh* | 滯 |
| Space-consciousness | *K'ung Chien Kan* | 空間感 |
| *Speed | *Su Du* | 速度 |

| | | |
|---|---|---|
| Speedy script | *Chi Chiu Chang* | 急就章 |
| Split brush | *Po Pi* | 破筆 |
| Stiff | *Ban* | 版 |
| Stone Drum (style) | *Shih Ku* | 石鼓 |
| Tendon | *Chin* | 筋 |
| "The Way" | *Tao* | 道 |
| *Three-dimensional | *Li Ti* | 立體 |
| "Too sweet" | *Tien* | 甜 |
| Turning brush | *Chuan Pi* | 轉筆 |
| Vigorous strength | *Li* | 力 |
| Vital life-force | *Ch'i* | 氣 |
| Void (nothingness) | *Wu* | 無 |
| Vulgar | *Su* | 俗 |
| Walking Grass (style) | *Hsing Tsao* | 行草 |
| Walking Script | *Hsing Shu* | 行書 |
| Wash | *Po' Mo* | 潑墨 |

*No exact Chinese word or phrase exists for this art term; a Chinese equivalent is included for the benefit of Chinese-speaking readers.

# Bibliography

## Materials in Chinese
### HISTORICAL DEVELOPMENT

Cheng Chang. *History of Chinese Painting*. Taiwan: Chung Hwa Book Co., 1966.
　鄭昶　中國畫學全史

Chian Mu. *An Outline of Chinese History*. 2 Vols. Taiwan: National Editorial Bureau, 1960.
　錢穆　國史大綱

Chiang Shan-Kuo. *The Origin and Structure of Chinese Characters*. 2 Vols. Shanghai: Commercial Press Ltd., 1933.
　蔣善國　中國文字之原始及其構造

Chu Fang-Pu. *Shell and Bone*. Taiwan: Commercial Press, Ltd., 1972.
　朱芳圃　甲骨學

*Encyclopedia of Chinese Art*. 40 vols. Ed. by Hwang Pin-Hung and Teng Shih. Taiwan: Kwang Wen Book Co., 1963.
　美術叢書　黃賓虹　鄧實

Feng Chen-Kai. *History of Chinese Calligraphy*. Taiwan: Art Books Co., 1974.
　馮振凱　中國書法史

Hsiao Hsiang-Wen. *Outline of Chinese History*. Taiwan: Ming Shan Book Co., 1972.
　蕭翔文　本國史概要

Hsu Shen. *An Analysis of the Structure of Chinese Characters*. Shanghai: Commercial Press, Ltd., 1933.
　許慎　說文解字

Hu Shih. *History of Ancient Chinese Philosophy.* Taiwan: Commercial Press, 1961.

　胡適　中國古代哲學史

Hwai Su, Monk. *Holy Mother Album.* Ed. by Tuan Wei-Yi. Taiwan: Hsing Hsuo Publishing Co., 1973.

　僧懷素　釋懷素聖母帖　段維毅

Jung Keng. *A Compilation of Chin Wen.* Taiwan: Lo Tien Publishers, 1974.

　容庚　金文編

Ogawa, Tamaki, Kanda, Kiichiro, et al. *A Complete Study of Chinese Calligraphy.* 6 vols. Taiwan: Mainland Book Store, 1975.

　小川環樹，神田喜一郎等　書道全集

Omura Nishigoke. *History of Chinese Art.* Shanghai: Commercial Press, Ltd., 1935.

　大村西崖　中國美術史

O-Yang Hsuen. *Reproduction of the Tablet Chiu Cheng Kung Li Ch'uan Ming by O-Yang Hsuen.* Ed. by Tuan Wei-Yi. Taiwan: Hsing Hsuo Publishing Co., 1971.

　歐陽詢　九成宮醴泉銘　段維毅

Peng Yuen-Tsan. *Biographical History of Painters through the Ages.* Taiwan: Far East Pictorial Book Co., 1956.

　彭蘊燦　歷代畫史彙傳

*Ritual Vessels Tablet of Han.* Ed. by Tuan Wei-Yi. Taiwan: Hsing Hsuo Publishing Co., 1971.

　漢禮器碑　段維毅

*The Stone Drum Inscriptions.* Ed. by Tuan Wei-Yi. Taiwan: Hsing Hsuo Publishing Co., 1972.

　石鼓文　段維毅

Tai Tseng-Yuan. *Preliminary Study of Etymology.* Shanghai: Chung Hwa Book Co., 1933.

　戴增元　文字學初步

Tsien Tsuen-Hsuin. *A History of Writing and Writing Materials in Ancient China.* Translation by Chou Ning-Sun of *Written on Bamboo and Silk,* Chicago: The University of Chicago Press, 1962. Hong Kong: The Chinese University of Hong Kong, 1975.

　錢存訓　中國古代書史　周寧森

Tung Tsoo-Pin. *A Study of Shell and Bone for the Past Sixty Years.* Taiwan: Art and Culture Press, Ltd., 1974.

　董作賓　甲骨學六十年

Wu Ch'i Ning. *Practical Etymology.* Taiwan: Commercial Press, 1969.

　吳契寧　實用文字學

Yang Kia-Lo. *A Basic Study of Etymology.* Taiwan: Ting Wen Book Co., 1972.
楊家駱　文字學發凡

## AESTHETIC STANDARDS

*Album of Famous Painters.*
名人畫冊

Chang Ch'ing-Chih. *A Study of Ch'i in the Appreciation of Chinese Painting and Calligraphy.* Taiwan: Ta Lung Press Co., 1973.
張清治　氣於書畫鑑賞中之研究

Chang Hsu. *Chang Hsu Album of Ancient Poems* Ed. by Tuan Wei-Yi. Taiwan: Hsing Hsuo Publishing Co., 1972.
張旭　唐張旭古詩等帖　段維毅

Chang Yan-Yuan. *Famous Paintings through the Dynasties.* Taiwan: Commercial Press, 1971.
張彥遠　歷代名畫記

Chen Shih-Tseng. *A Study of Wen-Jen Hwa.*
陳師曾　文人畫之研究

Chih Yung, Monk. *Poem of One Thousand Words Written in Tsao Style by Monk Chih Yung.* Ed. by Tuan Wei-Yi. Taiwan: Hsing Hsuo Publishing Co., 1972.
釋智永　釋智永千字文　段維毅

Chu Ching-Hsuan. *Record of Famous Paintings of the T'ang Dynasty.*
朱景玄　唐朝名畫記

Chu Kuang-Chian. *Fundamental Theories of Aesthetics.* Shanghai: Cheng Chung Book Co., 1947.
朱光潛　美學原論

———. *On Beauty.* Shanghai: Kai Ming Book Store, 1949.
談美

Chu Lin Pa Hsian. *On Ch'an.* Taiwan: Chung Yi Society, 1970.
竹林八賢　禪學概論

Chu Ta. *Ba Ba Shan Jen Landscape Paintings.*
朱耷　八大山人山水畫冊

*Dictionary of Chinese Calligraphy.* Vols. 2, 4. Hong Kong: Hai O Publishing Co., 1975.
書法大字典

Feng Chen-Kai. *Appreciation of the Famous Examples of Chinese Calligraphy through the Dynasties.* Taiwan: Art Books Co., 1973.

　　馮振凱　　歷代名碑帖欣賞

Fu Pao-Shih. *Theories on Chinese Painting.* Shanghai: Commercial Press, Ltd., 1936.

　　傅抱石　　中國繪畫理論

Ho Shao-Chi. *Album of Hsing Shu by Ho Tze Chen.*

　　何紹基　　　何子貞行書帖

Hsu Wei. *Hsu Tien-Ch'ih Album.* Ed. by Fei Chu-Lu. Shanghai: Commercial Press, Ltd., 1934.

　　徐渭　　徐天池畫册　　肥遯盧

———. *Hsu Tien-Ch'ih's Ink Paintings of Landscapes and Figures.* Shanghai: Commercial Press, Ltd., 1934.

　　徐天池水墨山水人物畫册

Hu Shih et al. *Chronological Biography of Ch'i Pai-Shih.* Shanghai: Commercial Press, Ltd., 1949.

　　胡適　　齊白石年譜

*Hwai Su Autobiography, Monk.*

　　釋懷素自序

Hwang Shen. *Album of Figure Forms, Flowers, and Landscapes by Hwang Shen.* Shanghai: Wen Ming Book Co.

　　黃　愼　　黃癭瓢人物花卉畫册

Kang You-Wei. *Extension of the Twin Arts: Literature and Calligraphy.* Shanghai: The World Book Co., 1935.

　　康有爲　　廣藝舟雙楫

Li Yang-Ping. *Li Yang-Ping Chuan Shu.* Ed. by Tuan Wei-Yi. Taiwan: Hsing Hsuo Publishing Co., 1972.

　　李陽冰　　李陽冰篆書　　段維毅

Liu Hai-Su, Ni Yi-Teh, et al. *Essays on the New Arts.* Shanghai: Ta Kung Book Co., 1935.

　　劉海粟、倪貽德　　藝術新論

Liu Kung-Chuan. *Liu Kung-Chuan Hsuan Mi Ta Tablet.* Taiwan: Hsing Hsuo Publishing Co., 1971.

　　柳公權　　柳公權玄秘塔

Mai Hwa-San. *An Introduction to Chinese Calligraphy.* Hong Kong: Shanghai Book Co., 1964.

　　麥華三　　歷代書法講座

National Palace Museum. *Sun Kuo Ting Manual of Calligraphy.* Peking: The National Palace Museum, 1938.

　　故宮博物院　　孫過庭書譜

Pao Shih-Chen. *On the Twin Arts: Literature and Calligraphy.* Shanghai: The World Book Co., 1935.
包世臣　藝舟雙楫

Shih Tao. *Album of Landscapes by Shih Tao.*
石濤　石濤山水畫册

———. *Album of Paintings on Su Tung Po's Poems.*
石濤畫蘇東坡詩序

———. *Ch'ing Hsiang Painting Album.*
清湘畫册

Shih Tze-Chen. *Aesthetics of Calligraphy.* Taiwan: Yi Wen Press, 1976.
史紫忱　書法美學

———. *Appreciation on Chinese Calligraphy.* Taiwan: Hwa Kang Press, 1975.
書道鑑賞

———. *New View on Chinese Calligraphy.* Taiwan: Art Books Co., 1974.
書道新論

Suzuki, D. T. *Zen Buddhism.* Translated from the Japanese by S. C. Li. Taiwan: Hsieh Chih Industrial Publishers, Ltd., 1971.
鈴木大拙　禪佛教入門　李世傑

Teng Ku. *Essays on Chinese Art.* Shanghai: Commercial Press, Ltd., 1938.
滕固　中國藝術論叢

Tung Ch'i-Chang. *Notes on Hwa Ch'an Studio.* Shanghai: The World Book Co., 1935.
董其昌　畫禪室隨筆

Wang Yuan-Ch'i. *Imitations of Landscape Paintings by Sung and Yuan Masters.* Ed. by Peng Shih. Shanghai: You Cheng Book Co.
王原祁　王麓台倣宋元山水册

Yu Chian-Hwa. *A Study on Chinese Painting.* Shanghai: Commercial Press, Ltd., 1941.
俞劍華　國畫研究

## TECHNIQUES

Chao Meng-Fu. *Chao Sung-Hsiuo Mo Pao.* Taiwan: Kwang Yi Book Co., 1958.
趙孟頫　趙松雪墨寶

Chiang Pai-Shih. *Supplementary Manual of Calligraphy*. Hong Kong: China Book Co., 1953.
姜白石　續書譜

Hsieh Hsi. *On Chinese Calligraphy*. Hong Kong: Wen Yuan Studio, 1960.
謝熙　書法淺言

Hwang Ying-P'iao. *Album of Figures, Flowers, and Landscapes by Hwang Ying P'iao*. Ed. by Chou Shih. Shanghai: Wen Ming Book Co.
黃癭瓢　黃癭瓢人物花卉山水畫冊　周氏

Kao Tao Pei Hai and Fu Pao-Shih. *Method of Painting Mountains*. Shanghai: People's Art Publishers, 1957.
高島北海　傅抱石　山水畫法

Mei Chu-Shan. *Yellow Mountain Masterpieces by Mei Chu-Shan*. Ed. by Chow Chin-Chuo. Shanghai: Commercial Press, Ltd., 1939.
梅瞿山　梅瞿山黃山精品　周今覺

Shih Cheng-Chung. *The Basic Techniques of Chinese Calligraphy*. Taiwan: Art Books Co., 1974.
史正中　書法入門

Shih Tao. *Album of Landscapes by Ta Ti-Tze* (Shih's pen name). Shanghai: You Cheng Book Co., 1924.
石濤　大滌子山水畫冊

Teng San-Mu. *A Handbook for Learning Calligraphy*. Hong Kong: Tai Ping Book Co., 1962.
鄧散木　學習書法必讀

Wu Ch'ang-Shuo. *The Album of Poems, Calligraphy, and Paintings by Old Man Foou Lu*. Shanghai.
吳昌碩　缶盧老人詩書畫集

——. *Masterpieces by Foou Lu*. Ed. by Liu Hai-Su. Shanghai: Shanghai Art Supplies Co., 1939.
缶翁遺墨集　劉海粟

Yang Kia-Lo. *A Study on the Four Gems: Brush, Paper, Ink and Inkstone*. Taiwan: The World Book Co., 1962.
楊家駱　文房四寶

*Materials in English*

Burling, Judith and Arthur. *Chinese Art*. New York: Bonanza Books.

Cameron, Alison Stilwell. *Chinese Painting Techniques*. Rutland, Vermont: Charles E. Tuttle Co., 1968.

Chen Wei. *The Four Books*. Macau: Chu Wen Tang Book Co., 1962.

Feng, Gia-Fu and English, Jane. *Tao Te Ching.* New York: Vintage Books, 1972.

Fung Yu-Lan. *A Short History of Chinese Philosophy.* New York: The Free Press, 1966.

Government of The Republic of China. *Chinese Art Treasures.* New York: Skira, 1961–1962.
Kwo, David. *Modern Chinese Paintings by David Kwo.* Chicago: The Art Institute of Chicago, 1955.

Lee Shao-Ch'ang. *China's Cultural Development.* East Lansing: Michigan State University Press, 1964.
Lee, Sherman E. *A History of Far Eastern Art.* Englewood Cliffs, New Jersey: Prentice-Hall, Inc.

National Gallery of Art. *The Chinese Exhibition.* Washington, D.C.: The National Gallery of Art, 1975.

Sickman, Laurence and Soper, Alexander. *The Art and Architecture of China.* Baltimore: Penguin Books, 1956.

Siren, Osvald. *The Chinese on the Art of Painting.* 1st edition, Peking: Henri Vetch, 1936. Paperback edition, New York: Schocken Books, Inc., 1963.

Sullivan, Michael. *The Arts of China.* Berkeley and Los Angeles: University of California Press, 1973.

Suzuki, D. T. *Essays on Zen Buddhism.* New York: Grove Press, Inc., 1961.

———. *Manual of Zen Buddhism.* New York: Grove Press, Inc., 1960.

Swann, Peter. *Art of China, Korea, and Japan.* London: Thames & Hudson, 1963.

Sze Mai-Mai. *The Way of Chinese Painting.* Translation into English of Wang Kai et al., *Mustard Seed Garden* (c. 17th cent.). New York: Modern Library-Random House, 1956.

Tsien Tsuen-Hsuin. *Written on Bamboo and Silk.* Chicago: The University of Chicago Press, 1962.

Yang Kia-Lo. *Truth and Nature.* Hong Kong: International Book Store, 1962.

Yee, Chiang. *Chinese Calligraphy: An Introduction to Its Aesthetic and Technique.* 3rd edition. Cambridge, Massachusetts: Harvard University Press, 1973.

# Index